Francis Bacon and the Masters

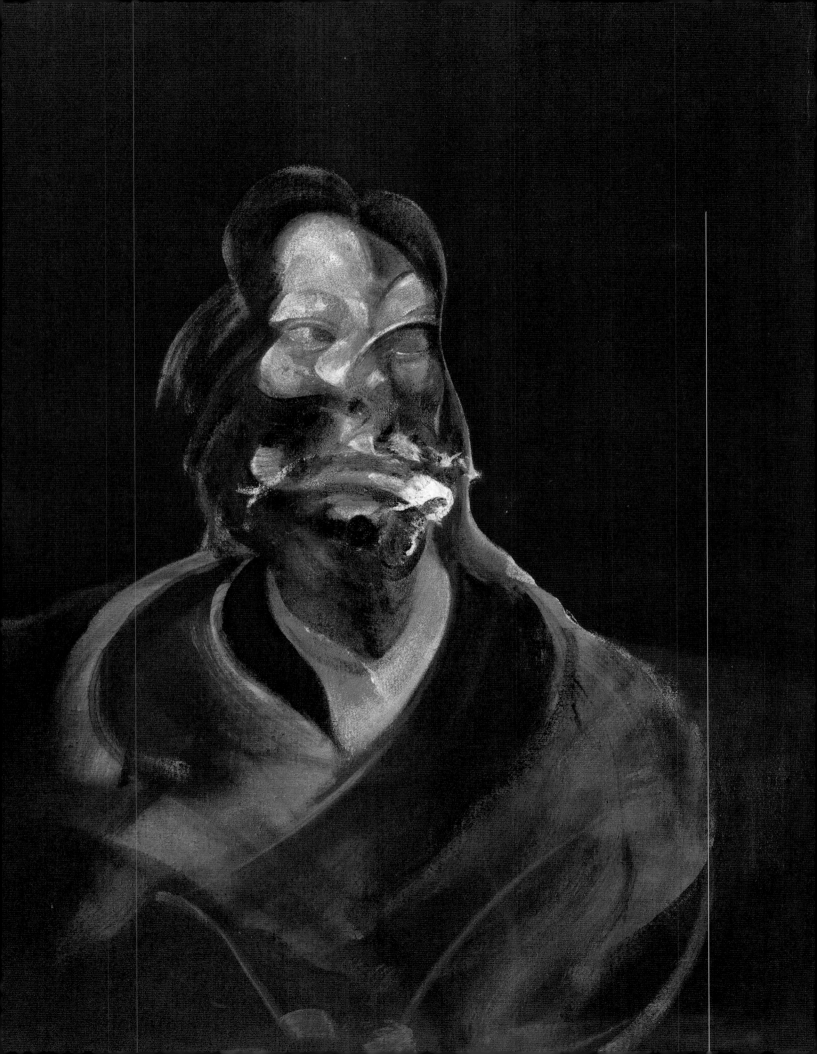

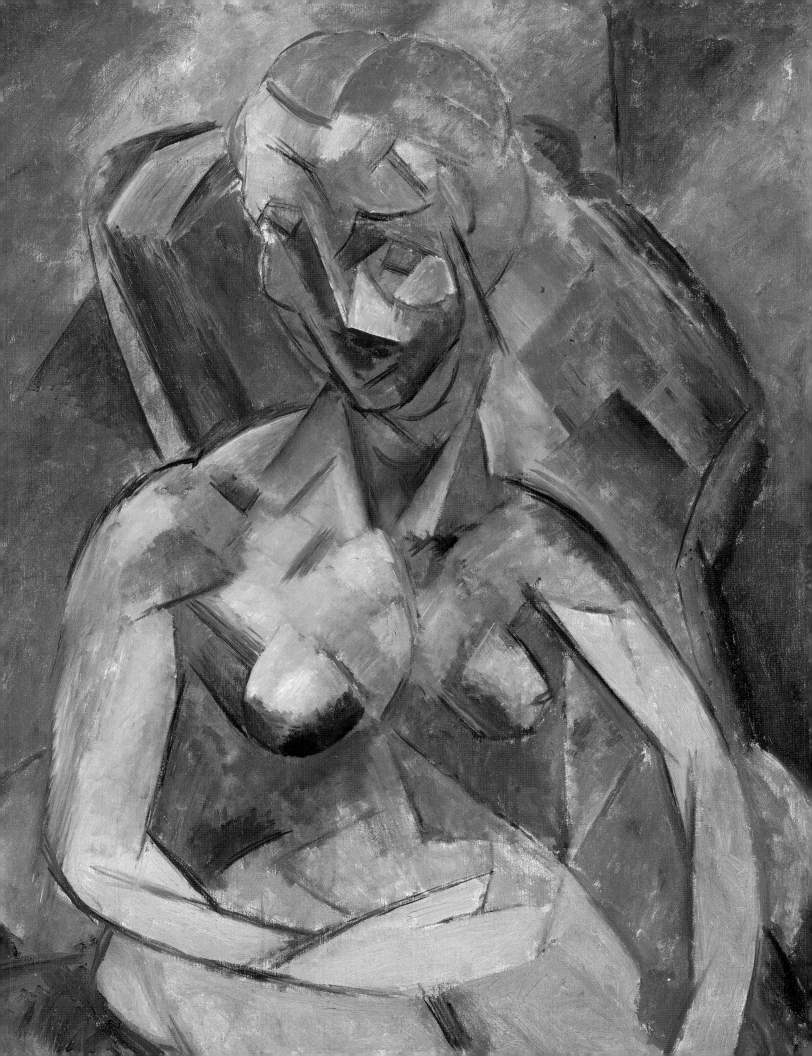

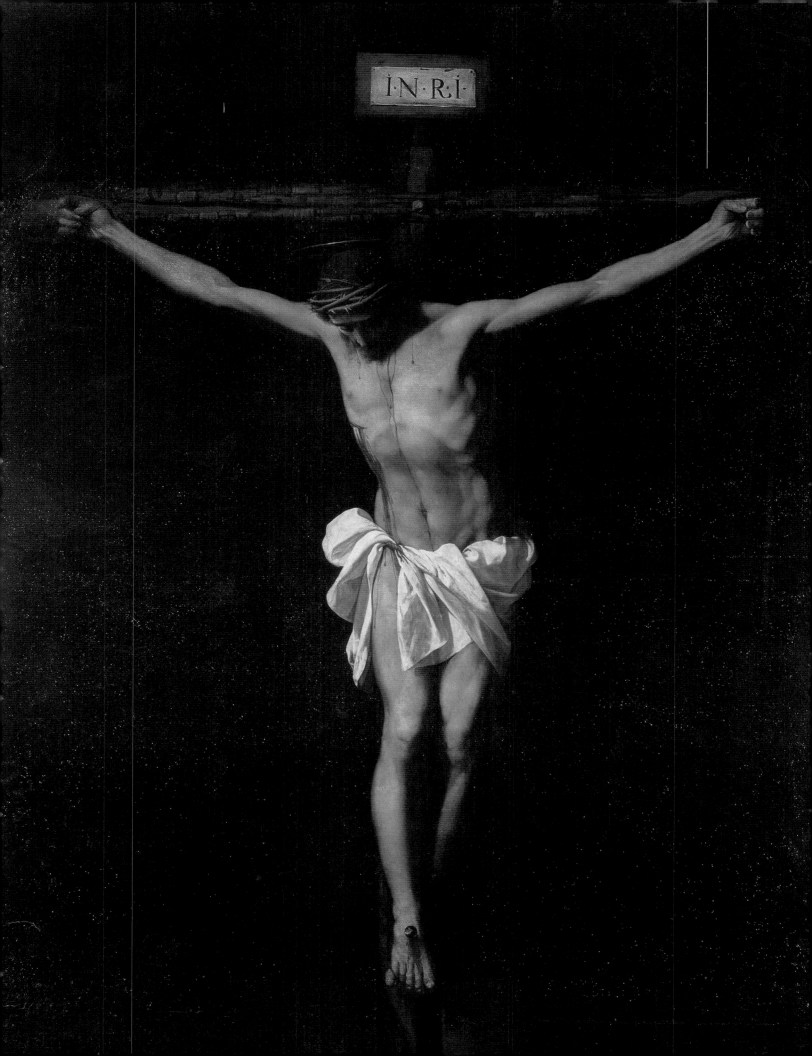

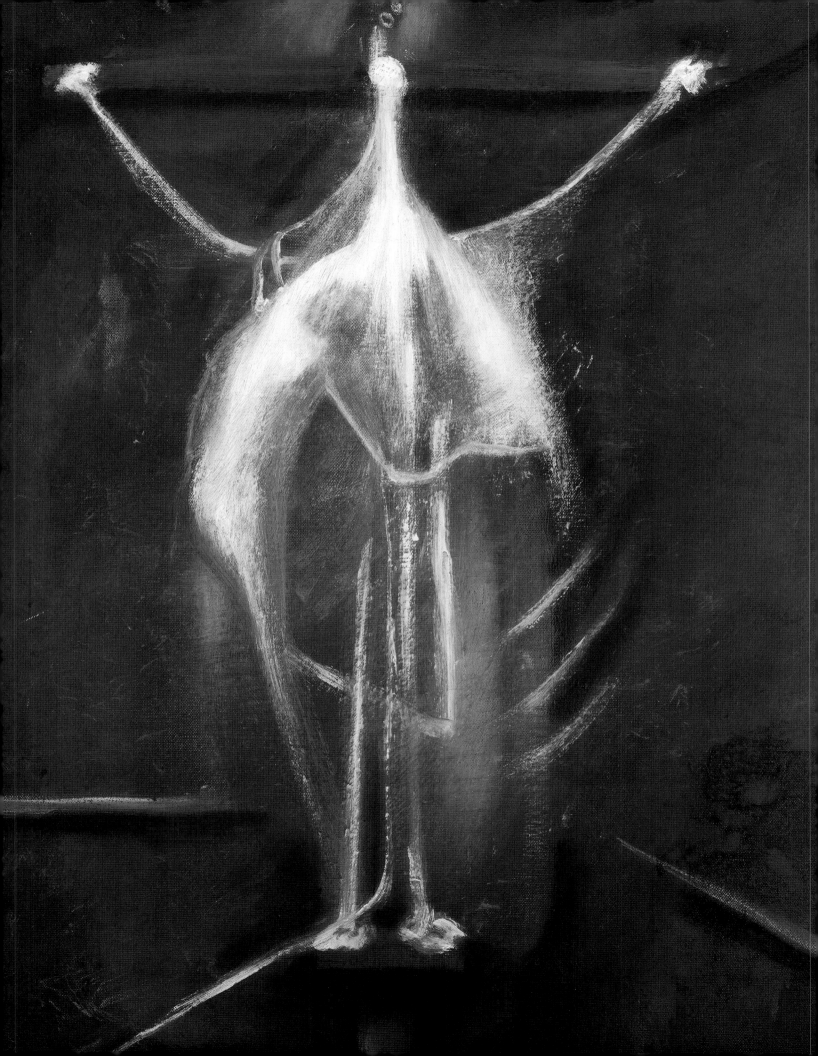

Francis Bacon and the Masters

**Sainsbury Centre for Visual Arts, University of East Anglia
State Hermitage Museum, St Petersburg**

SAINSBURY
CENTRE
for Visual Arts

 ЭРМИТАЖ
250

 ГОСУДАРСТВЕННЫЙ
ЭРМИТАЖ
The State Hermitage Museum

Francis Bacon and the Masters at the Sainsbury Centre for Visual Arts, University of East Anglia, Norwich, 17 April – 26 July 2015

First exhibited as *Francis Bacon and the Art of the Past* at the State Hermitage Museum, St Petersburg, 7 December 2014 – 8 March 2015

This catalogue is compiled by the Sainsbury Centre for Visual Arts, University of East Anglia, and the State Hermitage Museum

www.scva.ac.uk
www.hermitagemuseum.org

Academic Editors: Amanda Geitner,
 Thierry Morel, Calvin Winner
Editors: Frank Althaus, Mark Sutcliffe
Design: John Morgan studio, London
Photography: see p. 215

Cover: Francis Bacon, *Study for a Portrait of Van Gogh I*
Back cover: Detail from *Farms near Auvers*, 1890,
 Vincent van Gogh (1853–1890). Bequeathed
 by C. Frank Stoop 1933. ©Tate, London 2015
p. 2: Francis Bacon, *Portrait of Isabel Rawsthorne*
p. 3: Pablo Picasso, *A Young Lady*
p. 4: Alonso Cano, *Crucifixion*
p. 5: Francis Bacon, *Crucifixion*
pp. 10–11: Francis Bacon's Studio, photograph
 by Perry Ogden

Printed in Belgium
ISBN 978–1–906257–15–6

First published in 2015
Fontanka Publications
5A Bloomsbury Square
London WC1A 2TA
www.fontanka.co.uk

Academic Advisory Group
Professor Mikhail Piotrovsky
Director of the State Hermitage Museum, associate member of the Russian Academy of Sciences, member of the Russian Academy of Arts, professor of St Petersburg State University

Professor Paul Greenhalgh
Director, Sainsbury Centre for Visual Arts, University of East Anglia

Professor Edward Acton
Former Vice-Chancellor, University of East Anglia

Professor Simon Dixon
Professor of Russian History, School of Slavonic and East European Studies, University College London

Dame Elizabeth Esteve-Coll
Board Member, Sainsbury Centre for Visual Arts

Amanda Geitner
Chief Curator, Sainsbury Centre for Visual Arts

Professor Catriona Kelly
Professor of Russian, University of Oxford

Professor John Mack
Chairman, the Sainsbury Institute for Art

Dr Thierry Morel
Sainsbury Centre for Visual Arts, Curator at Large and Board Member, Hermitage Museum Foundation USA

Professor Peter Waldron
School of History, University of East Anglia

Moya Willson
Honorary Board Member, Sainsbury Centre for Visual Arts

Calvin Winner
Head of Collections Management and Conservation, Sainsbury Centre for Visual Arts

Guest Curator
 Dr Thierry Morel

Curator, State Hermitage Museum
 Dr Elizaveta Renne

Curators, Sainsbury Centre for Visual Arts
 Amanda Geitner, Calvin Winner

Curatorial Assistance
 Claire Allerton, Ksenia Galina

The exhibition organisers wish to express their sincere thanks to the following:
Aberdeen Art Gallery and Museums; Barber Institute of Fine Arts, University of Birmingham; Dublin City Gallery The Hugh Lane; Martin Harrison; Larissa Haskell; Murderme Collection; National Gallery, London; New Walk Art Gallery and Museum, Leicester; Pilar Ordovas; Anna Pavlova; Peter L. Schaffer; Jasper Sharp; The State Hermitage Museum; Tate; Victoria and Albert Museum; Jon Whiteley; Linda Whiteley; Yale Center for British Art, New Haven; The Estate of Francis Bacon and all private lenders

Francis Bacon and the Masters is supported by:

CHRISTIE'S

and

Peter L. Schaffer, A La Vieille Russie

The Sainsbury Centre is supported by:

The **Gatsby** Charitable Foundation

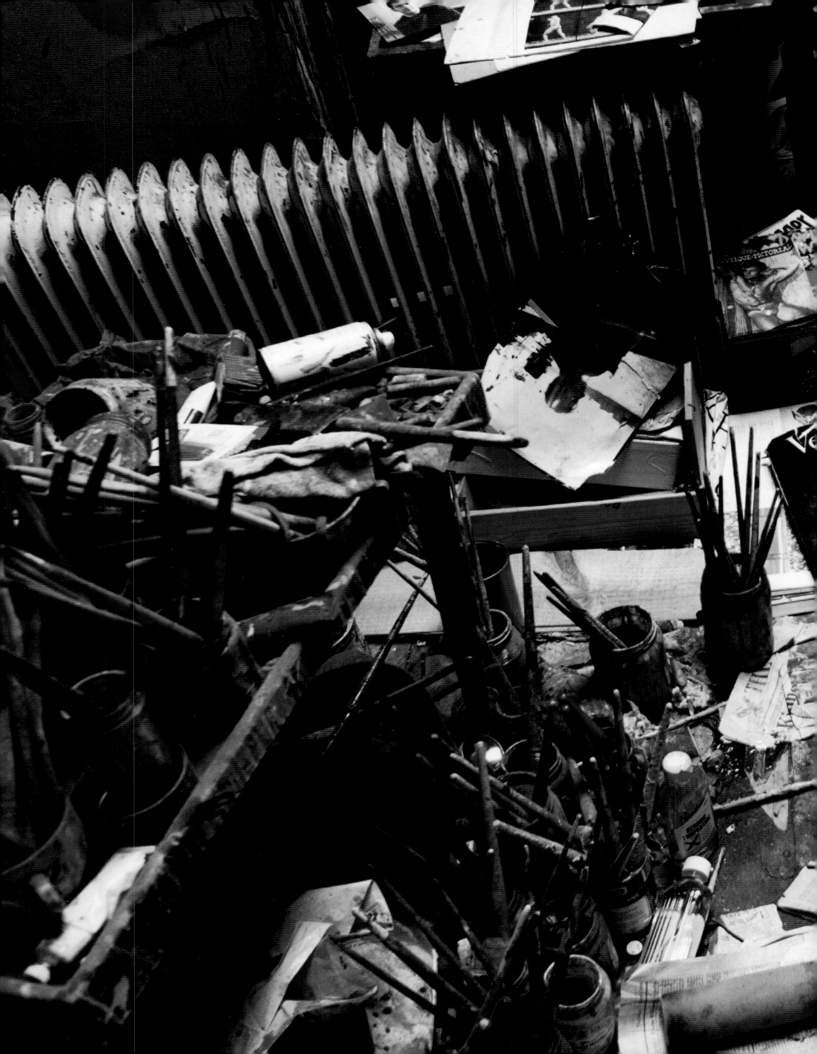

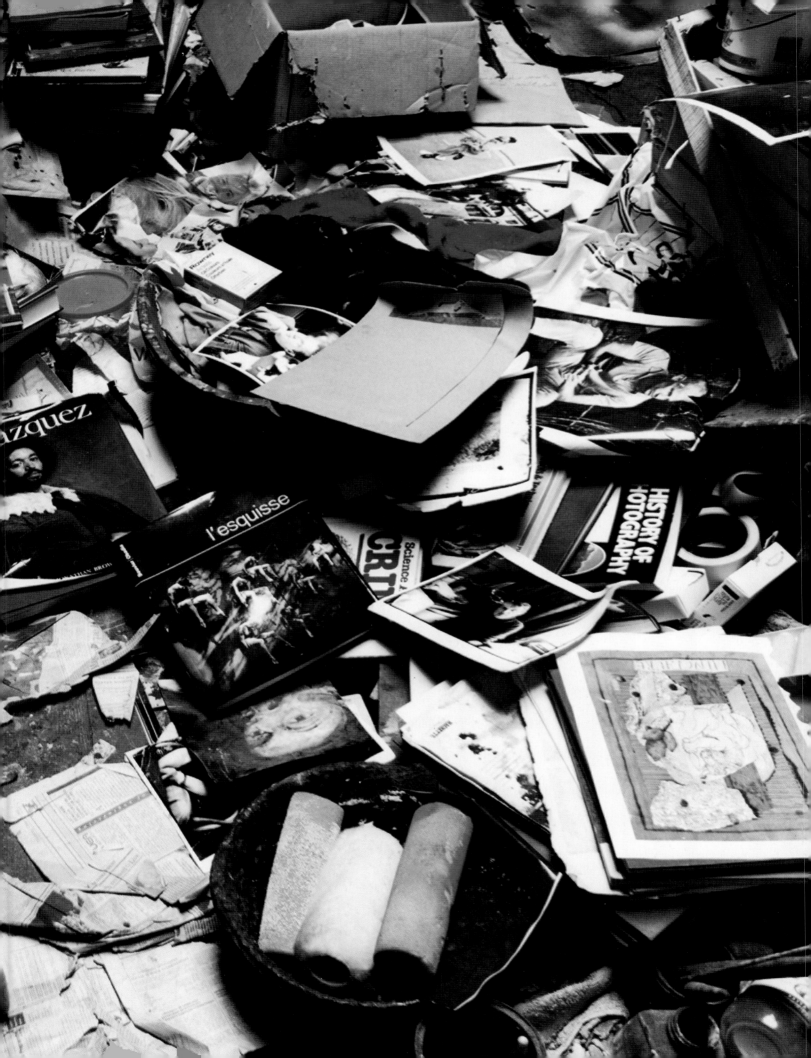

Francis Bacon and the Sainsbury Centre for Visual Arts

Francis Bacon sits in a complex place in the history of modern art. This isn't surprising: as a profoundly complex man it is most certainly the place he would have chosen. His work doesn't fit logically into mainstream histories of modern art, the histories that give preeminence to stylistic trends, logical progressions, or holistic theories. There was no 'ism' that contained and gave meaning to Bacon's œuvre. He was a representational artist in the age of abstraction. But as one of the greatest painters of his century, he was deeply Modern in his sensibilities – more interested in modernity than Modernism perhaps – and revealed this in his approach to paint and in his sense of what art was for. His art was about the maelstrom-like nature of life, the traumas of isolation, love, and personal identity, and as such, he struggled with the human issues of his age. He also felt intensely close to his painter forebears, the grand masters who had gone before him, and he endlessly made use of them in the search for his own language. Velázquez, Rembrandt, Michelangelo, Ingres, Van Gogh and many others fed his creativity, firing him into transformatory action. Like Picasso, he was an eclectic Modernist, who took what he needed from the art of the past to make the art of the present. That is what this exhibition is about: the use of the past by one of the greatest modern painters: the past re-interpreted into the psychologically tense, frenetic world of a man searching for meaning at the boundary-edges of life.

The exhibition also has another theme in its background. From early in his career, Bacon enjoyed the patronage and friendship of one of Britain's greatest collecting and philanthropic couples, Sir Robert and Lady Lisa Sainsbury. The great collection of Bacon's work at the Sainsbury Centre for Visual Arts, the institution Robert and Lisa built, is a direct result of this friendship, and a significant proportion of the Tate's Bacons are there because of them. Many of these works are in the exhibition. So the exhibition not only explores Bacon's love and use of earlier great art, it also illustrates the work of two of modern Britain's most generous and sensitive supporters of the arts.

Finally, the exhibition inaugurates a relationship between the State Hermitage Museum and the Sainsbury Centre for Visual Arts that will result in the two institutions staging scholarly projects and exhibitions well into the future. Cultural and intellectual exchange have always been the greatest means of fostering international understanding and friendship. We are grateful to our Russian friends and colleagues for taking part in this grand collaboration, for making the idea become a reality.

Paul Greenhalgh
Director, Sainsbury Centre for Visual Arts

Bacon in the Hermitage

Many years ago, after considerable organisational difficulties, one of Francis Bacon's great triptychs was shown at the Hermitage. Surprisingly, and contrary to my own expectations, people did not come in their droves to see it – which said more about the audience than about Bacon, of course. But after that we started to look for some way of doing a full-blown exhibition of Bacon that would chime with Hermitage traditions and its educational mission. In the course of this search I came across one of the most impressive museum installations I had seen – Bacon's studio, relocated to a museum in Dublin. Photographs of classical works of art, which Bacon used as a starting point for many of his fantasies, lay scattered on the floor and on various shelves.

After numerous conversations with British colleagues about a possible exhibition, the idea was born of combining Bacon's own works with those of Old Masters. The intention, however, was to create a dialogue not so much with actual prototypes, but with paintings from the Hermitage collection that bore interesting typological similarities to Bacon's. Thanks to our joint endeavour with the Sainsbury Centre and the kind generosity of many museums, we have been able to put together a fascinating exhibition in which signature works by Bacon hang side by side with signature works in the Hermitage collection, as well as with material from his studio.

Crowning everything at the Hermitage exhibition is the portrait of Pope Innocent X by Velázquez from the seat of the Duke of Wellington, Apsley House, in London. Not only is the work an eminently suitable partner for Bacon, it also provides a direct link with the portrait of the Duke of Wellington in the War Gallery in the Winter Palace, reflecting the long and warm relations between the Hermitage and the Duke's descendants.

We are very grateful to all those who helped bring about this complex exhibition. I am sure that it will be received enthusiastically by an appreciative audience.

Mikhail Piotrovsky
Director, State Hermitage Museum

Thierry Morel **Francis Bacon and the Art of the Past**

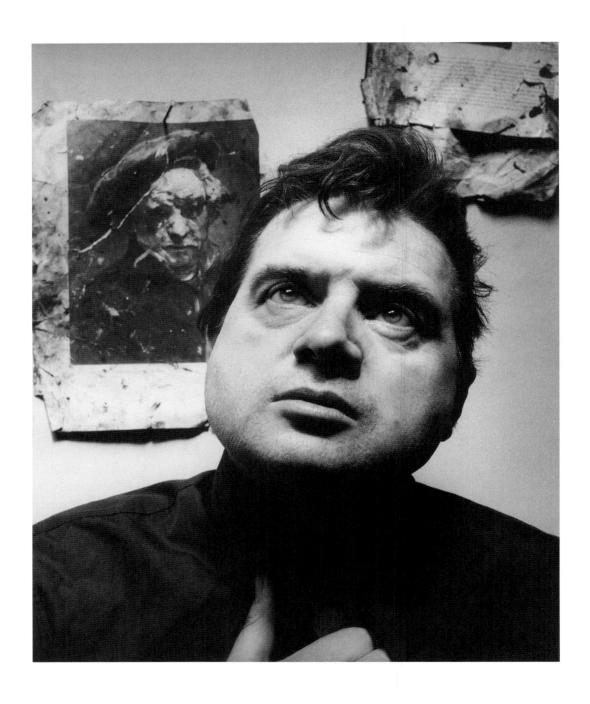

And then too, to be a painter now, I think that you have to know, even if only in a rudimentary way, the history of art from pre-historic times right up to today. You see, I have looked at everything in art. And also at many kinds of documentary books.[1]

Francis Bacon never hid his fascination with the art of the past. His love of the work of the Old Masters was personal, but he also believed that the study of their art should be a prerequisite for all contemporary painters. Most artists have acknowledged an interest in the art of previous eras in one way or another. Few, though, have embraced it as openly as Francis Bacon, and at times for him it became an obsession.

Neither the exhibition nor this essay attempts to demonstrate that Bacon's entire body of work derived directly from that of past artists, sculptors and painters; rather, it offers some interpretative keys to the creative genius of one of the most revered artists of the last hundred years. The selection of paintings and sculptures here, taken almost exclusively from the collection of the State Hermitage Museum in St Petersburg, dates from ancient times to the twentieth century. It includes a number of works that directly influenced Bacon, and others that evoke the types of artwork he studied. His paintings have been set alongside those of other artists, or framed in the context of earlier eras, before now: in recent years most notably at exhibitions at the Kunsthistorisches Museum in Vienna, the Fondation Beyeler in Basel, the Ashmolean Museum in Oxford and the Ordovas Gallery in London.[2] Here, however, the focus is less on the juxtaposition of works, and more on the mysterious cycle of Bacon's creation: his observation, interpretation and integration of the art of the past. Furthermore, the extraordinary variety and breadth of the State Hermitage's collection, combined with the invaluable holdings of the Sainsbury Centre in Norwich and the Hugh Lane Gallery in Dublin, have allowed for an unprecedented assemblage of masterpieces alongside a comprehensive range of documentary material.

Bacon left many clues to his perceptions and uses of the art of the past, not just in interviews (notably those with David Sylvester) but also through the material found in his London studio, now in the Hugh Lane. This includes the artist's library and a number of prepared and unfinished canvases, as well as a vast quantity of documents, brushes and paint tubes – all of it amounting to an archaeologist's dream. The piles of books, hundreds of torn pages, stained photographs and press cuttings lying on the floor testify to a cultured and inquisitive mind at work. And here amongst the debris of the studio lie the raw materials of the secret alchemy with which Bacon created his highly charged art.

Bacon's biographers all refer to the significant impact on his early artistic development of works of other artists, whether encountered in museums, exhibitions or books. During his three-month sojourn in France as a young man he visited the fine collection of the duc d'Aumale in Chantilly, as well as the Louvre and the Picasso exhibition at the Paul Rosenberg gallery. A few individual works made a lasting impression, and these occasionally reappear as references in his later work, notably in the echoes of Poussin's *Massacre of the Innocents* from Chantilly.

Francis Bacon and the Art of the Past

The earliest known painting in this exhibition, the *Crucifixion* of 1933 (cat. 40), while typifying Bacon's particular fascination with the theme of Christ's Passion, is evidence of his more general interest in tragic subjects. Although baptised and – at least in theory – educated as a Protestant, Bacon always described himself as an atheist. As he explained to David Sylvester, he saw the Crucifixion not so much as a conventional religious subject, but as a theme that allowed for the expression of extreme human emotions: 'Well, there have been so very many great pictures in European art of the Crucifixion that it's a magnificent armature on which you can hang all types of feelings and sensation. You may say it's a curious thing for a non-religious person to take the Crucifixion, but I don't think that has anything to do with it. The great Crucifixions that one knows of – one doesn't know whether they were painted by men who had religious beliefs.'[3] Bacon was particularly drawn to Cimabue's *Crucifix* (fig. 2), created for the Church of Santa Croce in Florence, in which the figure of Christ is 'just moving, undulating down the cross',[4] and which Bacon referenced, inverted, in his own *Three Studies for a Crucifixion* (fig. 3).

Bacon's first *Crucifixion* uses a rather sombre and restrained palette, mostly black and grey. It translates the mute nature of sorrow in a manner that brings to mind Alonso Cano's painting on the same theme (cat. 24), in which the body of Christ appears in isolation, lost in a dark and empty universe.

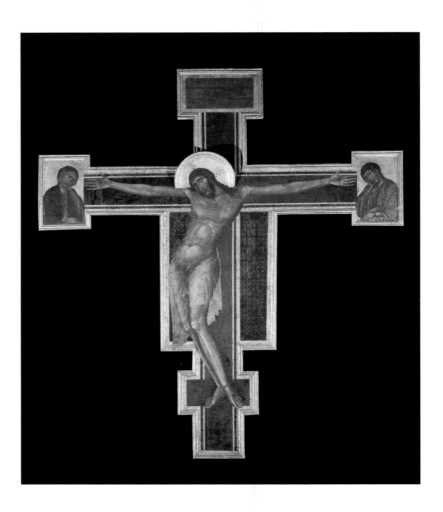

Francis Bacon and the Art of the Past

By contrast, Bacon employed a very bright, almost blinding, orange in the background of his *c.*1944 triptych, *Three Studies for Figures at the Base of a Crucifixion* (London, Tate), focusing the mind of the viewer on the suffering and ambiguous nature of figures that are both human and bestial.[5] The scene is dominated by the raw pathos of the scream. Bacon often associated the Crucifixion with images of slaughterhouses and meat, referring to the 'smell of death'.[6] The triptych format that he used throughout his career is also, of course, a familiar religious idea borrowed from the art of the past: a symbol of the mystery of the Trinity.

The theme of Christ's Passion and the references to earlier *Crucifixions* provided Bacon with inspiration and a point of departure. He clearly saw his work as belonging to a great tradition – an acceptance, not a rejection, of the past, as he admitted with some humility: 'Yes, they breed other images for me. And of course one's always hoping to renew them.'[7] Many artists have set out to shock, not least the Surrealists, and fashion-conscious contemporary artists continue to do so as they compete for attention in a global market. But Bacon's respect for artistic tradition suggests his powerful and often shocking treatment of the symbols of sacred art had a deeper significance. He used shock effects not for their own sake, but in response to a vision of the world that in its recurrent darkness can be compared to the art of Goya.

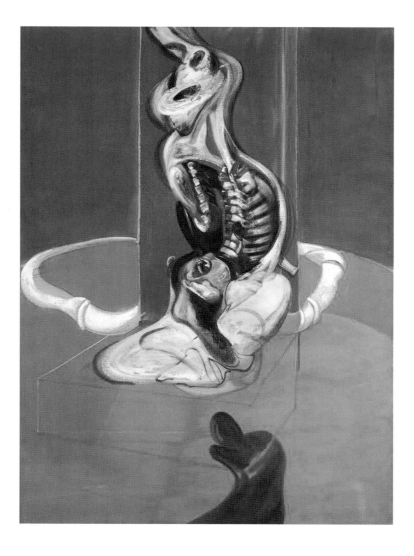

Francis Bacon and the Art of the Past

One of Bacon's most impressive series of works, popularly known as the 'screaming popes', was based on a disturbing reworking of Diego Velázquez's iconic *Portrait of Pope Innocent X* in the Doria Pamphilj collection in Rome (fig. 4; also known in versions in London, Washington and elsewhere). Bacon denied that he chose this particular portrait because of its iconic status, or simply because it was one of the most memorable of papal portraits. Instead, he justified his choice on the grounds of its undeniable artistic merits: 'It comes from an obsession with the photograph that I know of Velázquez's *Pope Innocent X*.' He thought it 'one of the greatest portraits that have ever been made, and I became obsessed … by the *Pope*, because it just haunts me, and it opens up all sorts of feelings and areas of – I was going to say – imagination, even, in me … I think it's the magnificent colour of it.' David Sylvester, shrewd and insightful art critic that he was, then aptly remarked: 'But you've also done two or three paintings of a modern Pope, Pius XII, based on photographs, as if the interest in the Velázquez had become transferred onto the Pope himself as a sort of heroic figure.' Sylvester continued: 'Since there's the same uniqueness, of course, in the figure of Christ, doesn't it really come back to the idea of the uniqueness and the special situation of the tragic hero? The tragic hero is necessarily somebody who is elevated above other men to begin with.'[8] Bacon agreed with these conclusions but then appeared to dismiss this

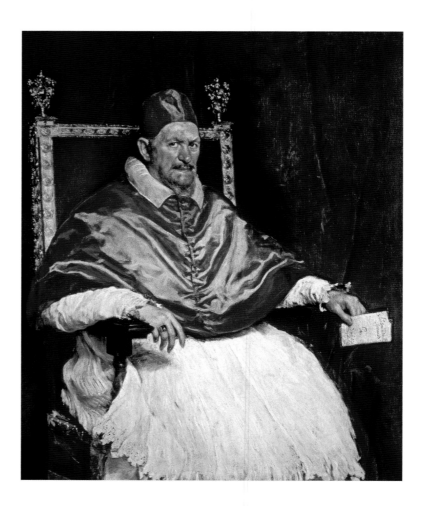

Figure 5: Francis Bacon, *Study after Velázquez*, 1950; cat. 41

Figure 6: Still from Sergei Eisenstein's film *Battleship Potemkin*, 1925

celebrated series on two counts: first because he felt that the images were 'silly', and secondly because he had not managed to paint them in the way he had intended: 'When I made the Pope screaming, I didn't want to do it in the way that I did it – I wanted to make the mouth, with the beauty of its colour and everything, look like one of the sunsets or something of Monet, and not just the screaming Pope. If I did it again, which I hope to God I never will, I would make it like a Monet.'[9]

The mouth, the most powerful and memorable detail in the Pope paintings, derives in part from a fixation with the human mouth stimulated by a 'very beautiful hand-coloured book on the disease of the mouth' that Bacon had bought, as well as from Poussin's figures in *The Massacre of the Innocents* and the screaming figure of an old woman on the Odessa steps in Sergei Eisenstein's silent film *Battleship Potemkin* (fig. 6). All these images left such a forceful impression on the artist in his formative years that he was inspired with the ambition 'one day to make the best painting of the human cry'.[10] This wish remained unfulfilled and he admitted to David Sylvester that he felt he had never achieved a better result than Poussin or Eisenstein.

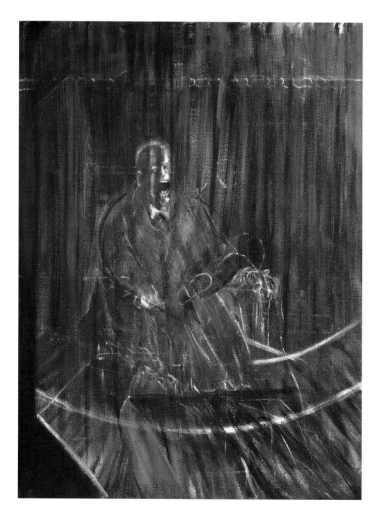

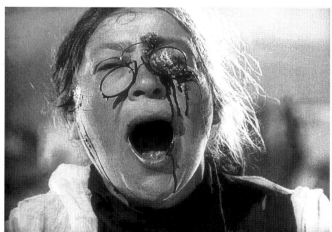

Francis Bacon and the Art of the Past

References to film and old-master painting in the same breath characterises the eclectic range of interests that underlie Bacon's art. Although his regular visits to art galleries throughout Europe are well recorded, Bacon often deliberately belittled their importance, as if they might somehow undermine the public's perception of his own creativity. With little formal training, he perhaps felt that the immediate presence of awe-inspiring masterpieces might have impeded his ability to paint. He could nonetheless rely on his astonishing visual memory and acute sense of observation to recollect the techniques and, particularly, the colours used by some of the great artists of the past.

Bacon was also an avid collector of photographs – notably in books on ancient art, and catalogues raisonnés of Old Masters, Impressionists and sculptors of many periods. He used them not just to invigorate his memory, but primarily to install in his mind a complex kaleidoscope of visual references through which new images would emerge. The primary image, therefore – whether a portrait or a photograph – was no more than a point of departure from which he embarked on a mysterious process of addition, elision and metamorphosis. The often mystifying or tragic character of the resulting figures allowed them to transcend their individuality: the portrait was no longer just a stylised representation of a particular person, but an allegory, a mood, a universe. It is this universality and idealisation of the representation of the human form that drew Bacon to Egyptian, Greek and Roman art.

The work of Van Gogh was another inspiration to Bacon, who created a series of paintings loosely based on the artist's self-portrait as it appears in the *Painter on the Road to Tarascon* (fig. 7). Bacon read Van Gogh's correspondence with his brother Theo, in which Vincent spoke of his artistic ambitions and enthusiasms, and gave moving expression to his despair. The *Road to Tarascon* was tragically destroyed during the Second World War, so Bacon's reinterpretation of it in a series represented here by the *Studies for a Portrait of Van Gogh I* and *IV* (cat. 51 and 56) is thus imbued with enhanced pathos and intensity.[11]

Bacon used photographs and, to some extent, sculpture as a means to study the human body in motion. He referred to Eadweard Muybridge's books of photographs as a 'dictionary' of human motion.[12] Muybridge's photographs of the body, of bodies posing for X-ray, as well as the X-ray images themselves, were particularly influential. Bacon's study of these photographs had good art-historical precedence – Edgar Degas, much admired by Bacon, was also deeply interested in Muybridge's work. Bacon's interest extended beyond photography to include the medium of film, and he was also fascinated by the transformation of images through their distortion, folding, cutting and staining. He amassed great quantities of photographs of dead wild animals and bodies, many taken on the battlefield, which represented to him nothing more than various visual states of a given creature. The fragmentation of form also appealed to him, both in his torn photographs and in damaged ancient sculptures and reliefs. Commenting on the Elgin Marbles in the British Museum, he questioned 'whether if one had seen the whole image they would seem as poignant as they seem as fragments'.[13]

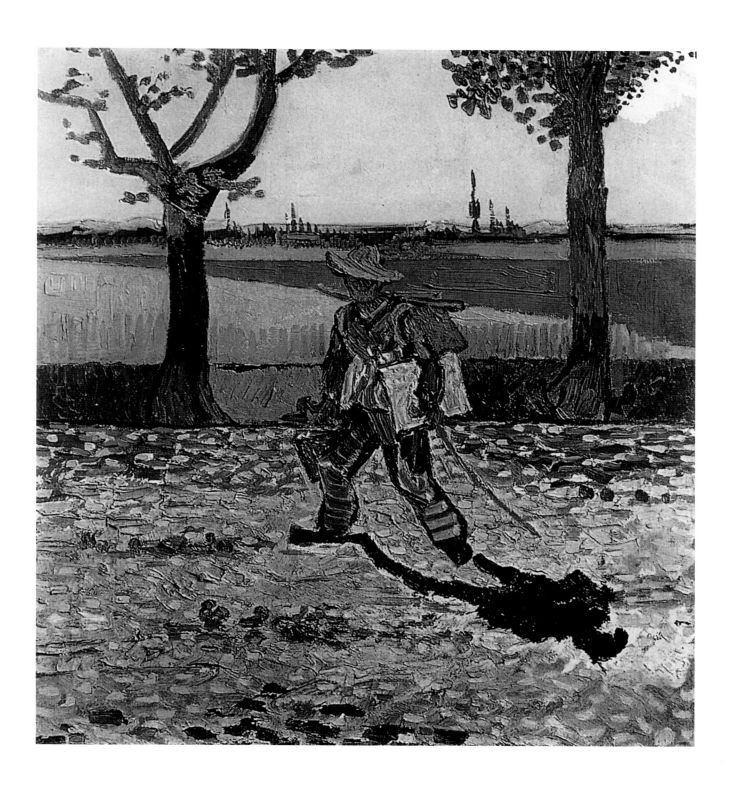

Figure 8: Francis Bacon in his studio at 7 Reece Mews

Figure 9: Diego Velázquez, *Las Meninas*, or *The Family of Philip IV*, *c*.1656; Museo del Prado, Madrid

The concept of distortion that Bacon mentioned in relation to his studies of Velázquez's *Pope* applies also to the images he used in his studio.[14] His interpretation of human portraits, figures, animals and landscapes was generated through an unceasing process of transmutation from one state to another. Bacon even used photographs of his own paintings to create new ones: 'I've been trying to use one image I did around 1952 and trying to make this into a mirror so that the figure is crouched before an image of itself.'[15] The literal and figurative use of mirrors offers a further link with the seventeenth-century Spanish master. The mirror in Velázquez's *Las Meninas* (fig. 9) reflects the painting and the royal sitters, who occupy the space of the viewer; but reflected, too, is the artist himself. In Bacon's work the use of the mirror is a constant leitmotiv, and a conspicuous presence in his studio throughout his career – probably springing from his early career as an interior designer in the 1930s and 40s, when he created rugs and pieces of furniture for an elite clientele. Bacon's studio radically changed in appearance over the years, but the same round mirror that began life as a decorative accessory completing the stylish interior of a fashionable designer became one of his chief working tools. It is no coincidence that one of Bacon's best-known photographic portraits shows him posing in his studio with the mirror in the background (fig. 8).

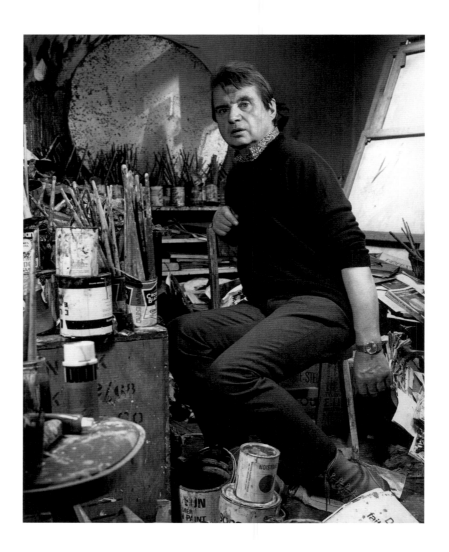

Francis Bacon and the Art of the Past

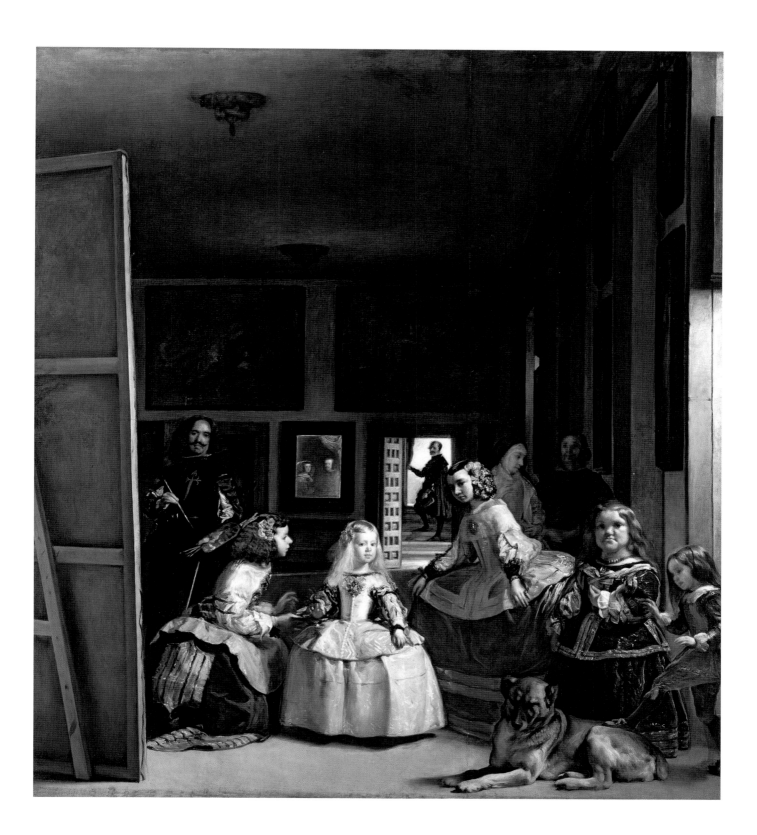

Bacon habitually portrayed himself reflected in a mirror, though his fascination with his own features appears to have been a matter of practical expediency, for he claimed that he had difficulties finding people willing to sit, while those who agreed tended to die off. Although he acknowledged the inherent value of the practice of self-portraiture, he claimed that he would rather paint good-looking people than paint himself because he 'loathed' his own face. In a revealing remark to Sylvester, he commented that, 'One of the nicest things Cocteau used to say is: "Each day in the mirror, I watch death at work"'.[16] The spectre of encroaching mortality seems to lurk over several of his studies of the head. It was represented explicitly by the life mask of William Blake that Bacon kept in his studio (p.179), and by the painting he created from it (cat. 48). Masks, both life and death, were clearly a subject that intrigued him: many of the pages that he tore from books on archaeology illustrated Egyptian, Greek or Roman death masks and effigies (pp.173–6).

Bacon was consistently drawn towards sculpture; and portraiture, with its traditional reliance on the modelling of a discrete object, offered him a parallel with the sculptor's creative process.[17] Unlike much twentieth-century avant-garde art, his work implies a space beyond the picture surface. His liking for arranging objects in triptychs recalls the attempts of a number of painters from the Renaissance onwards to match the multiple viewpoints of sculpture by depicting a head from several angles – one of the best known being Van Dyck's triple portrait of Charles I,[18] made specifically as a model for a bust by Bernini.[19] Bacon, in common with a handful of painters who made use of sculpture in preparing their compositions – Degas in particular – was also sensitive to the experimental nature of *modelli*. His work in this vein is not dissimilar to the effect of the double images of a figure in motion produced by the camera, or the multiple photographic portraits that Bacon took of himself from several angles, or the photographs he often used, for example, in the series of paintings of Henrietta Moraes.

Bacon's distortion of his subject was an essential element of his art. 'I'm always hoping to deform people into appearance; I can't paint them literally', he said.[20] Van Gogh, one of his favourite painters, provided him with a precedent: '[Van Gogh] was able to be almost literal and yet by the way he put on the paint gives you a marvellous vision of the reality of things.'[21] Rembrandt, too, offered Bacon a model of a reality altered through miraculous technique, where textured flesh and contrasts of light and shade are created by a rich, sombre palette and extravagant impasto. Bacon's paint has a dense Rembrandtesque quality: 'I work between thick and thin paint. Parts of it are very thin and parts of it are very thick. And it just becomes clogged, and then you start to put on illustrational paint.'[22] What Bacon also observed and emulated in Rembrandt was the serialisation of images: portraits and, in particular, self-portraits representing the same sitters or the artist himself over time. 'Oddly enough, if you take the great late self-portraits of Rembrandt, you will find that the whole contour of the face changes time after time; it's a totally different face, although it has what is called a look of Rembrandt, and by this difference it involves you in different areas of feeling.'[23]

With a characteristic touch of cynicism, Bacon described contemporary art as 'completely a game by which man distracts himself'.[24] And while there is undoubtedly an element of game-playing in Bacon's approach to the Old Masters, there is also, whether consciously or not, an element of respect for their belief that their art served a higher purpose – one that defied the limits not just of their individuality, but also of their own mortality.

1. David Sylvester, *The Brutality of Fact: Interviews with Francis Bacon*, London, 1987 (reprinted 2012), p.199.
2. *Francis Bacon and the Tradition of Art* (2004, Vienna: Kunsthistorisches Museum; Basel: Fondation Beyeler), *Francis Bacon and Henry Moore* (2013, Oxford: Ashmolean Museum), *Francis Bacon and Rembrandt* (2011, London: Ordovas Gallery), Martin Harrison, *Movement and Gravity: Bacon and Rodin in Dialogue* (2013, London: Ordovas).
3. Sylvester, p.44.
4. Ibid., p.14.
5. See Luigi Ficacci, *Bacon*, 2003, pp.13–19.
6. Sylvester, p.23.
7. Ibid., p.14.
8. Ibid., pp.24–6.
9. Ibid., p.72.
10. Ibid., p.34.
11. Bacon also developed an interest in landscape through the work of Van Gogh, along with other painters such as Cézanne. Ironically, Bacon claimed that he worked on landscape because of his 'inability to do the figures', and although he much preferred the latter, he produced numerous landscapes. With such paintings as his *Landcape near Malabata, Tangier* (cat. 63), employing an opulent palette and a diversity of brushwork, he succeeded in creating what he described as 'an essence of landscape' (Sylvester, p.65).
12. Sylvester, p.30.
13. Ibid., p.114.
14. For further analysis of this point see Margarita Cappock's essay in this catalogue, pp.148–67.
15. Sylvester, p.37.
16. Ibid., p.146.
17. Paul Joannides's essay in this catalogue (pp.26–36) argues that sculpture in general and the work of Michelangelo in particular were crucial to Bacon's artistic development.
18. Royal Collection, Windsor Castle; see also Philippe de Champaigne's triple portrait of Richelieu (*c.*1640; London, National Gallery), also made as a model for Bernini.
19. Probably destroyed in the fire at Whitehall in 1698.
20. Sylvester, p.146.
21. Ibid., p.172.
22. Ibid., p.18.
23. Ibid., p.28.
24. Ibid., p.29.

Francis Bacon and the Art of the Past

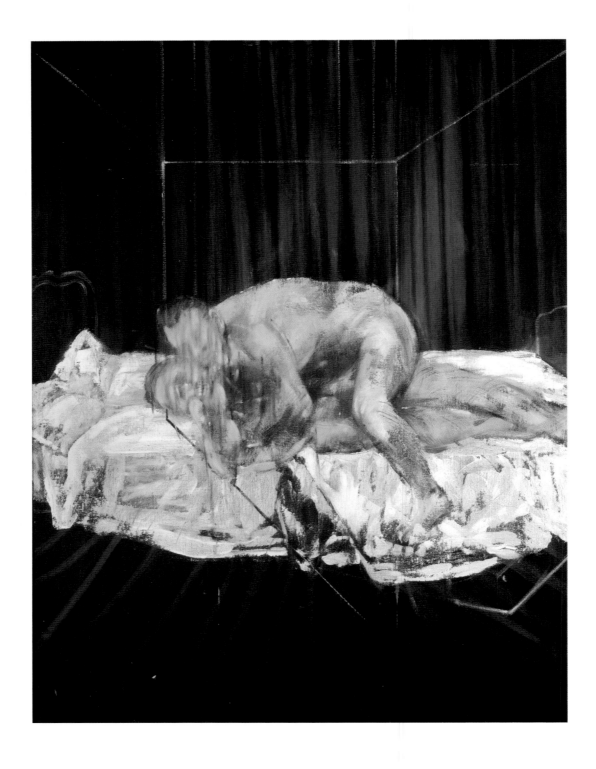

Francis Bacon did not practise as a sculptor, although he occasionally thought of doing so, but his affinity with sculpture was profound.[1] Often neglecting surface design, he concentrated on plastic form, and his breakthrough painting, the triptych *Three Studies for Figures at the Base of a Crucifixion* (*c*. 1944; London, Tate), with its insistent evocation of the male genitals, sets the figures as though on modelling tables. To place isolated forms in undefined settings is an inherently sculptural concept. The form generates energy and tension in its circumambience, compelling space to conform to it. And in negotiations between rather small forms and rather large canvases, Bacon often deployed a further sculptural device: the external armature, or skeletal box, largely inspired by Giacometti.[2]

As a painterly painter, Bacon was devoted to the seventeenth-century masters, Velázquez and Rembrandt, and greatly admired Titian, especially the late work.[3] One might therefore have expected him to respond to the pictorialism and open structures of Baroque sculpture, but although it is likely that some of Bernini's more compact models appealed to him, Bacon's imagination focused on the Classical tradition, specifically in its Hellenistic phase. This was not always conscious. Thus when John Russell connected Bacon's *Two Figures* (fig. 10) with the antique *Wrestlers* (fig.11), he added that Bacon had never seen the Uffizi marble.[4] But the relation is obvious and Bacon cannot have been ignorant of a group so central to Western visual culture, infinitely copied and reproduced, and an inspiration for Bacon's own inspiration, Eadweard Muybridge.[5] Bacon's denial that he had seen *Wrestlers* was surely not deliberate falsehood, for he was generally honest about his art; but, like many artists, he probably felt it unwise to probe too deeply the sources of his inspiration. Bacon looked at everything, took it in and ground it up; he would not necessarily have remembered – or cared – whence a potent image arose.[6]

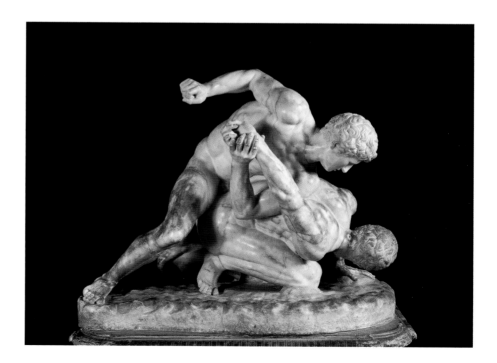

Bacon, Michelangelo and the Classical Tradition

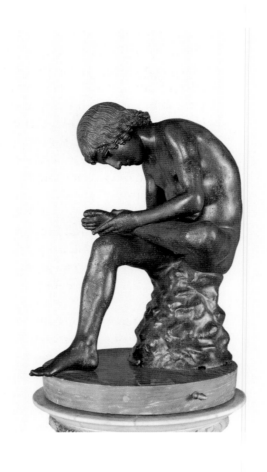

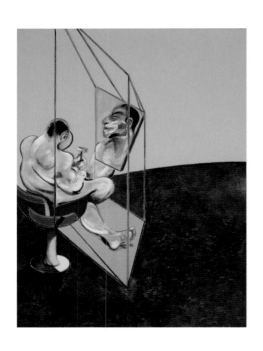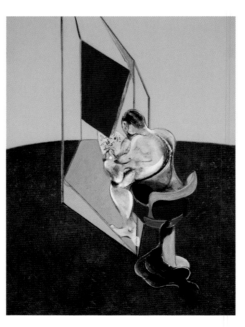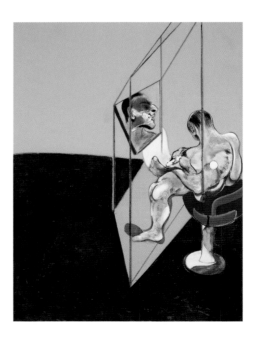

If Bacon's orientation to the Classical tradition was not always fully conscious, it was strong, indeed, fundamental. Even his portrait heads refer not to painted portraiture, but to the sculpted bust, with its antecedents in Roman Antiquity and the Renaissance: three-dimensional form is what Bacon's twists and smears seek to disfigure.[7] Bacon's repertoire is relatively limited and his attempts to extend it in paintings such as *George Dyer Riding a Bicycle* (1966; Basel, Fondation Beyeler) and the depictions of lower bodies with cricket pads attract little attention even from unconditional admirers. In his core work, however, the Classical is deeply felt: Dyer's back in the triptych *Three Figures in a Room* (1964; fig. 15), for example, or the *Three Studies of the Male Back* (1970; fig. 13) recall the back of the *Torso Belvedere*. But Michelangelo's *Day*, of which Bacon had several tearings (fig. 18), Rodin's *Thinker* and Picasso's *Acrobat* also had parts to play, as did the antique *Spinario* (fig. 12). The figure in the left-hand panel of the *Crucifixion* (1965; Munich, Pinakothek der Moderne) and the *Female Nude Standing in a Doorway* (1972; Paris, Centre Georges Pompidou) are both based on a standing Venus while that in the central panel of *Triptych* (1974; private collection) references a crouching Venus. In relation to such antecedents, Bacon's distortions and eviscerations acquire an iconoclastic energy.

No artist with a sculptural imagination can avoid Michelangelo, the classical tradition's greatest representative. Bacon told David Sylvester: 'I am sure that I have been influenced by the fact that Michelangelo made the most voluptuous male nudes in the plastic arts' – a statement that reveals admiration but also interpretative narrowness.[8] Notwithstanding the uses to which others put his forms, for Michelangelo the body was a vehicle of the soul, and beauty was a manifestation of the divine. An inquisitor – who might have been expected to know – famously remarked to Veronese, 'there is nothing in Michelangelo that is not spiritual'. Seeing God in the human body, Michelangelo was committed to its integrity.[9] To represent physical damage was unbearable; even among those skeletons beginning to don flesh in the *Last Judgement*, physical form remains intact, and the vilest of the devils are corrupted, not damaged. Of course, many of Michelangelo's sculptures are unfinished, which would surely have appealed to Bacon, but it was only near the end of his very long life, in his *Crucifixion* drawings and spectral *Rondanini Pietà*, that the soul begins the erosion of the body.[10] But such intense spirituality would have left Bacon, a resolute materialist, indifferent, and there is no indication that he responded to Michelangelo's latest works.

Michelangelo's role in Bacon's œuvre was primarily motivic. Like Picasso, Bacon used photographs, not originals, and whether he spent much time studying Michelangelo's paintings and sculptures in the flesh is doubtful. But his knowledge – active or latent – was extensive. Bacon's studio, now in Dublin, is revealing.[11] It contains several books on Michelangelo: the general studies by Howard Hibbard (1975) and Linda Murray (1980), and Nicholas Wadley's well-illustrated survey as well as those by Frederick Hartt on *The Paintings of Michelangelo* (1964) and *The Drawings of Michelangelo* (1971). Bacon seems to have possessed three copies of the latter as well as the catalogues of Michelangelo's drawings in the British Museum by Johannes Wilde (1953), and in the Uffizi and Casa Buonarroti by Paola Barocchi (1962), as well as Luitpold Dussler's *Die Zeichnungen des Michelangelo* (1959). He also owned Martin Weinberger's

Michelangelo: the Sculptor (1967; fig. 18), which he seems to have found particularly stimulating, despite the black-and-white illustrations not being of high quality – something he perhaps preferred. Until the year before his death, Bacon continued to buy books on Michelangelo.[12]

From these books, from all of which he tore pages, it might seem that Bacon's interests lay more in Michelangelo's drawings than in his paintings and sculptures, and that it is to them that one should look for sources of his art. But one should not over-emphasise this. From his earliest years Bacon would have known and absorbed Michelangelo's sculptures and paintings, which were much more widely reproduced than his drawings. Nor is there evidence that Bacon sought to look at Michelangelo's drawings in reality. Had he emerged from Soho to walk as far as the British Museum, he could have seen the great exhibition of Michelangelo drawings mounted there in 1975; but Nicholas Turner, the co-curator, tells me that to the best of his knowledge Bacon did not visit it.

The torn-out pages offer insights, but not a programme. Bacon surely studied pages that he did not tear out, and no doubt tore pages from other books and journals. Although an assiduous reader he was hardly a caring bibliophile, and we do not know how many books he abandoned or destroyed.[13] So while we should be aware of possible links between his paintings and the torn-out pages, we need not confine ourselves to these in looking for sources. In some areas of his visual vocabulary, Bacon so internalised Michelangelesque motifs

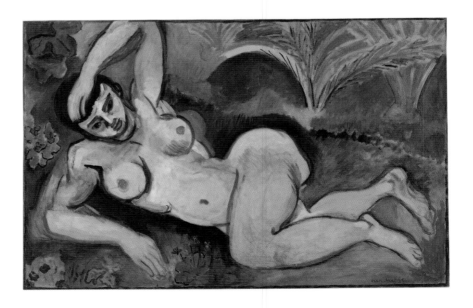

that it would hardly be appropriate to think of them as borrowings. Thus the arm raised above the shoulder, exposing the armpit and lifting the ribcage, is a motif employed by Michelangelo to generate pathos and express vulnerability, and it recurs in many of Bacon's paintings. But it would be naive to insist that he derived it directly from Michelangelo, for it was taken up by some of Michelangelo's contemporaries, and, of course, in the nineteenth century by Rodin – an inescapable presence for Bacon's generation and a sculptor for whom he expressed admiration. And this leads to Matisse, whose painting Bacon claimed to dislike (although he learned a lot from it) but whose sculpture he sometimes praised. One of Matisse's most Michelangelesque bronzes – and the associated painting *Nude bleu (Souvenir de Biskra)* (fig. 14) – surely lay behind Bacon's *Three Figures in a Room* (fig. 15).[14]

Many – perhaps most – of Bacon's forms are, in the Freudian sense, over-determined. They are fusions. Thus his seated figures, either in isolation or in his triptychs, are frequently posed leaning backwards, resting one ankle on the other knee. This is a motif found in some of Michelangelo's drawings for *ignudi* (decorative nude figures) on the Sistine Ceiling, including a sheet in Casa Buonarroti; the imbalance and energy are striking. But whether Bacon studied this, and, if he did, whether he was aware of using it, are open questions. And since Michelangelo himself drew upon the *Spinario*, Bacon, consciously or not, was situating his work within a broader tradition. *Spinario* echoes are found in many of his paintings, and the pose is particularly – although not only – associated with his paintings of Lucian Freud.[15]

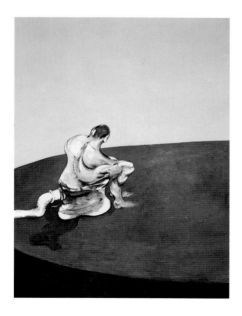 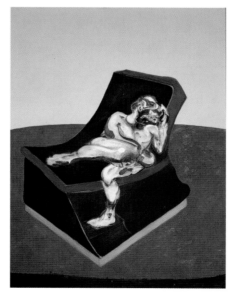 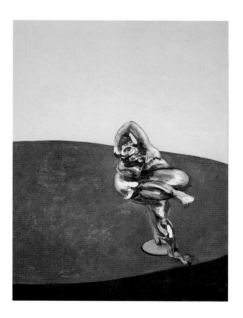

Bacon, Michelangelo and the Classical Tradition

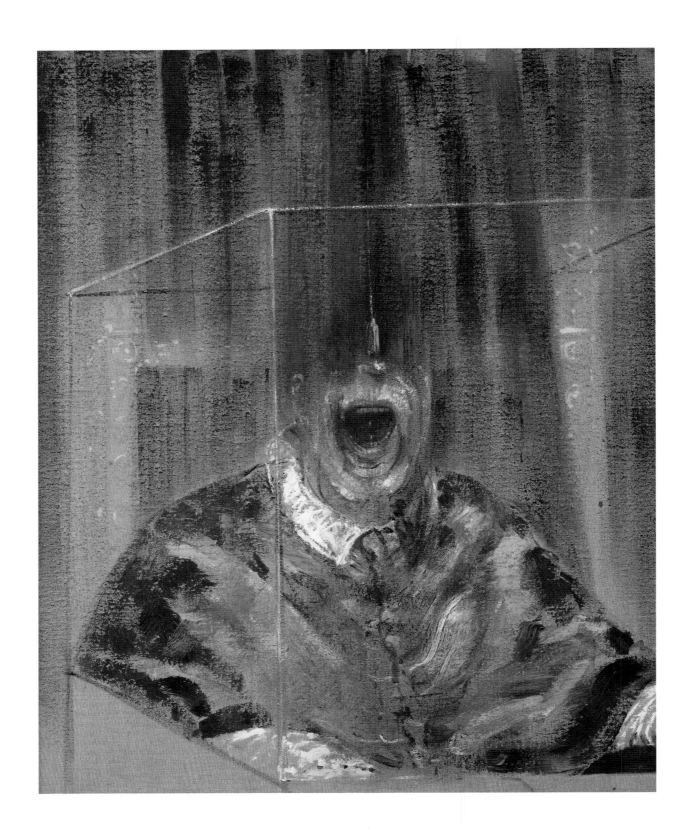

Figure 16. Francis Bacon, *Head VI*, 1949;
The Arts Council of Great Britain, London

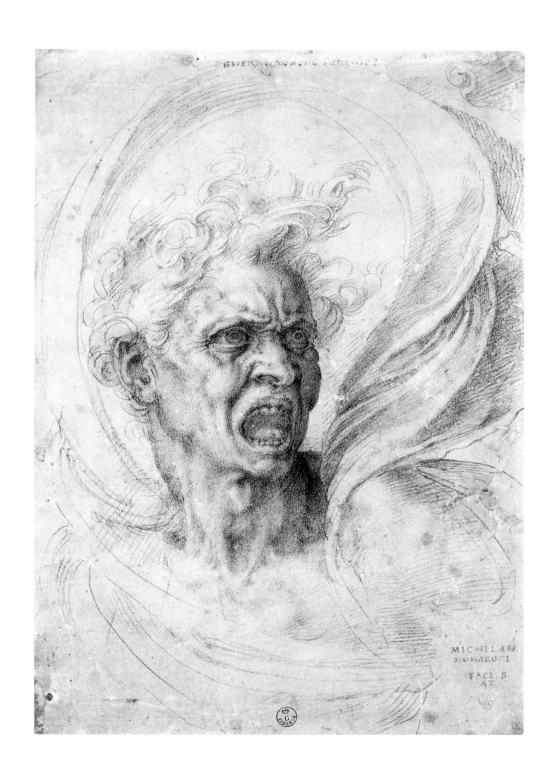

Figure 17. Michelangelo, *L'Anima Damnata*, *c.*1523;
Galleria Stampe e Disegni degli Uffizi, Florence

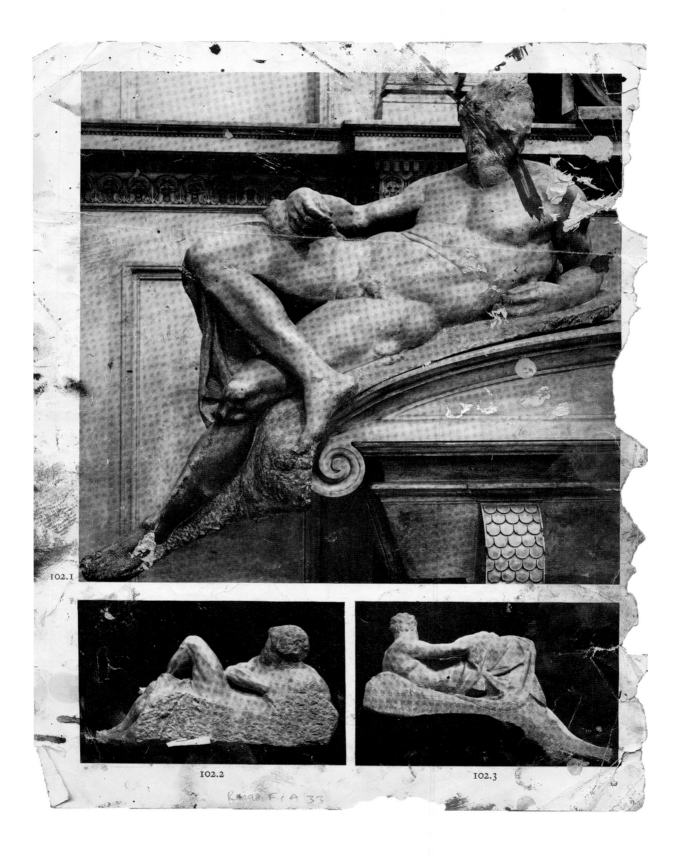

102.1

102.2

102.3

RM98 F1 A 33

Figure 18. Leaf from Martin Weinberger, *Michelangelo: the Sculptor*, London and New York, 1967; Dublin City Gallery The Hugh Lane

Figure 19. Francis Bacon, *Triptych – Studies of the Human Body*, 1979; private collection

Michelangelo is not customarily thought of as a physiognomist, but he created several facial archetypes. At least one links with Bacon. In his *Head VI* (fig. 16), Bacon famously fused Velázquez's *Innocent X* with the shot of an elderly woman, her face slashed and her shattered pince-nez forced into her eye, from Sergei Eisenstein's *Battleship Potemkin* (fig. 6, p. 19).[16] But the Odessa Steps sequence is not reportage: it is a construct devised by a man of deep visual culture. The horrifying close-up was a knowing choice and, referring to it, Bacon was situating himself within a genealogy that, starting with the *Laocoön* and including Poussin, whom he mentioned, and Guido Reni, whom he did not, had been given special impetus by Michelangelo in his renowned and much copied *Anima Damnata*, the first of his drawings to be engraved (fig. 17).[17]

Although Michelangelo executed vast pictorial schemes, the single body was the most vital part of his art, so much so that his obsession with it could disrupt projected ensembles, such as the tomb for Pope Julius II. Bacon, who never attempted multi-figure compositions, responded intensely to this isolation. One of the sculptures that Bacon referenced fairly directly is the Hermitage *Crouching Boy* (cat. 11) – surely the basis for *Study for Crouching Nude* (1952; Detroit Institute of Arts), *Two Figures in a Room* (1959; cat. 57) and *Triptych, May–June* (1973; private collection), commemorating Dyer's death. *Crouching Boy* may have affected Bacon all the more directly since its execution is relatively simplified. Among other sculptural borrowings, Bacon's *Study of the Human Body in Movement* (1982; Marlborough International Fine Art), is surely based on Michelangelo's wax model of a slave in Casa Buonarroti, now mounted horizontally but planned as upright; its fragmentary state would also have attracted Bacon.[18] And Lucian Freud, in the *Double Portrait of Freud and Frank Auerbach* (1964; Stockholm, Moderna Museet), seems to fuse two of Michelangelo's *ignudi*.

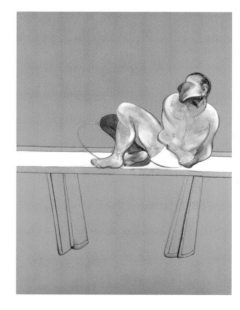

Bacon, Michelangelo and the Classical Tradition

One could easily multiply such echoes but to do so would add little; many of Michelangelo's forms were embedded in Bacon's imagination. In two cases, however, Bacon does seem consciously to have referenced Michelangelo both in parts and, less expectedly, as an ensemble. In his 1976 *Figure in Movement* (private collection), which seemingly shows one man striking downwards at another, Bacon probably referenced Michelangelo's model of *Samson and the Two Philistines*, from a plate in Weinberger. And in his 1979 work, *Triptych – Studies of the Human Body* (fig. 19), the two reclining figures either side of a central element, but directed inwards rather than outwards, refer to the Medici Tombs, an image of which Bacon tore out (fig. 18).[19] The left-hand figure was based on *Evening*, and that on the right is virtually a direct quote from *Day*, both seen from the back and again from Weinberger. The blurred central form, perhaps an interlaced couple, seems to fuse reminiscences of the *ignudi*. This triptych, which surely counts among Bacon's strongest and most resolved works, is as near an overt homage to Michelangelo as he created. In the relative integrity of the flanking figures, as opposed to the turmoil of the central panel, it also achieves something of that power of contrast, and that moral and spiritual energy, that were central to Michelangelo.

1. David Sylvester, *Interviews with Francis Bacon*, 3rd ed., London, 1987, p. 74. Parts of what follows overlap with a perceptive essay by Martin Harrison, 'Bacon and Sculpture' in *Francis Bacon / Henry Moore: Flesh and Bone*, catalogue of an exhibition at the Ashmolean Museum, 2013–14, pp. 31–48, which I read only late in the preparation of my essay.
2. See Bacon's discussion of this in Sylvester, pp. 108–12.
3. He spoke movingly of the *Death of Actaeon* (Michael Peppiatt, *Francis Bacon, Anatomy of an Enigma*, London, 1996, pp. 246–7).
4. John Russell, *Francis Bacon*, London and New York, 2nd ed., 1979, p. 94. Bacon indirectly acknowledged the debt in his 1980 work *The Wrestlers, after Muybridge*.
5. In his absorption of Muybridge, Bacon ingested many Classical referents, in which Muybridge was steeped.
6. 'Composted beyond recovery' as Russell put it. Thus Bacon specified that the right-hand panel in *Three Studies for a Crucifixion* of 1962 was inspired by Cimabue's *Crucifix* –inverted – but who could have recognised this without Bacon's guidance? (See also Thierry Morel in this catalogue, pp. 16–17.)
7. Memorably imitated/parodied by Don Levy in *Herostratus*.
8. Sylvester, p. 114; Bacon said that he would find it very difficult to 'disentangle the influence of Michelangelo and the influence of Muybridge'. Luigi Ficacci's brilliant essay, 'Francis Bacon e l'ossessione di Michelangelo', Milan, 2008, provides a penetrating analysis of Bacon's approach. See also David Sylvester, *Looking Back at Francis Bacon*, London, 2000, pp. 67–8, 238. In his *Artist's Eye* exhibition at the National Gallery in 1985, Bacon included Michelangelo's *Entombment*, as Ficacci (p. 33) emphasises.
9. Ficacci (pp. 7ff) perceptively locates Michelangelo's presence in Bacon's 1949 *Study from the Human Body* (Melbourne, National Gallery of Victoria), which is something of a leitmotiv in his essay; although the painting has no precise prototype in Michelangelo's œuvre, it is redolent of his work and presents the body relatively undamaged.
10. Of course, Michelangelo broke his Florence *Pietà* in a rage and some of his wax and clay models are now fragmentary.
11. I am most grateful for access to this material; some of it is published in Margarita Cappock, *Francis Bacon's Studio*, London, 2005, especially pp. 143–7; Martin Harrison, *In Camera, Francis Bacon Photography, Film and the Practice of Painting*, London, 2005, especially 'Michelangelo and Muybridge', pp. 55–80; Martin Harrison and Rebecca Daniels, *Francis Bacon, Incunabula*, London, 2008, pp. 21–30.
12. E.g. Catherine Whistler, *Michelangelo and Raphael Drawings in the Ashmolean* (1990) and Alexander Perrig, *Michelangelo's Drawings, The Science of Attribution* (1991).
13. Bacon probably owned some of Ludwig Goldscheider's Phaidon volumes, for many years the most available body of reproductions.
14. Might there be an echo of Matisse's *Goldfish* (1912; Copenhagen) in Bacon's *Reclining Figure 3* (1959; Dusseldorf)?
15. See, for example, Michel Leiris, *Francis Bacon: full face and in profile*, New York, 1983, nos 40, 54, 55, 57, 62, 76, 112, 121, 122, 125.
16. That she is a bourgeois promenader and not, as invariably stated, a nurse or nanny, was pointed out to me many years ago by June Robinson.
17. Luitpold Dussler, *Die Zeichnungen des Michelangelo*, Berlin, 1959, fig. 189.
18. Bacon knew well Michelangelo's wax model of a slave in the V&A – see Harrison, *Bacon /Moore*, p. 38; Harrison, like Ficacci (pp. 52–3), notes the strong link between Michelangelo's *Dying Slave* and Bacon's *Painting 1950* (Leeds, City Art Gallery; fig 33, p. 155).
19. A slightly different interpretation in Harrison, *Bacon / Moore*, p. 36. Ficacci (pp. 34–6) shows that the Medici tombs also underlay, appropriately, the 1971 triptych *In Memory of George Dyer* (Basel, Fondation Beyeler).

Bacon, Michelangelo and the Classical Tradition

Illustrations

1 Francis Bacon
Study (Imaginary Portrait of Pope Pius XII), 1955
Oil on canvas, 108.6 × 75.6 cm
Cat. 47

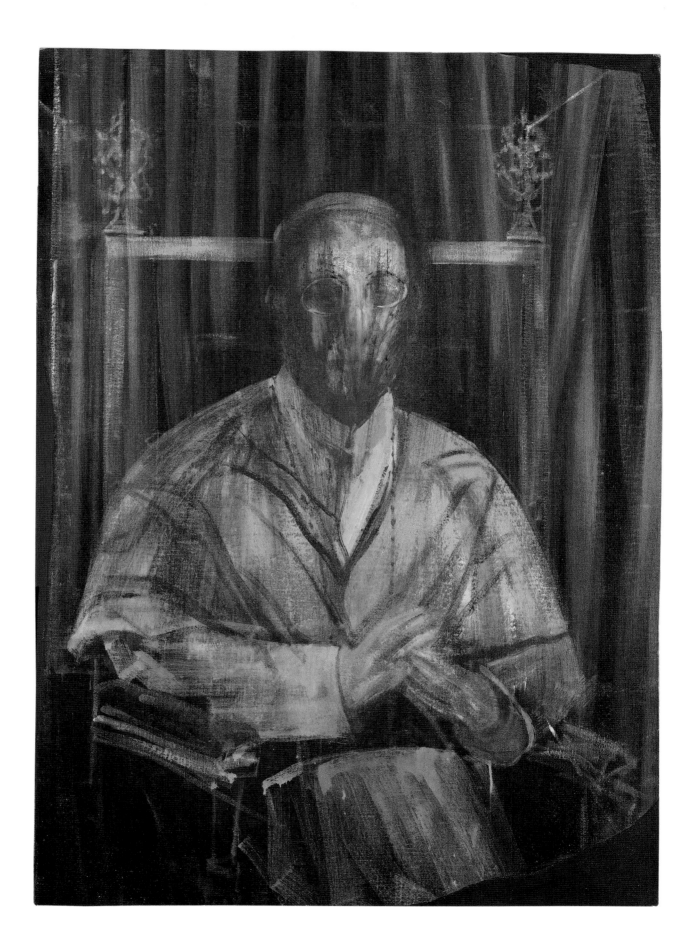

2 *Upper Part of a Statue of a King*
13th century BC
Sandstone, h. 51 cm
Cat. 2

3 *Statue of Amenemhat* III
2nd half of 19th century BC
Black granite, h. 86.5 cm
Cat. 1

4 Francis Bacon
 Sketch for a Portrait of Lisa, 1955
 Oil on canvas, 61 × 54.9 cm
 Cat. 49

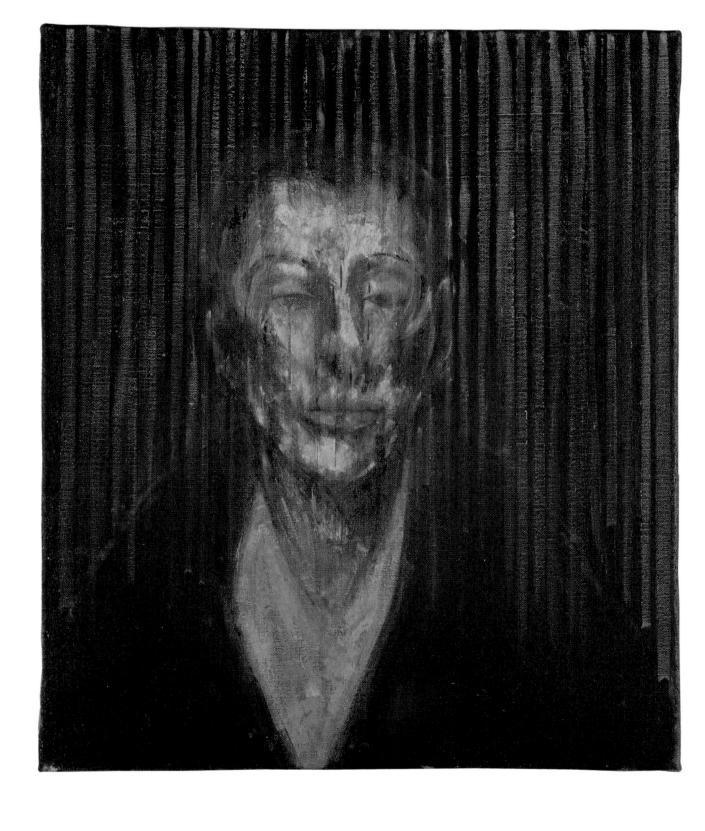

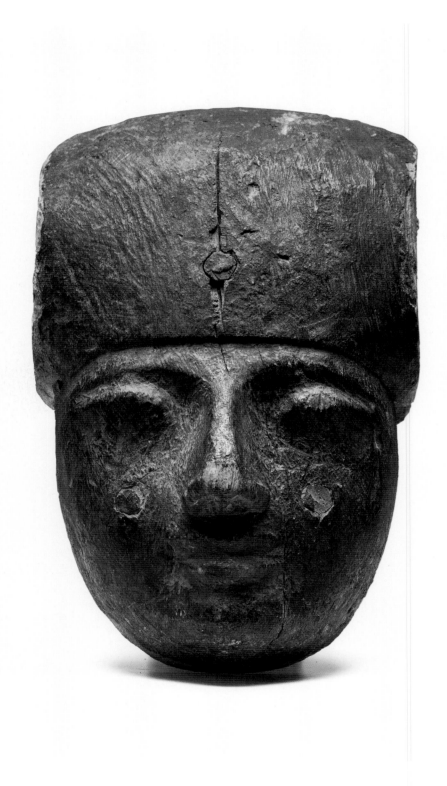

5 *Face of an Anthropoid Coffin*
11th – 8th century BC
Wood, h. 24.5 cm
Cat. 3

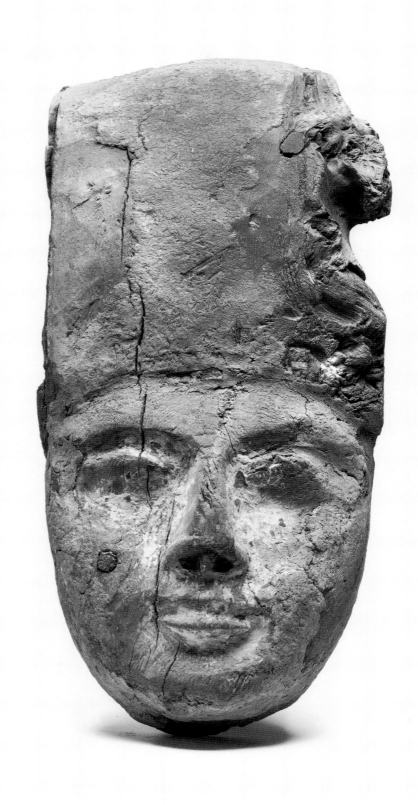

6 *Face of an Anthropoid Coffin*
11th – 8th century BC
Wood, h. 35 cm
Cat. 4

7 Francis Bacon
Portrait of Lisa, 1957
Oil on canvas, 59.7 × 49.5 cm
Cat. 54

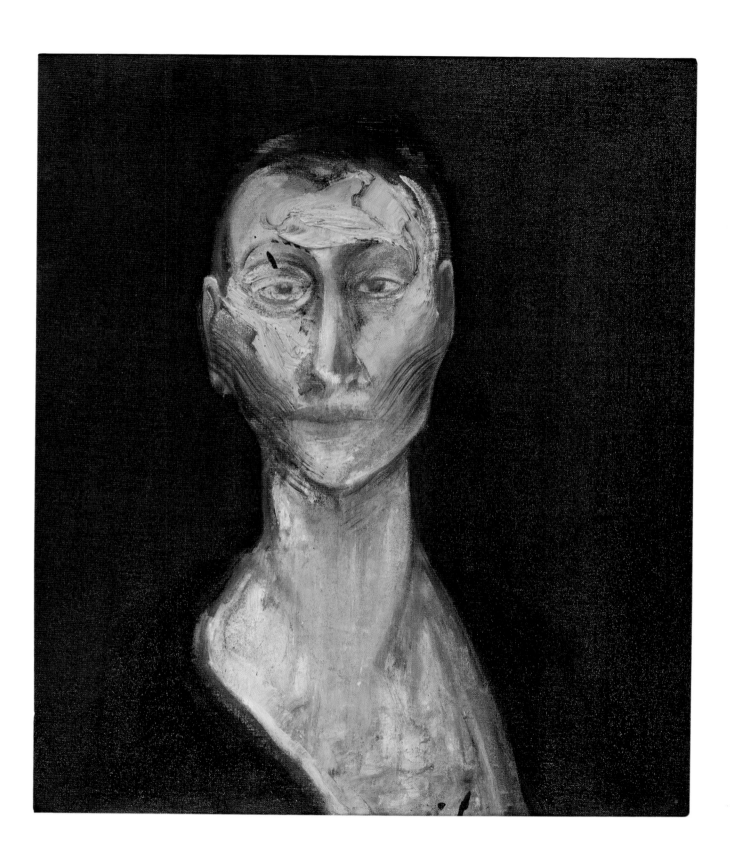

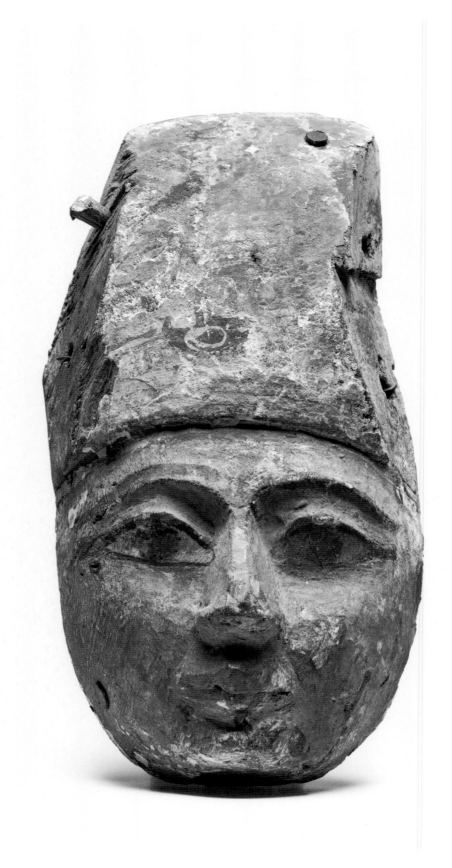

8 *Face of an Anthropoid Coffin*
1st millennium BC
Wood, h. 30 cm
Cat. 5

9 *Fragment of a Mummy Mask*
10th – 9th century BC
Cartonnage, h. 22 cm
Cat. 6

10 *Fragment of a Mummy Mask*
1st century BC – 1st century AD
Cartonnage, h. 14.5 cm
Cat. 7

11 *Head of a Youth*
 Roman copy of Greek original, 2nd century AD
 Marble, h. 23 cm
 Cat. 10

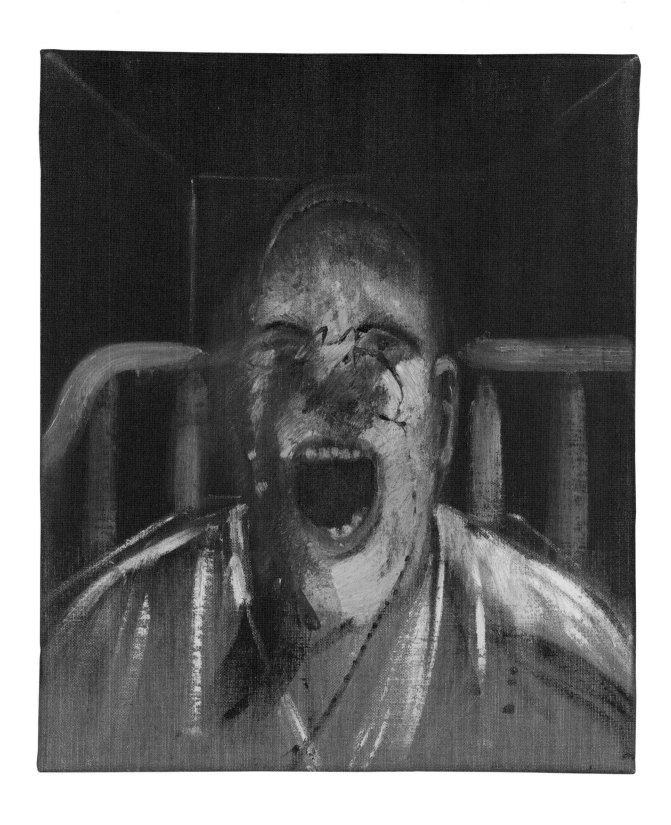

12 Francis Bacon
Study of a Head, 1952
Oil on canvas, 49.5 × 39.3 cm
Cat. 44

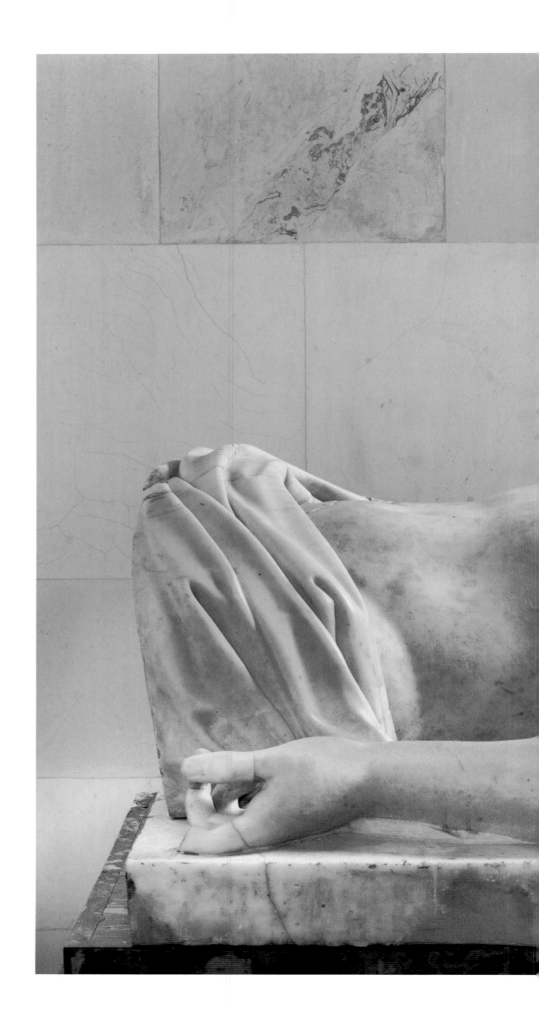

13 *Sleeping Endymion*
Roman copy of Greek original,
2nd half of 2nd century AD
Marble, l. 106 cm
Cat. 9

14 Francis Bacon
Study for Portrait of P. L., No. 2, 1957
Oil on canvas, 151.8 × 118.5 cm
Cat. 55

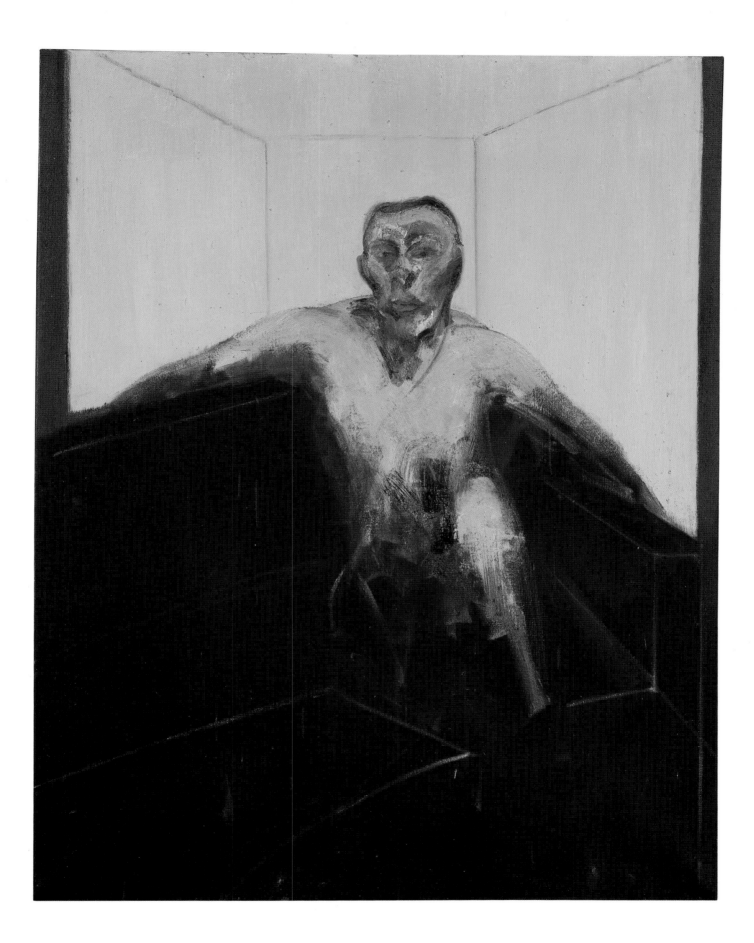

Portrait of a Roman
50–40 BC
Bronze, h. 39 cm
Cat. 8

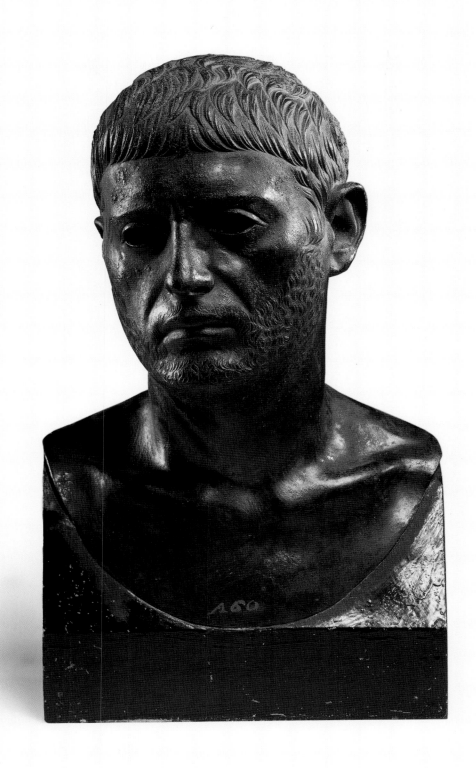

16 Michelangelo Buonarroti
 Crouching Boy, c. 1530–4
 Marble, h. 54 cm
 Cat. 11

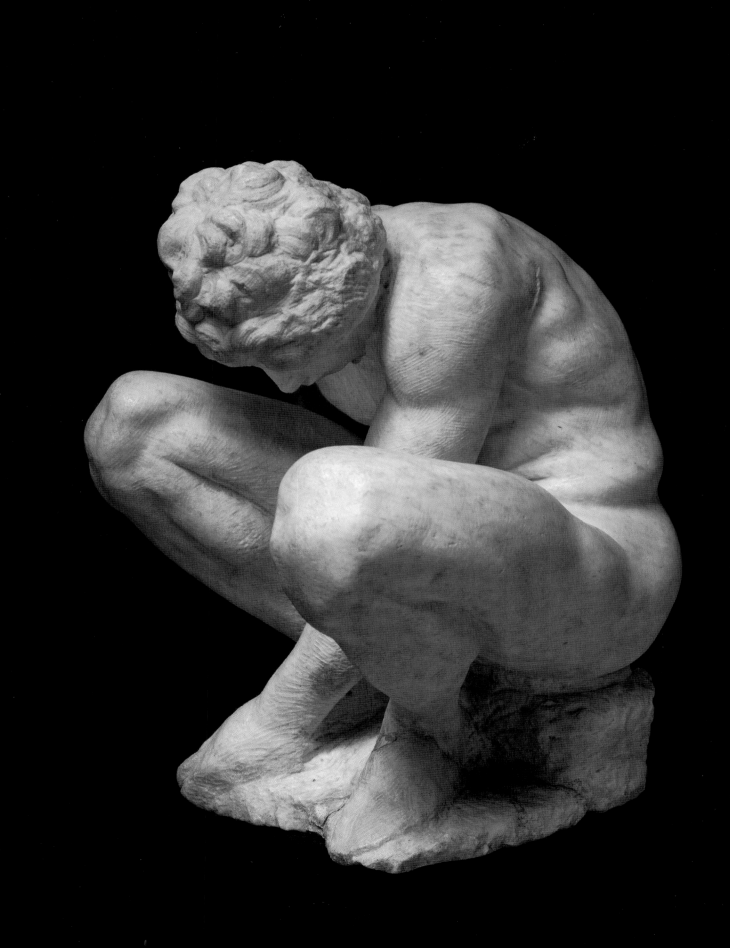

17 Francis Bacon
 Two Figures in a Room, 1959
 Oil on canvas, 198 × 142 cm
 Cat. 57

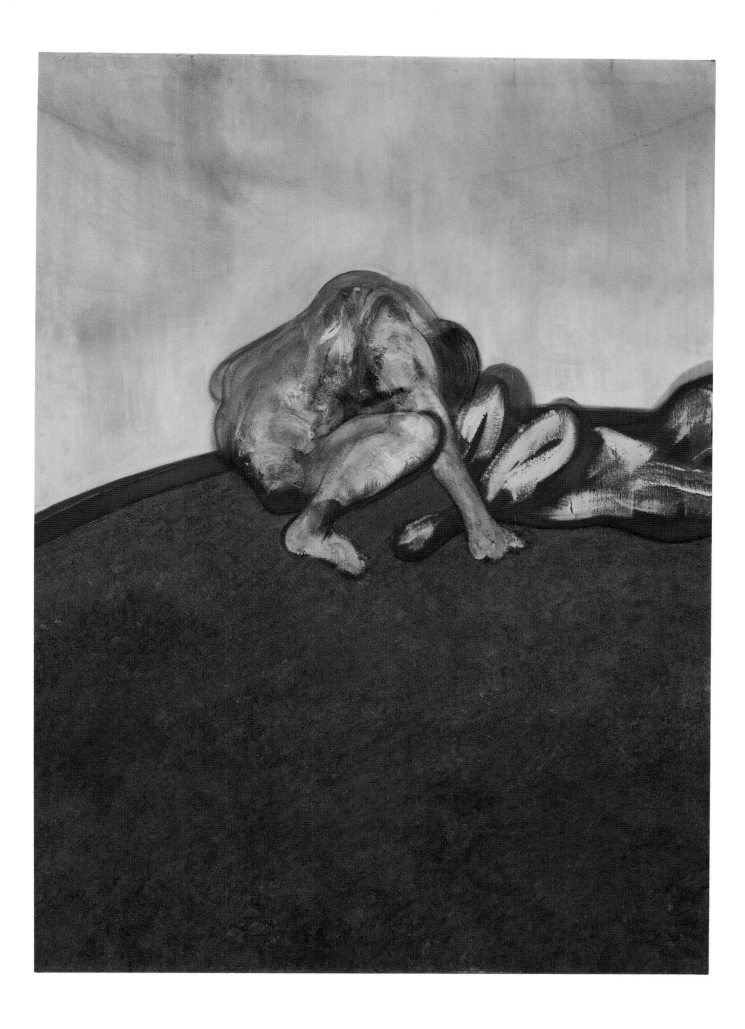

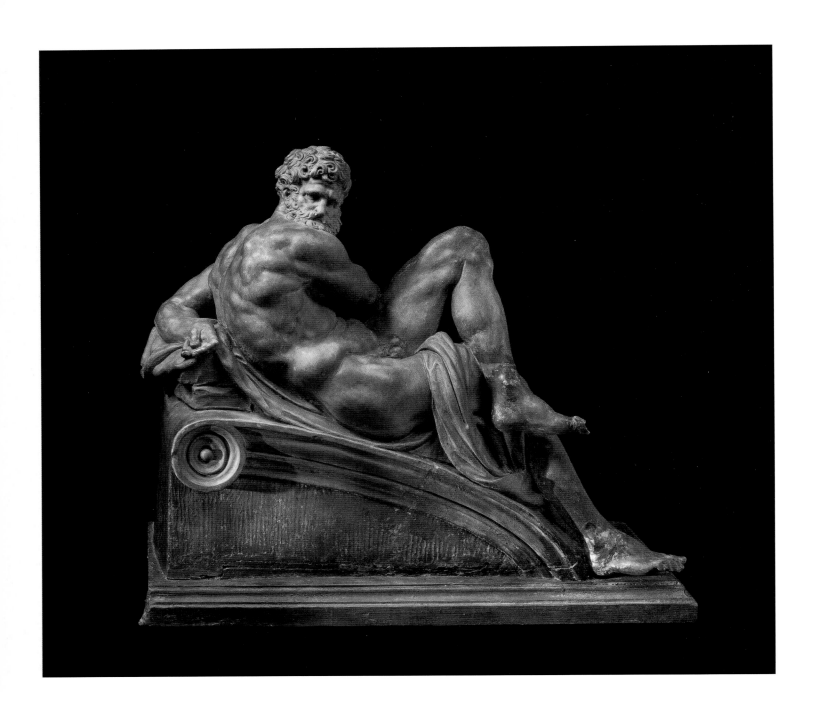

18 *Day*, 2nd half of 16th century
From an original by Michelangelo
Terracotta, h. 51 cm, l. 56 cm
Cat. 12

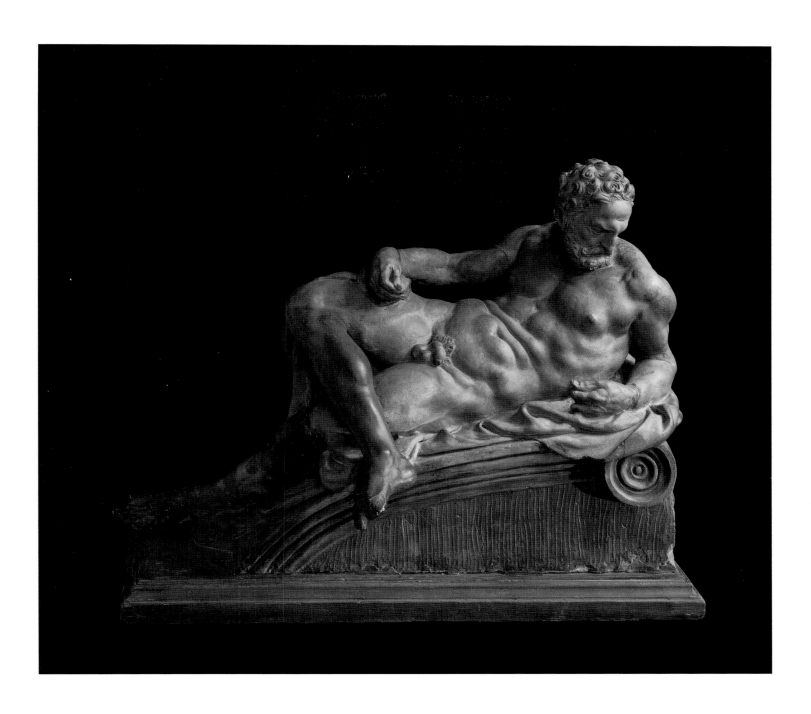

19 *Evening*, 2nd half of 16th century
 From an original by Michelangelo
 Terracotta, h. 50 cm, l. 68 cm
 Cat. 13

20 Baccio Bandinelli
Sleeping Hercules, 16th century
Marble, 56 × 27 cm
Cat. 14

21 Francis Bacon
 'Figures in a Landscape', 1956
 Oil on canvas, 147.3 × 132.1 cm
 Cat. 52

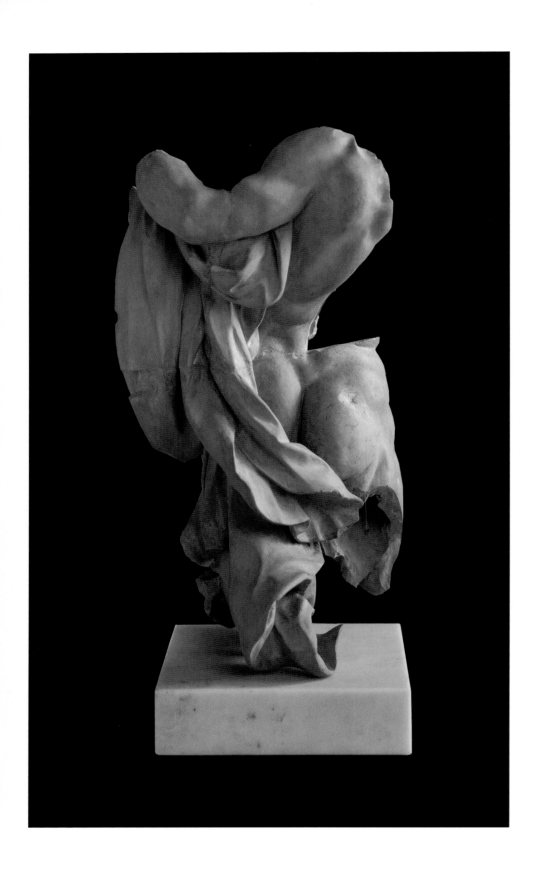

22 Gian Lorenzo Bernini
 Torso of Pluto, c.1621
 Terracotta, h. 38 cm
 Cat. 16

23 Gian Lorenzo Bernini
 Torso of Neptune, 1620
 Terracotta, h. 37 cm
 Cat. 15

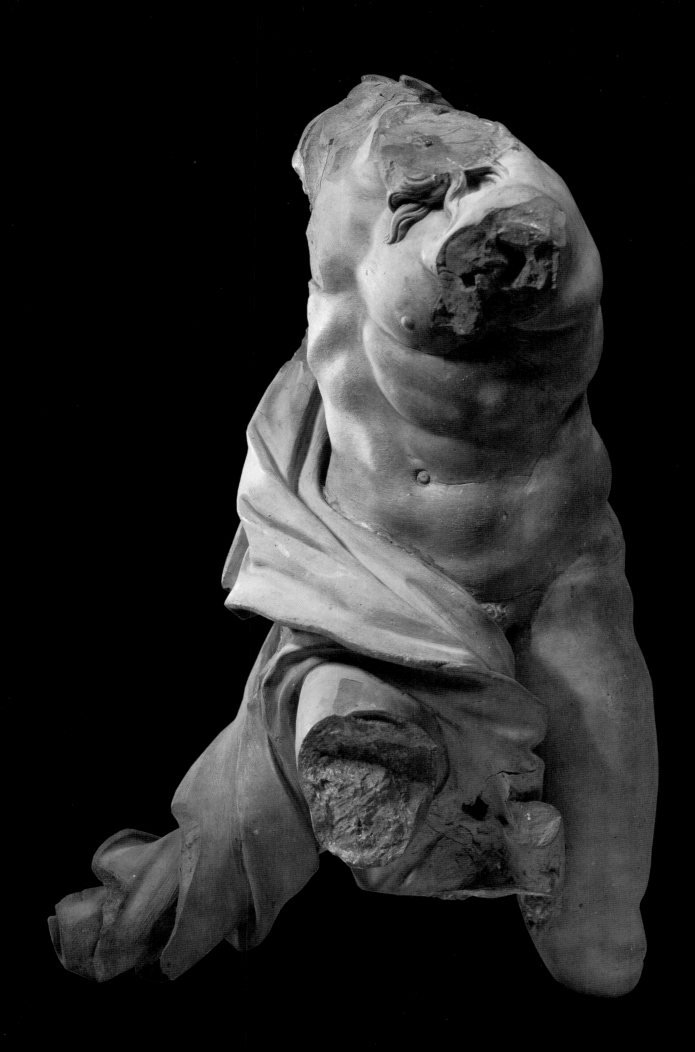

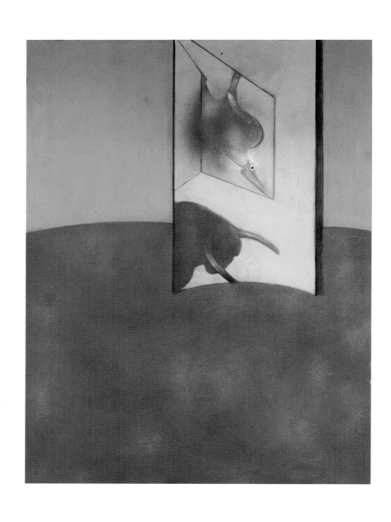

24 Francis Bacon
 Triptych, 1987
 Oil on canvas, 198 × 147.5 cm
 (each panel)
 Cat. 67

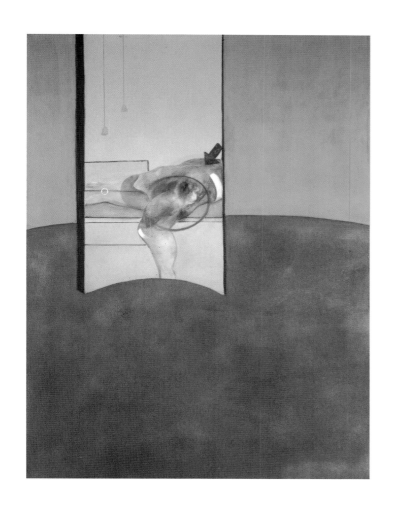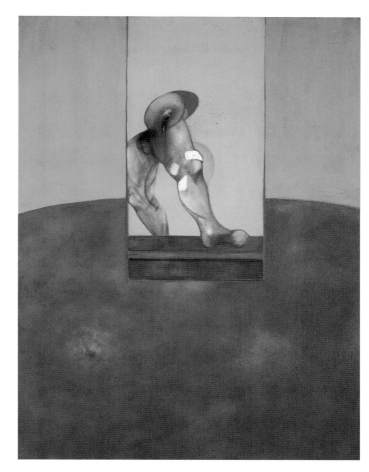

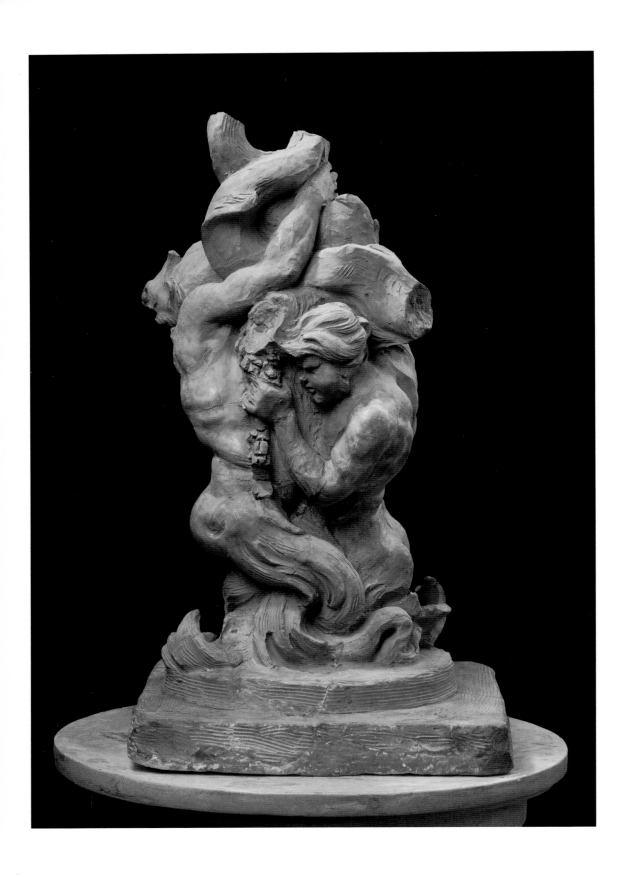

25 Gian Lorenzo Bernini
 Tritons Holding Dolphins, c. 1652
 Terracotta, h. 47.5 cm
 Cat. 17

26 Alessandro Algardi
 Titan, c. 1650
 Terracotta, h. 36.5 cm
 Cat. 18

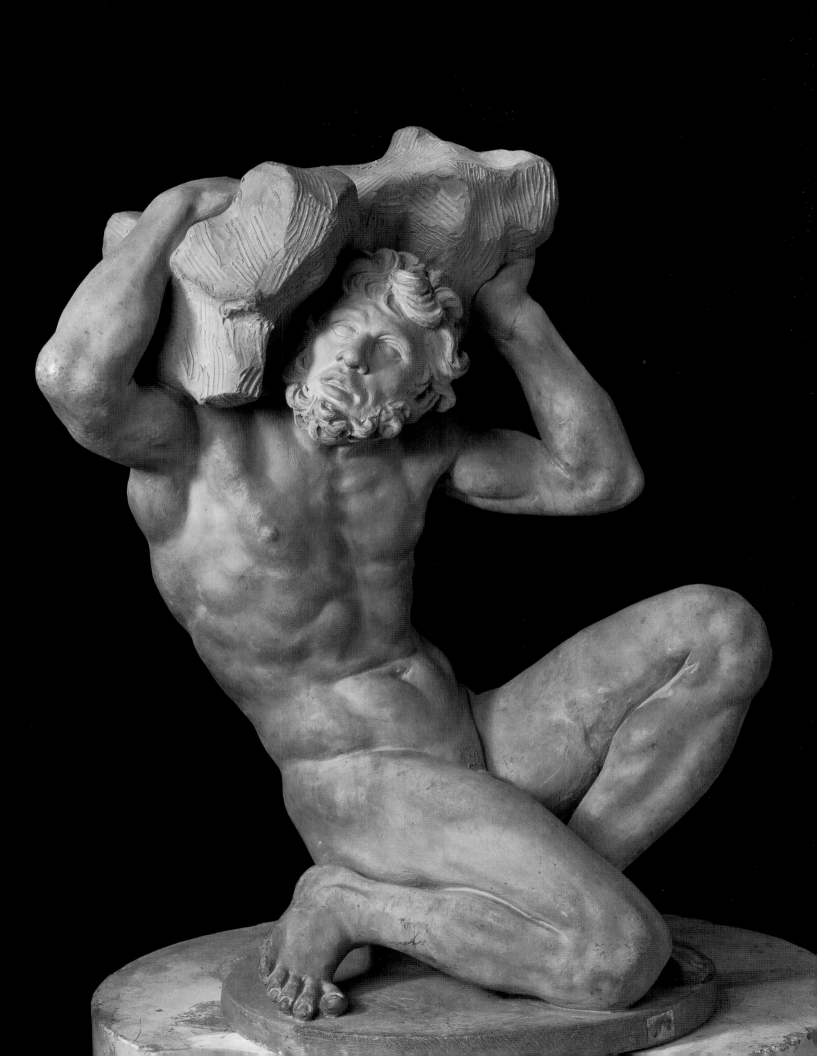

27 Francis Bacon
'Marching Figures', 1952
Oil on canvas, 198.1 × 137.2 cm
Cat. 42

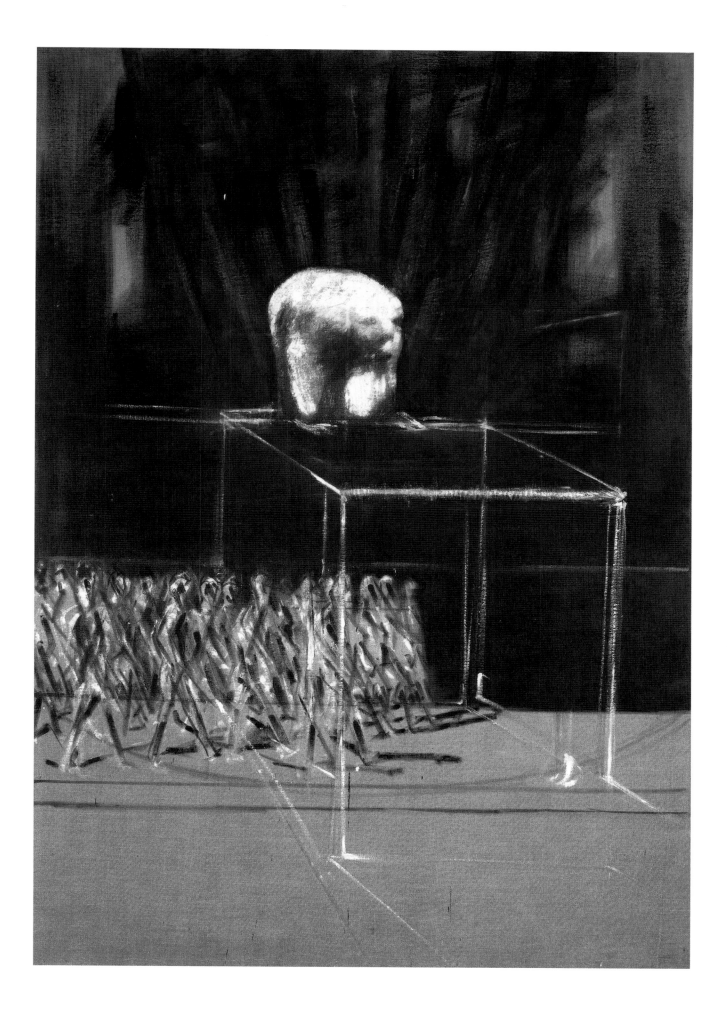

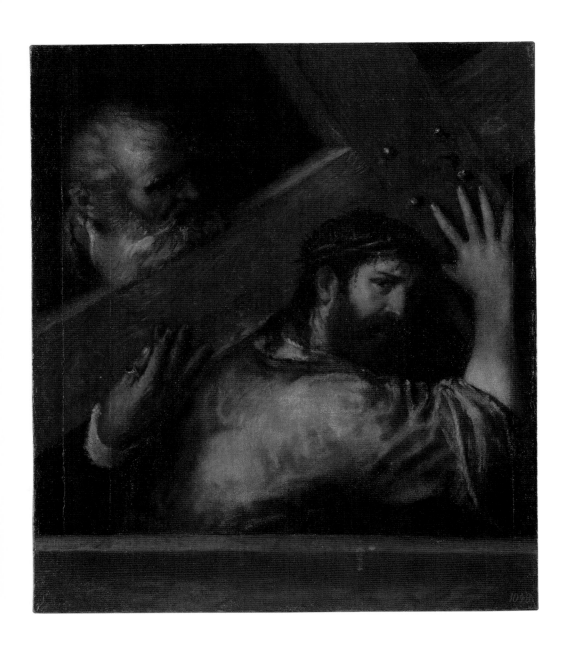

28 Titian (Tiziano Vecellio)
Christ Bearing the Cross, 1566–70
Oil on canvas, 89 × 77 cm
Cat. 23

29 Alonso Cano
The Crucifixion, c. 1636–8
Oil on canvas, 265 × 173 cm
Cat. 24

30 Francis Bacon
 Crucifixion, 1933
 Oil on canvas, 60.5 × 47 cm
 Cat. 40

31 Diego Velázquez
*Pope Innocent X, c.*1650
Oil on canvas, 82 × 71.5 cm
Cat. 26

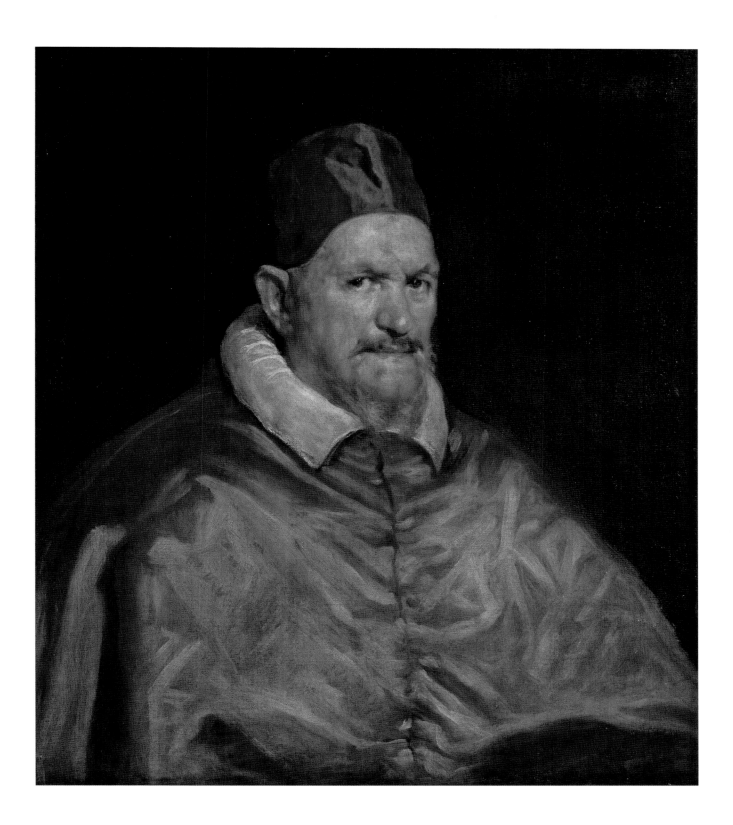

32 Francis Bacon
Pope I, 1951
Oil on canvas, 197.8 × 137.4 cm
Cat. 43

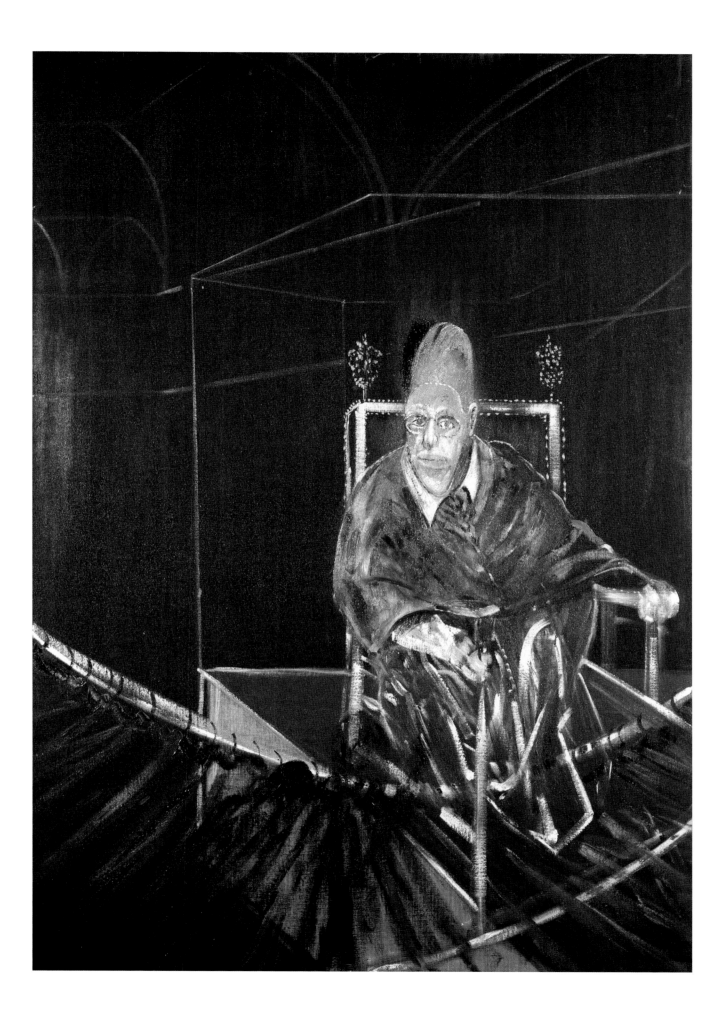

33 Francis Bacon
 'Study after Velázquez', 1950
 Oil on canvas, 198.1 × 137.2 cm
 Cat. 41

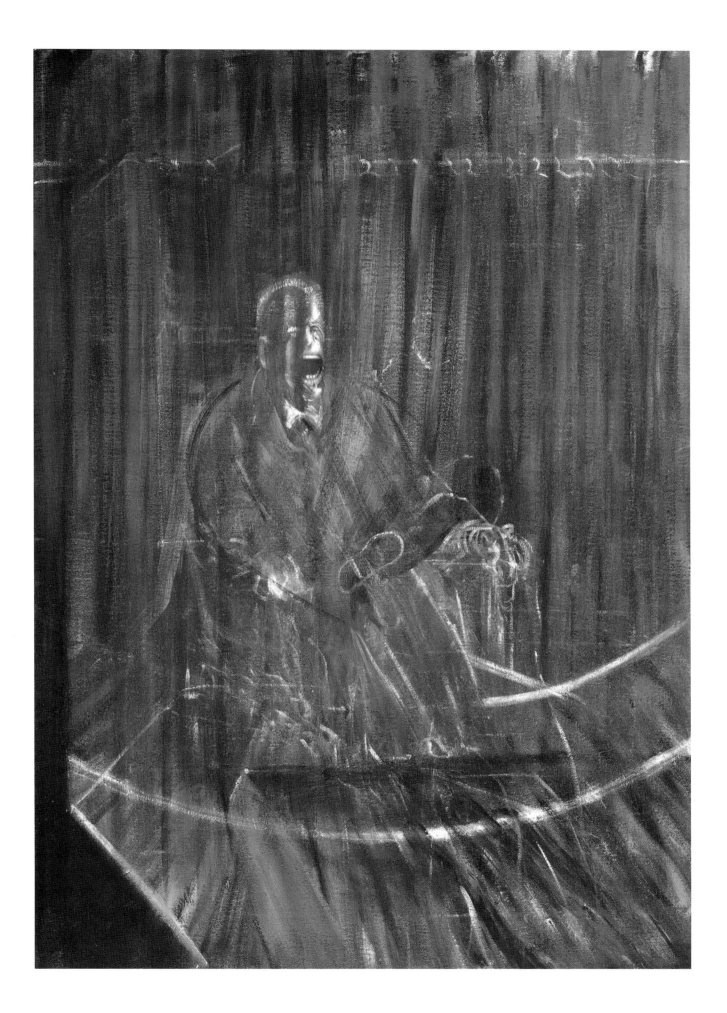

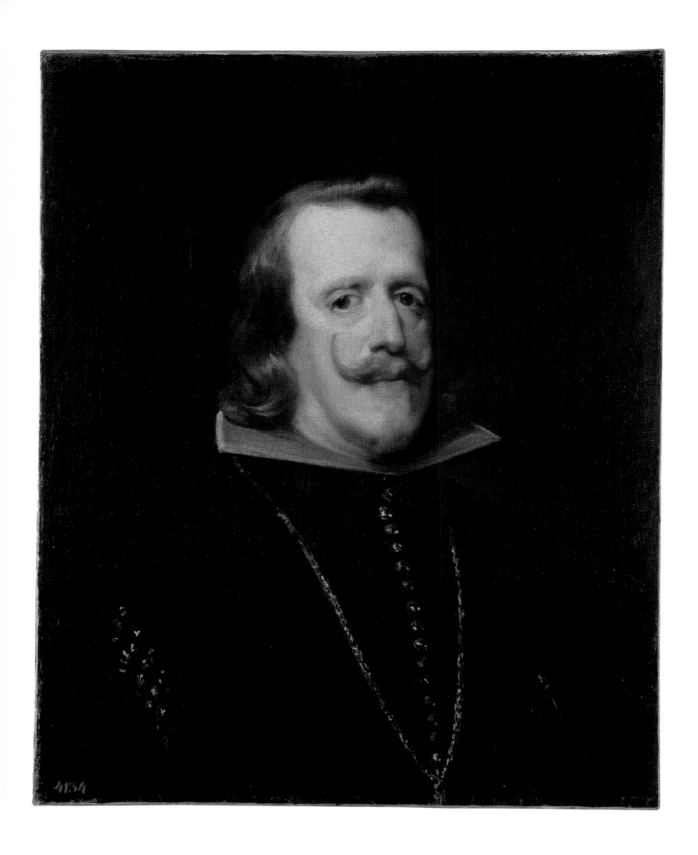

34 Studio of Diego Velázquez
 Portrait of Philip IV, Late 1650s
 Oil on canvas, 67 × 53 cm
 Cat. 27

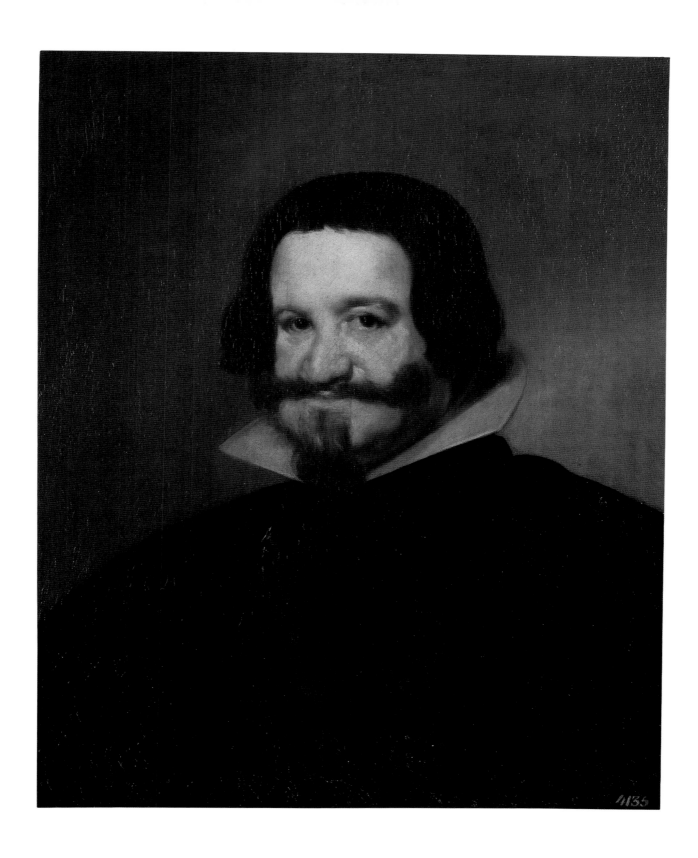

35 Diego Velázquez
Portrait of the Count-Duke of Olivares, c. 1638
Oil on canvas, 67 × 54.5 cm
Cat. 25

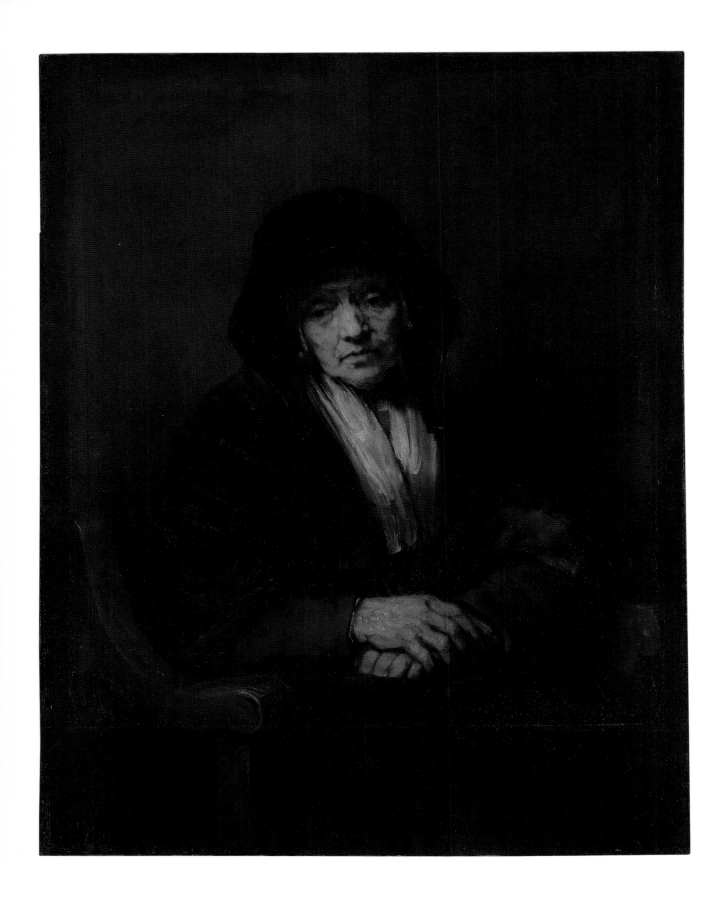

36 Rembrandt Harmensz. van Rijn
 Portrait of an Old Woman (Old Woman in an Armchair), 1654
 Oil on canvas, 109 × 84 cm
 Cat. 29

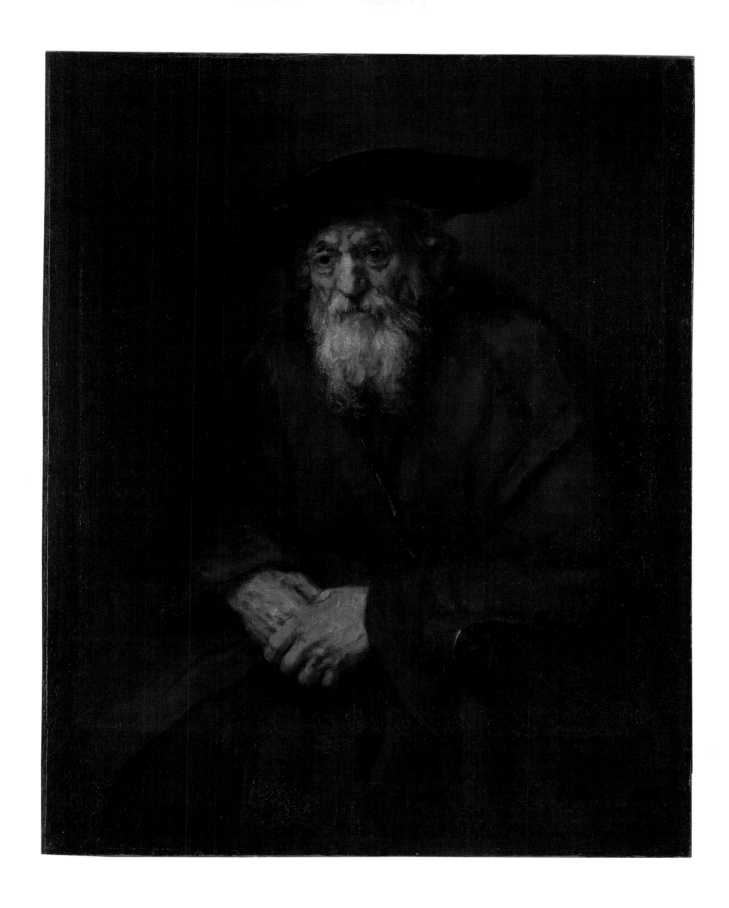

37 Rembrandt Harmensz. van Rijn
Portrait of an Old Man (Old Man in an Armchair), 1654
Oil on canvas, 109 × 85 cm
Cat. 28

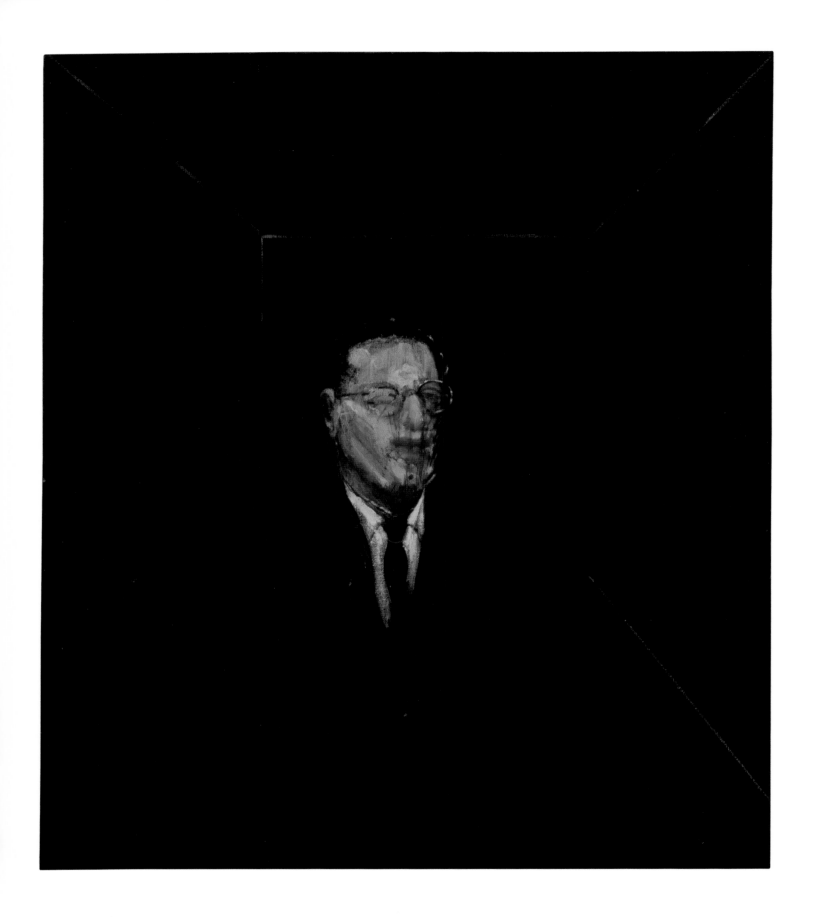

38 Francis Bacon
Portrait of R.J. Sainsbury, 1955
Oil on canvas, 114.9 × 99.1 cm
Cat. 46

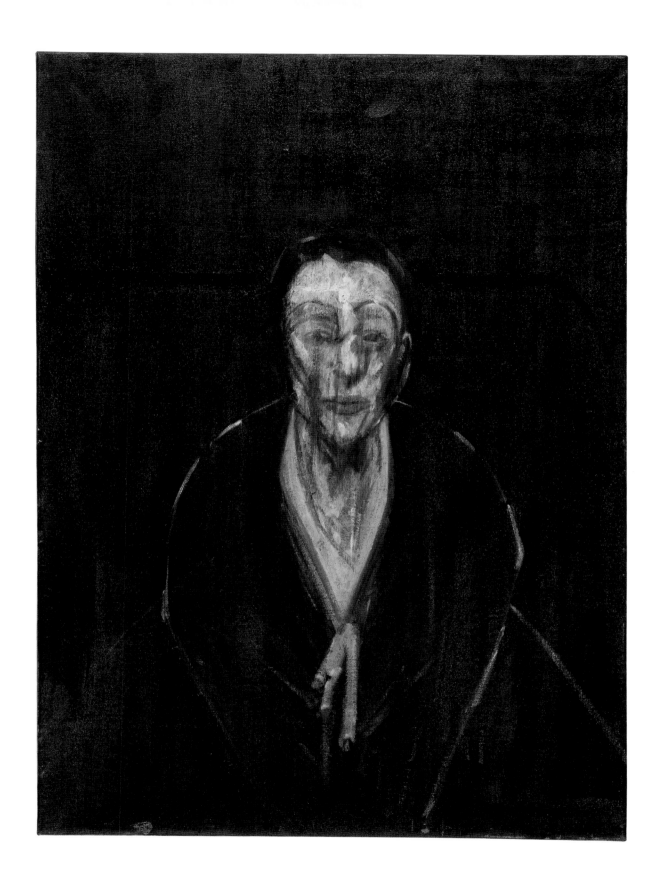

39 Francis Bacon
Portrait of Lisa, 1956
Oil on canvas, 100.6 × 72.7 cm
Cat. 50

40 Jean Auguste Dominique Ingres
 Portrait of Count Nicolai Dmitrievich Gouriev, 1821
 Oil on canvas, 107 × 86 cm
 Cat. 30

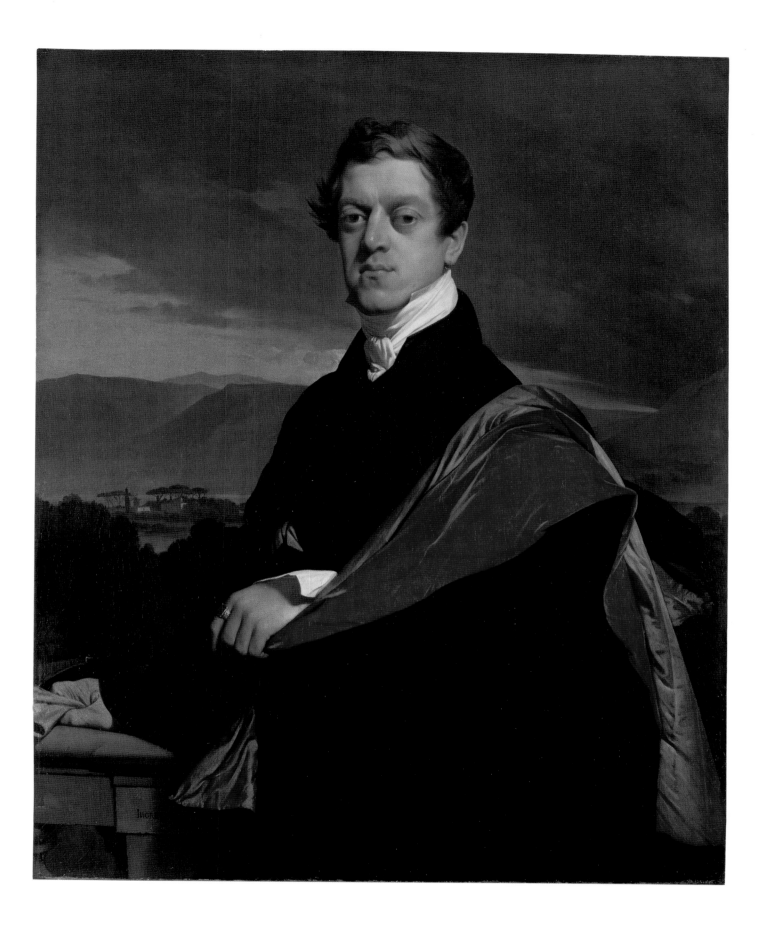

Francis Bacon
Head of a Man, 1960
Oil on canvas, 38.5 × 32 cm
Cat. 59

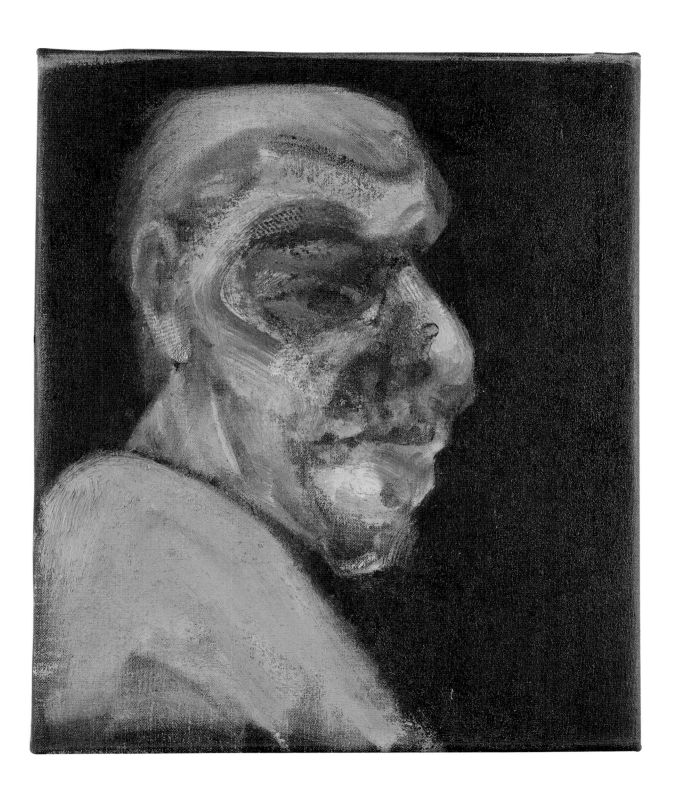

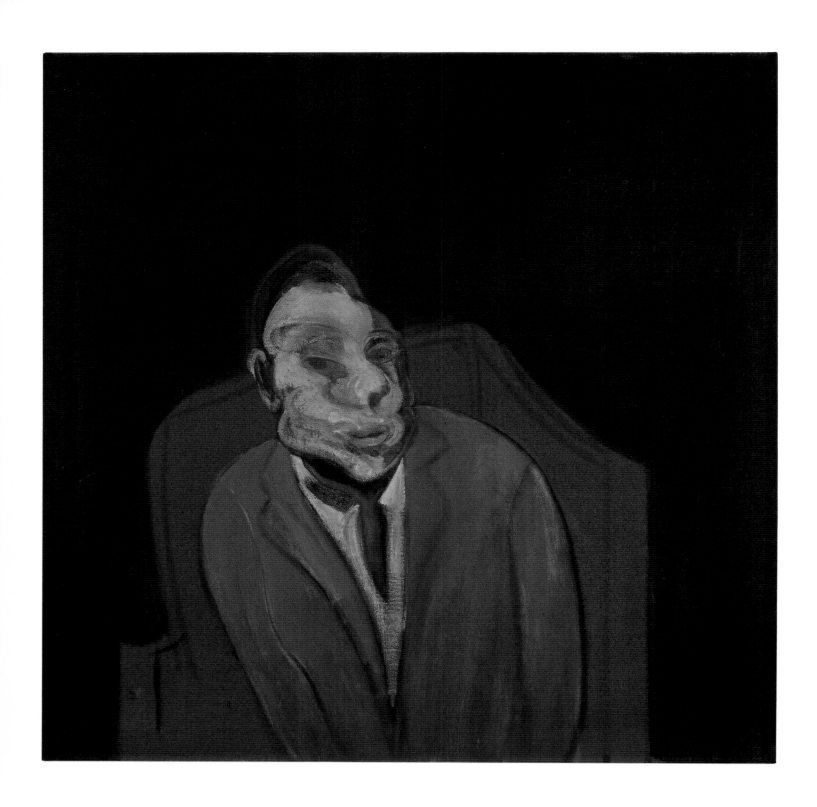

42 Francis Bacon
 Head of a Man, 1960
 Oil on canvas, 85.2 × 85.2 cm
 Cat. 60

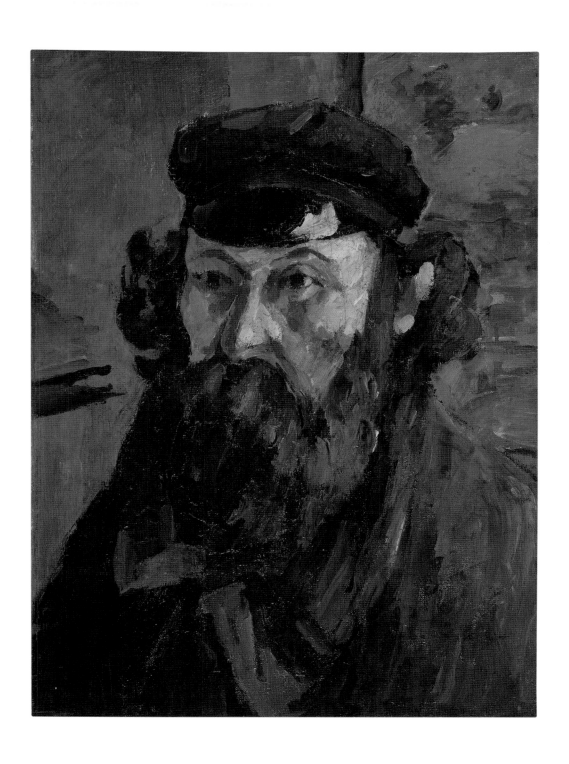

43 Paul Cézanne
Self-Portrait in a Cap, *c.*1873
Oil on canvas, 53 × 39.7 cm
Cat. 31

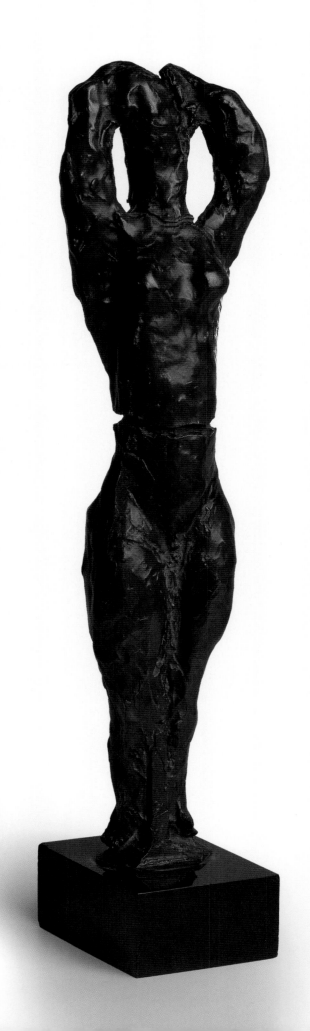

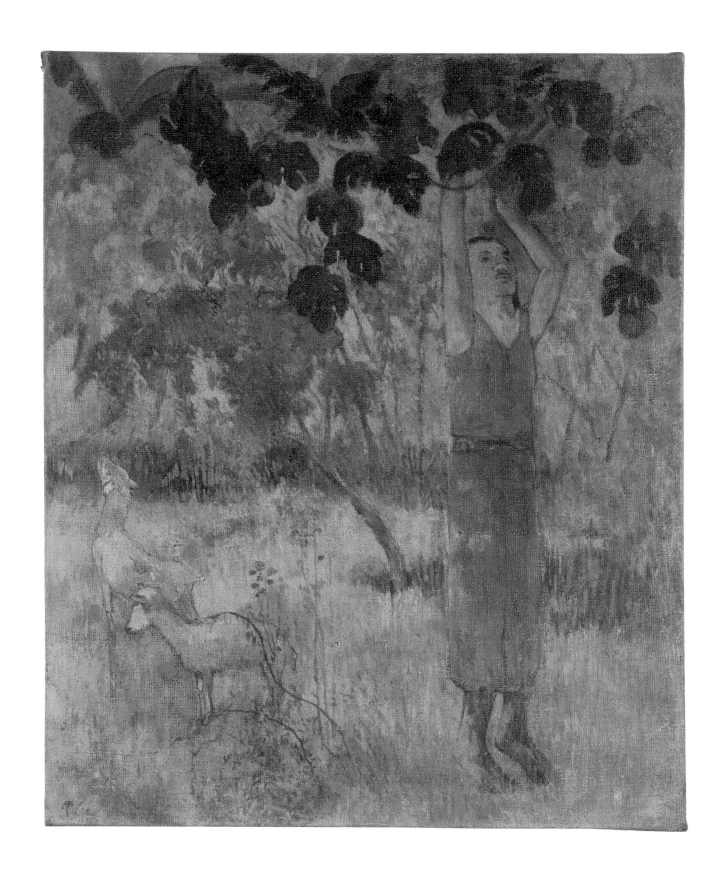

44 Henri Matisse
Standing Nude (Katia), 1958
Bronze, h. 45 cm
Cat. 22

45 Paul Gauguin
Man Picking Fruit from a Tree, 1897
Oil on canvas, 92.5 × 73.3 cm
Cat. 34

46 Francis Bacon
 Study of a Nude, 1953
 Oil on canvas, 59.7 × 49.5 cm
 Cat. 45

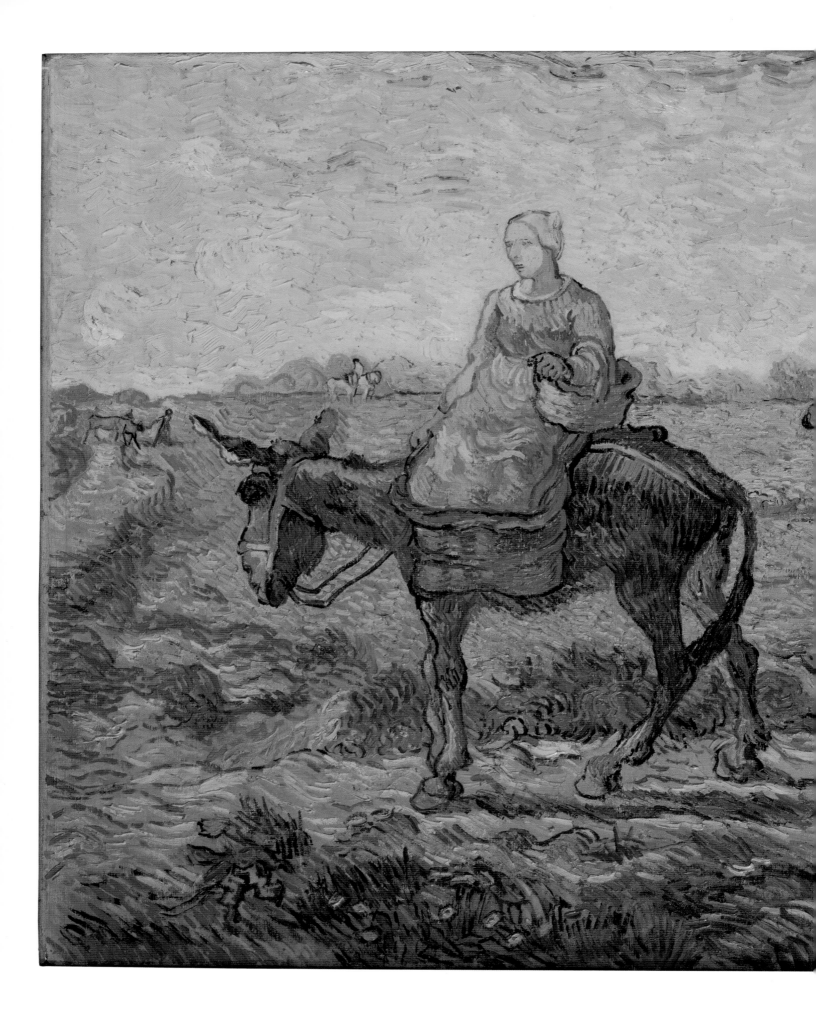

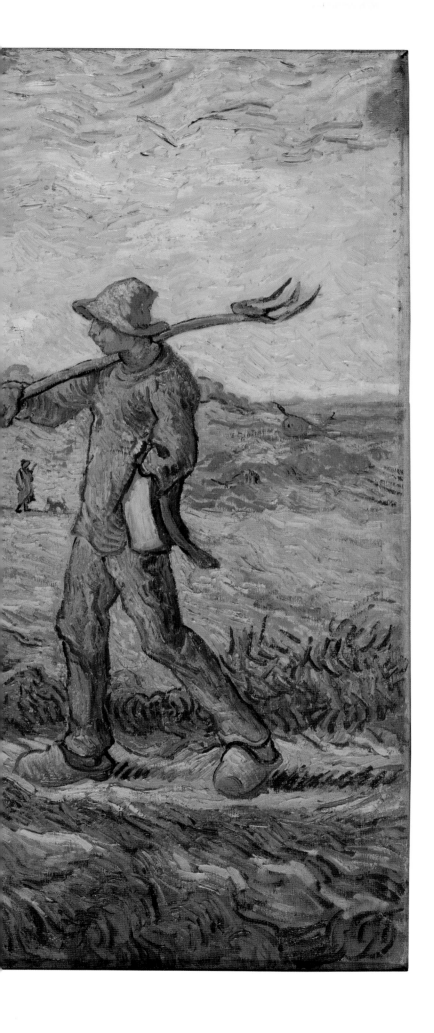

47 Vincent van Gogh
 Morning. Going out to Work, 1889
 Oil on canvas, 73 × 92 cm
 Cat. 32

48 Francis Bacon
 Study for a Portrait of Van Gogh IV, 1957
 Oil on canvas, 152.4 × 116.8 cm
 Cat. 56

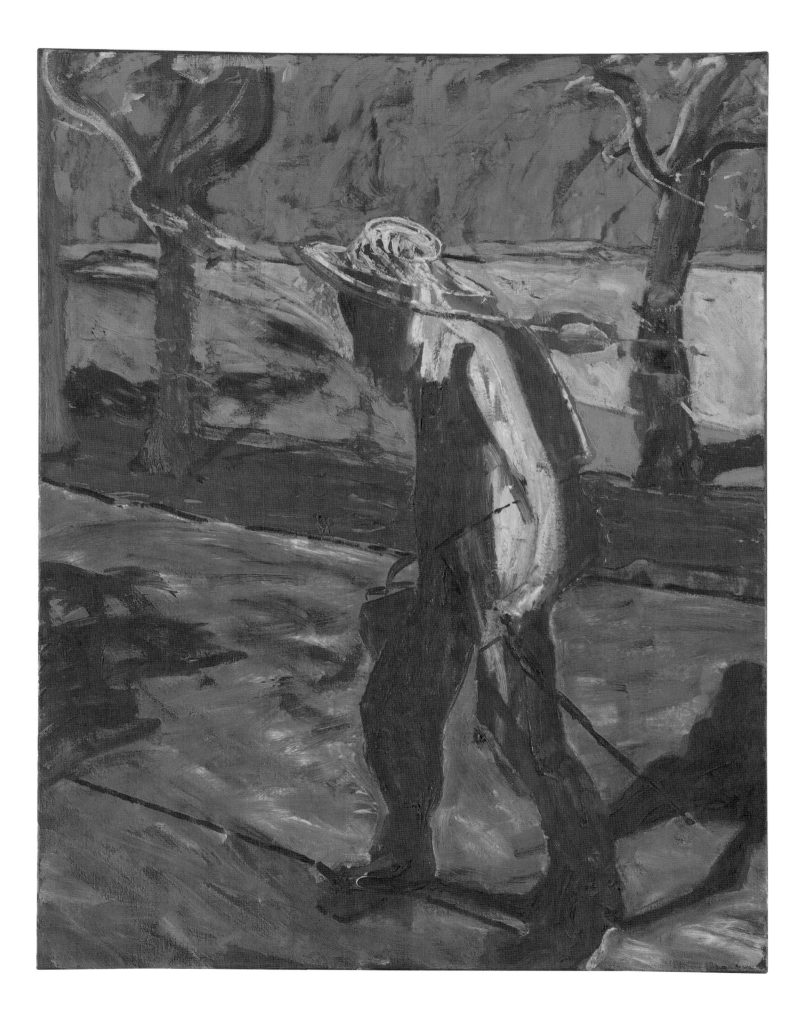

49 Francis Bacon
 Study for a Portrait of Van Gogh I, 1956
 Oil on canvas, 154.1 × 115.6 cm
 Cat. 51

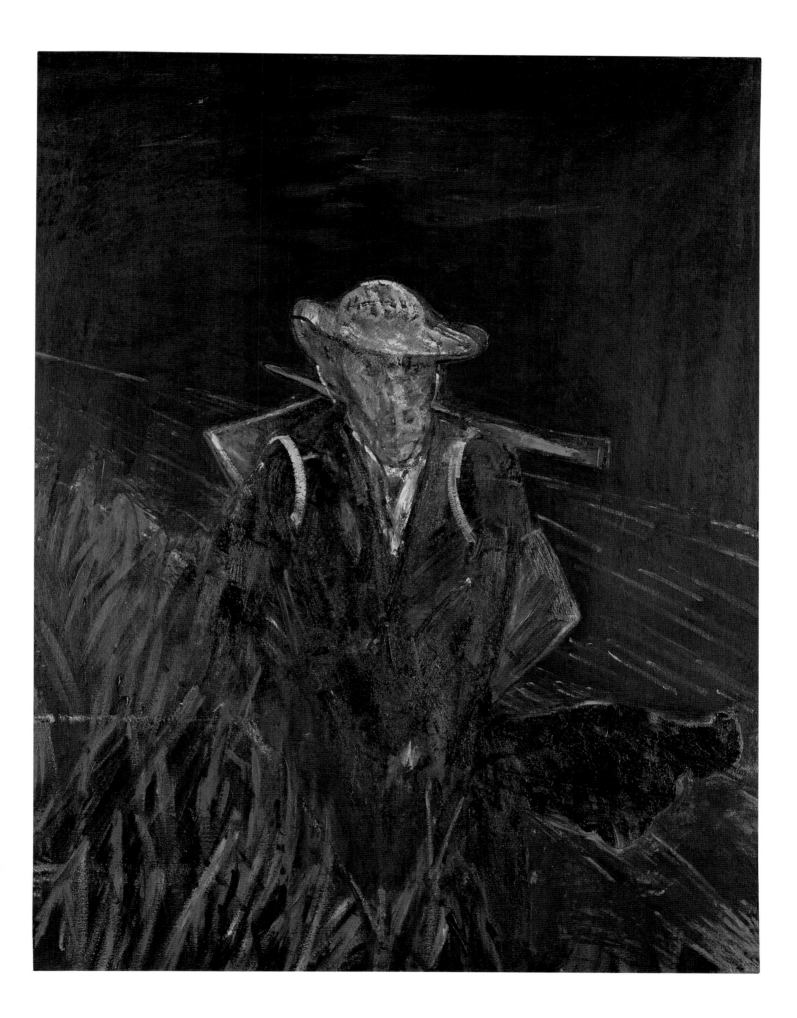

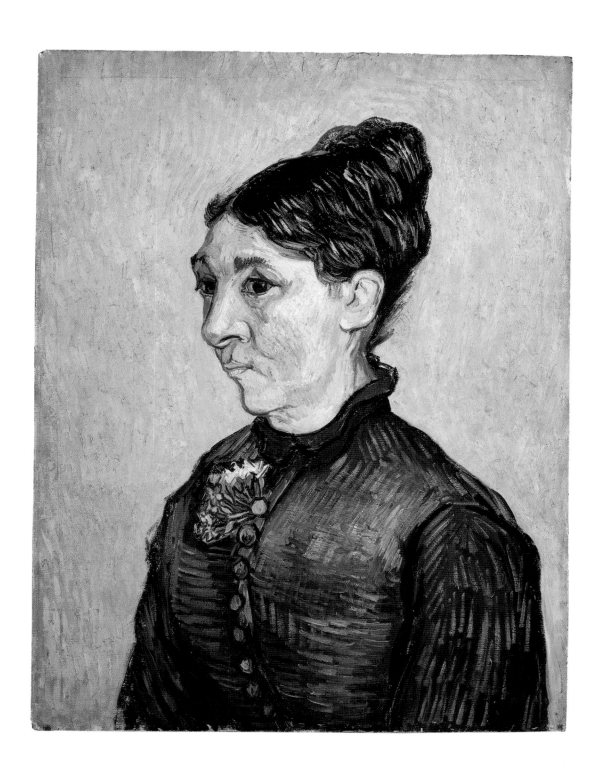

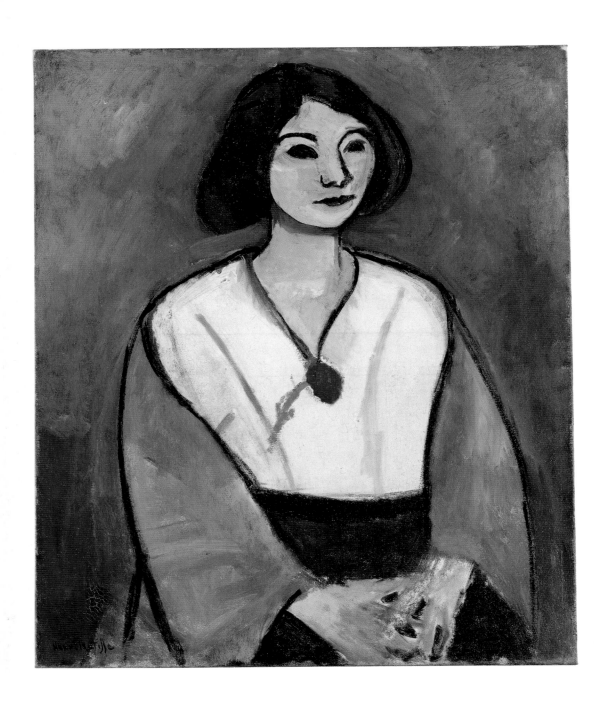

51 Henri Matisse
 Woman in Green, c. 1909
 Oil on canvas, 65 × 54 cm
 Cat. 36

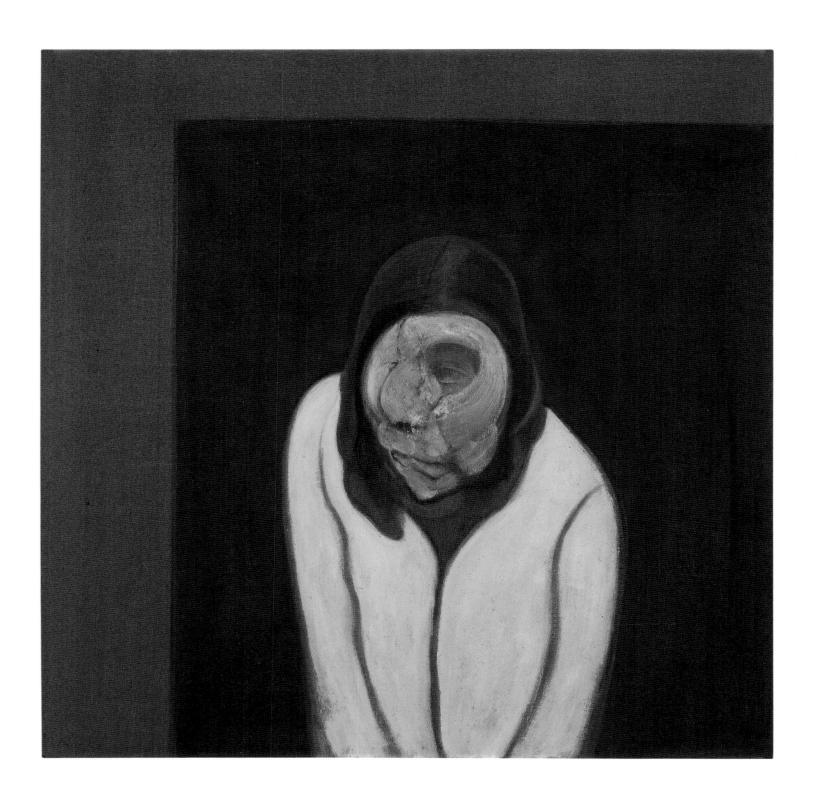

52 Francis Bacon
 Head of Woman, 1960
 Oil on canvas, 85.2 × 85.2 cm
 Cat. 61

53 Auguste Rodin
Study for The Sinner (The Repentant),
1st half of 20th century
Bronze, l. 37 cm
Cat. 21

54 Francis Bacon
 Lying Figure, 1959
 Oil on canvas, 198.5 × 142.6 cm
 Cat. 58

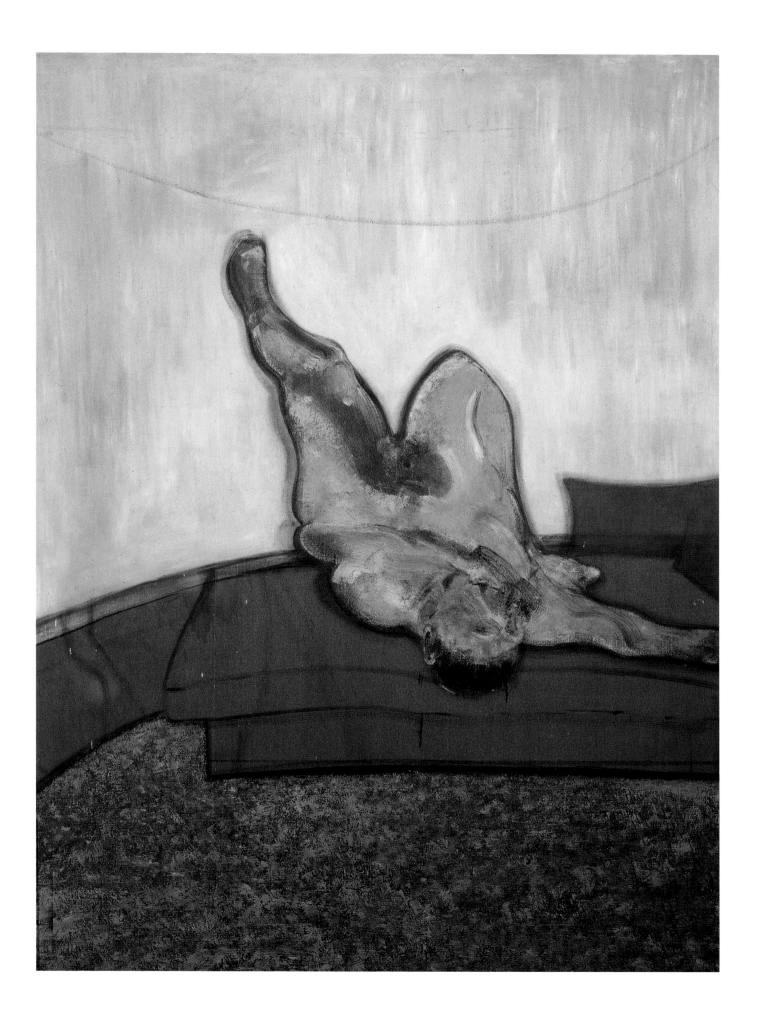

55 André Derain
Portrait of an Unknown Man Reading a Newspaper (Chevalier X), c. 1911–14
Oil on canvas, 162.5 × 97.5 cm
Cat. 38

56 Francis Bacon
Seated Figure, 1961
Oil on canvas, 165.1 × 142.2 cm
Cat. 62

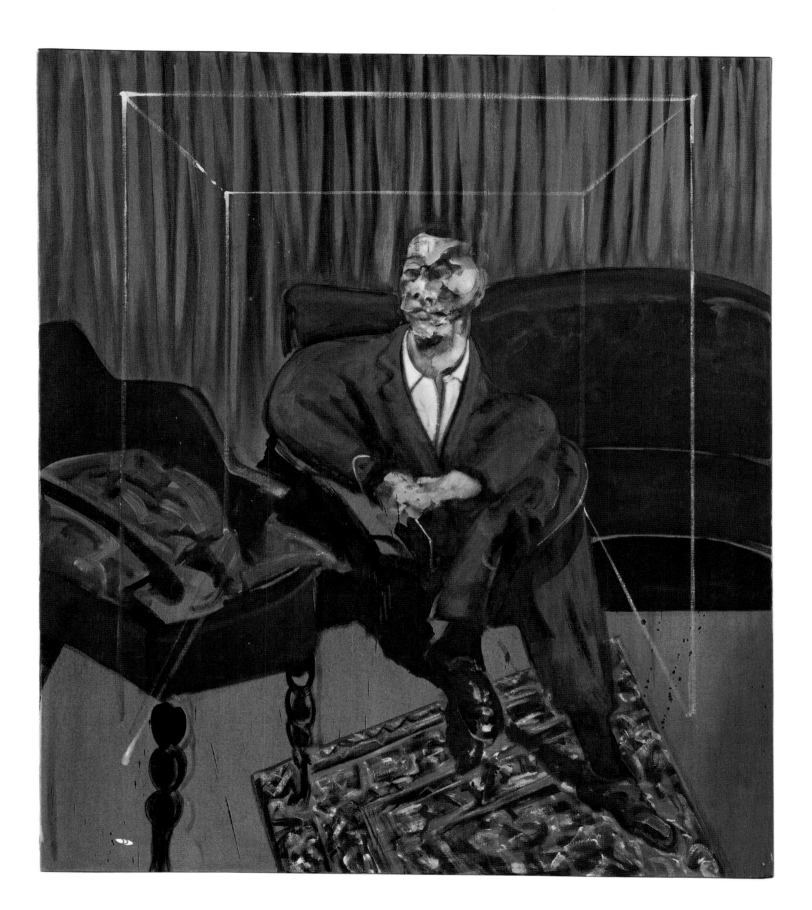

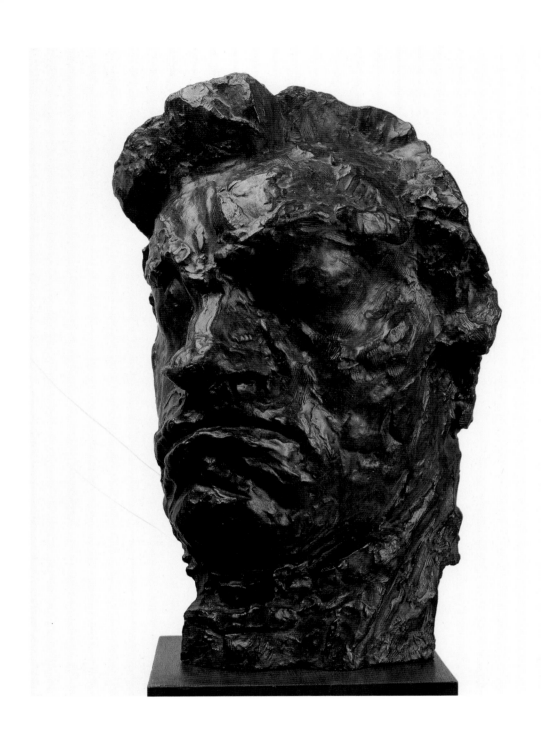

57 Émile-Antoine Bourdelle
Ludwig van Beethoven. Grand Masque Tragique, Early 20th century
Bronze, 76 cm
Cat. 19

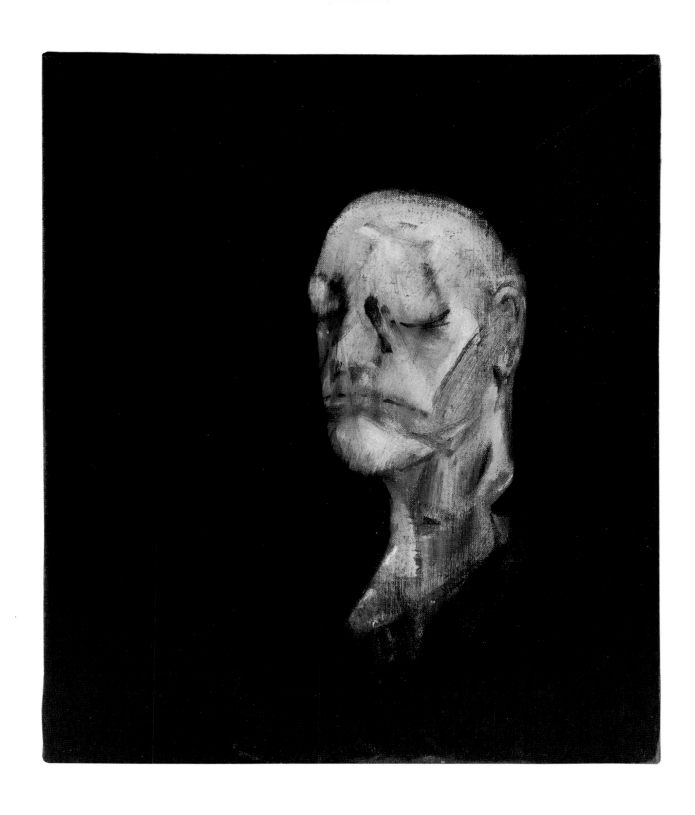

58 Francis Bacon
 Study for Portrait II (After the Life Mask of William Blake), 1955
 Oil on canvas, 61 × 50.8 cm
 Cat. 48

59 Pablo Picasso
A Young Lady, 1909
Oil on canvas, 91 × 72.5 cm
Cat. 37

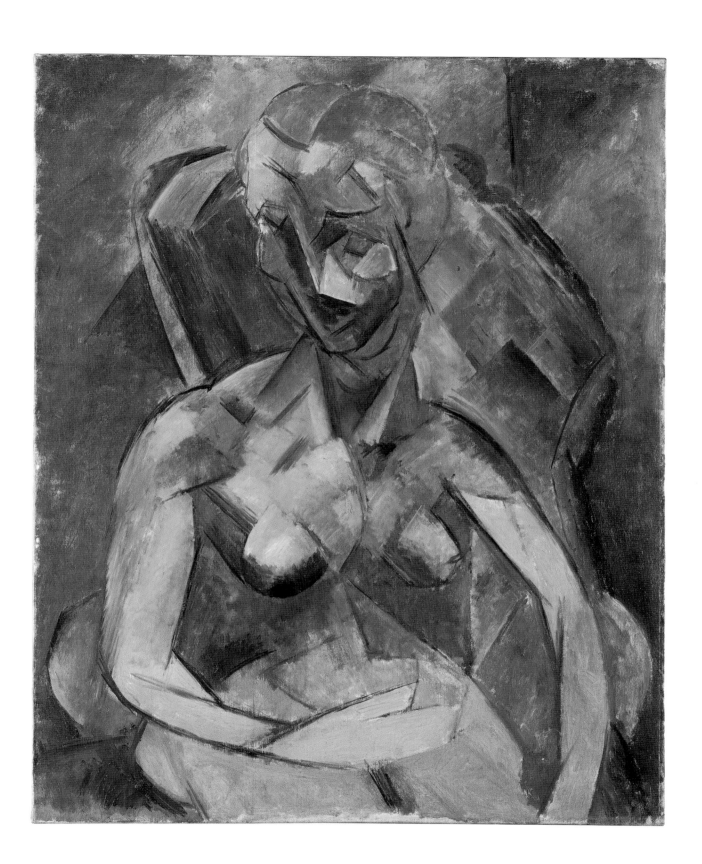

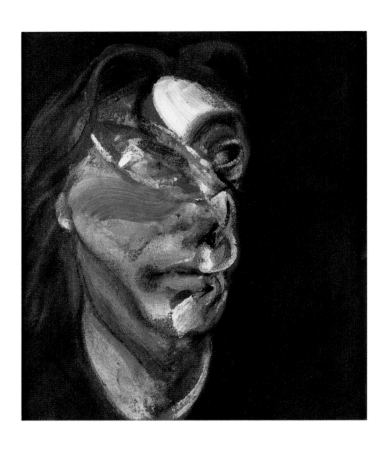

60 Francis Bacon
Three Studies for Portrait of Isabel Rawsthorne, 1965
Oil on canvas, 35.5 × 30.5 cm (each panel)
Cat. 64

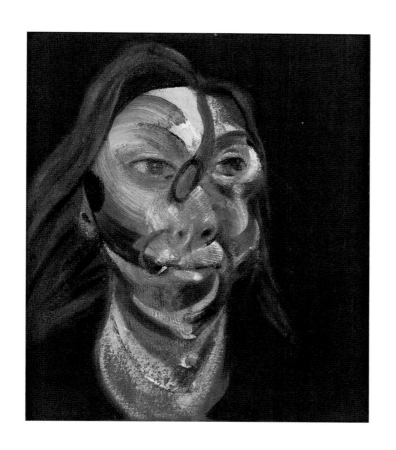
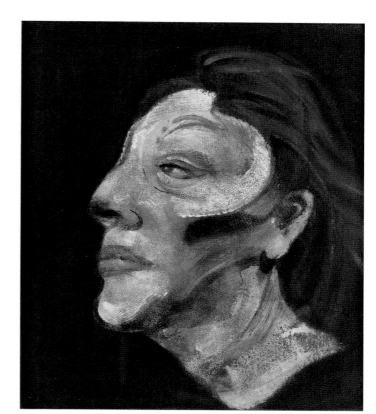

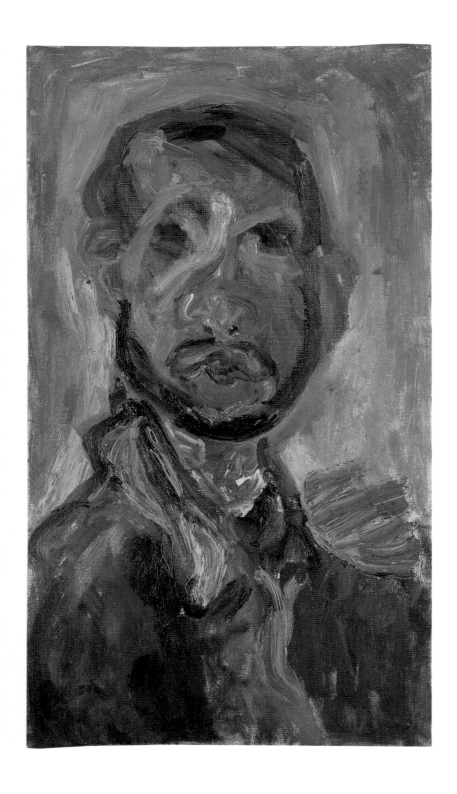

61 Chaïm Soutine
Self-Portrait, Early 1920s
Oil on canvas, 54 × 30.5 cm
Cat. 39

62 Francis Bacon
Portrait of Isabel Rawsthorne, 1966
Oil on canvas, 81.3 × 68.6 cm
Cat. 65

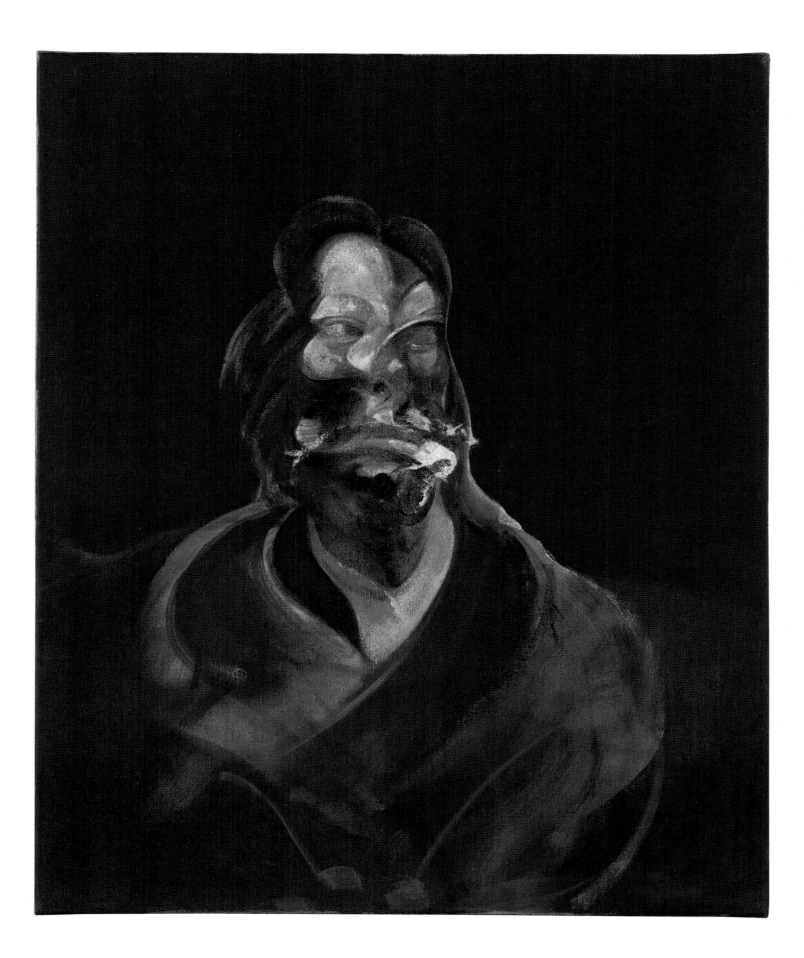

63 Francis Bacon
Owls, 1956
Oil on canvas, 61 × 51 cm
Cat. 53

64 Francis Bacon
Landscape near Malabata, Tangier, 1963
Oil on canvas, 198 × 145 cm
Cat. 63

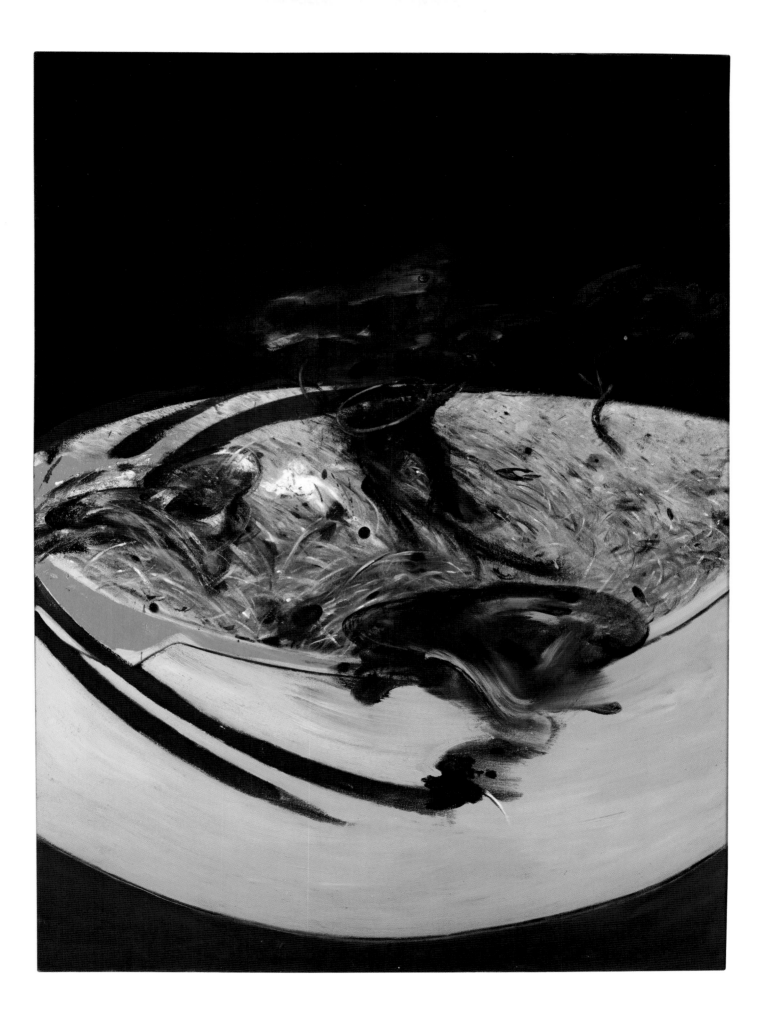

65 Auguste Rodin
Eternal Spring, *c.* 1906
Marble, h. 77 cm
Cat. 20

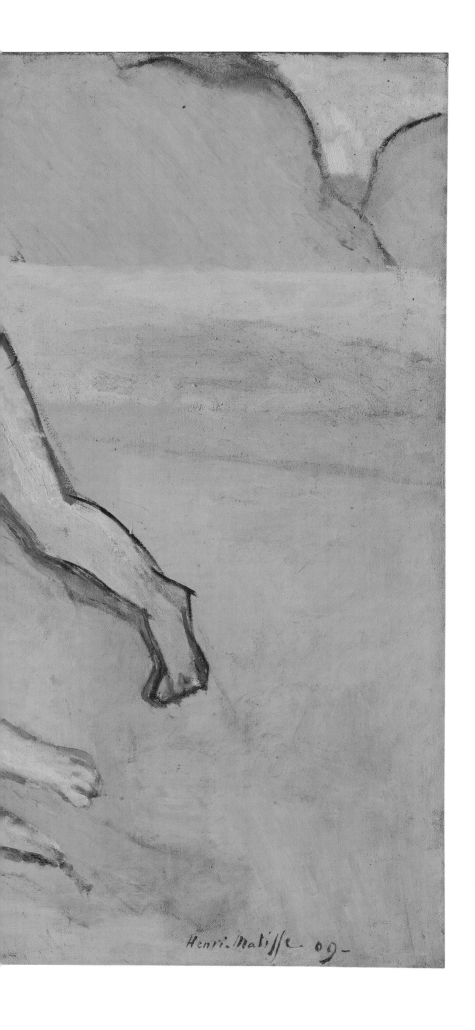

Henri. Matisse. 09-

66 Henri Matisse
Nymph and Satyr, 1908–9
Oil on canvas, 89 × 116.5 cm
Cat. 35

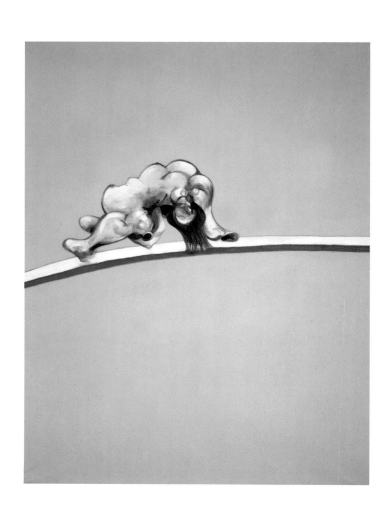

67 Francis Bacon
 Studies of the Human Body, 1970
 Oil on canvas, 198 × 147.5 cm (each panel)
 Cat. 66

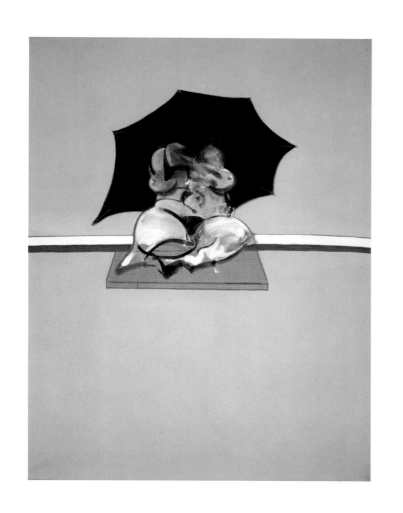
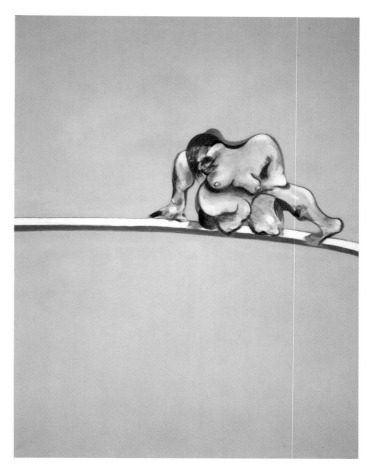

Amanda Geitner

A Very Modern Patronage
Francis Bacon and the Robert and Lisa Sainsbury Collection

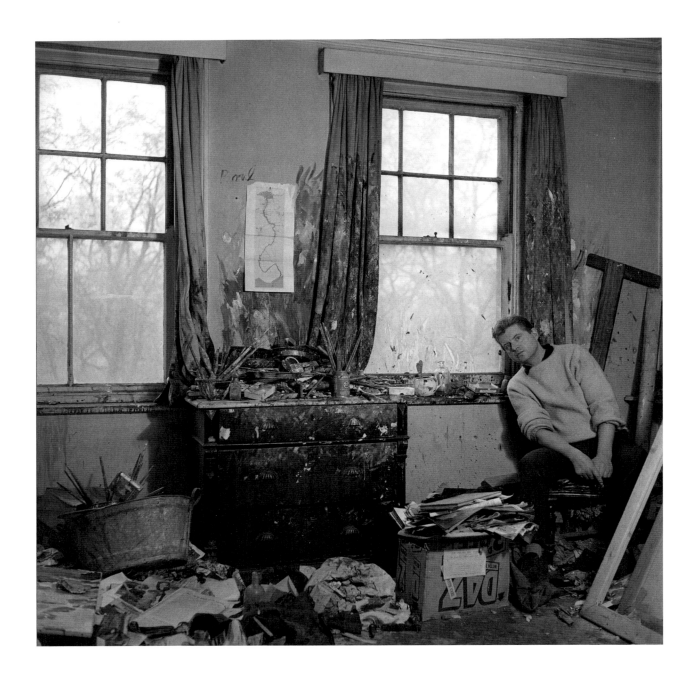

In 1953 Lisa Sainsbury went to see Erica Brausen at the Hanover Gallery in London. Brausen was the owner of the gallery and had been a friend since 1937, when Lisa and her husband Robert had bought from her a mutual wedding present: a painting by Amedeo Modigliani. During her visit, a group of paintings stacked against a wall caught Lisa's attention, and one, Francis Bacon's *Study of a Nude* (1953; cat. 45), captivated her. Lisa returned home with the painting to show Bob, as he liked to be known, who was equally fascinated. The painting was purchased and subsequently known in the Sainsbury family as 'the diving man'. This moment, significant in the lives of artist and patrons alike, marked the beginning of a relationship – a lasting friendship – which saw the Sainsburys acquire by 1965 a collection of thirteen works by Bacon.

Two years after that first purchase, the Sainsburys met Bacon and commissioned him to paint portraits of Robert and, later, Lisa. The resulting *Portrait of R. J. Sainsbury*, created in March 1955 (cat. 46), is an extraordinary essay in economy. Robert's likeness is described with only the suggestion of his face and neck, with some detail applied to his shirt and tie. His shoulders and torso dissolve entirely into the inky background. As in other works of this period, Bacon has located the figure within a depth of space with only the briefest delineation of pale lines describing a room-like frame around the figure. The subject wears glasses; his left eye is open, his right eye obscured. The work bears a relationship to the *Man in Blue* series of paintings of businessmen, which Bacon had begun the previous year while staying in the Imperial Hotel, Henley-on-Thames. Robert was very pleased with the portrait, writing to the artist Henry Moore, another great friend of the Sainsburys, 'Francis Bacon has just finished my portrait. It is a fascinating picture and I am thrilled with it. I hope that when we get back from Greece you will come and see it as well as some of the recent acquisitions.'

In the same year Lisa also began to sit for Bacon. Of the eight works begun at this time, three survive, the earliest of which is *Sketch for a Portrait of Lisa* (1955; fig. 21). For much of the 1950s, prior to his move to 7 Reece Mews in 1961, Bacon was without a permanent address. He lived variously in London, Henley-on-Thames and Monte Carlo, visited his mother in South Africa and his lover Peter Lacey in Tangiers, and ended the decade with a period of five months working at Porthmeor Studios in St Ives, Cornwall. In 1955 Lisa sat for Bacon in London and told of the cold of his studio (she and Robert would sit in their coats), the stacked debris and the constant risk of getting paint on her clothes. She and Bacon would chat and gossip, and she remembered these sittings as immensely enjoyable. But although they spent a significant amount of time in each other's company, it is difficult now to ascertain how much of the surviving paintings, if anything at all, was painted in Lisa's presence. A letter from Bacon to Robert in July 1956 in which he describes his time in Tangiers concludes, 'All my love to you both and thank you again for everything. Tell Lisa I think a portrait of her will come up one day here. I am not satisfied with what I have done of her.'

A Very Modern Patronage

Figure 21. Francis Bacon, *Sketch for a Portrait of Lisa*, 1955; Robert and Lisa Sainsbury Collection, University of East Anglia (cat. 49)

Figure 22. Francis Bacon, *Portrait of Lisa*, 1956; Robert and Lisa Sainsbury Collection, University of East Anglia (cat. 50)

Figure 23. Francis Bacon, *Portrait of Lisa*, 1957; Robert and Lisa Sainsbury Collection, University of East Anglia (cat. 54)

The three extant paintings of Lisa are a remarkable record of Bacon's working practices at the time: each one is an iconic, arresting image. In *Sketch for a Portrait of Lisa* (1955; fig. 21) the figure looms forward, Lisa's distinctive features are simultaneously a close likeness and a clear evocation of the early Egyptian sculptures Bacon admired. The surface of the image is subject to a vertical striation, a shuttering effect that Bacon had experimented with in works such as *Screaming Man* (1952; private collection) and *Study of the Human Head* (1953; private collection). This device, as with his subsequent insistence that his works be shown in heavy gilt frames and behind glass, distances the viewer from the subject and makes ambiguous the spatial relationship between figure and ground.

In *Portrait of Lisa* (1956; fig. 22), Bacon places her further back in the space, bearing a clearer relationship to *Portrait of R. J. Sainsbury*, but here the sweep of the coat around Lisa's shoulders is minimally delineated. The vertical emphasis is suggested in this painting through lines down the face, which is given a formal, mask-like structure by the black arcs around the eyebrows, eyes and cheekbones. The figure is brought forward once more in *Portrait of Lisa* (1957; fig. 23), the most painterly of the three, where the face and neck are energetically moulded with thick impasto and broad brush stokes, prefiguring the almost sculpted manipulation of paint that characterises Bacon's unflinchingly carved faces of the mid-1960s.

All the paintings of Robert and Lisa Sainsbury are titled 'portrait', but a formal sitting for Bacon was an unusual transaction. A portrait might be thought to describe a work in which the identity of the subject is the principal concern, the sitter's status and authority thus being confirmed by their being painted. In the mid-1950s the Sainsburys were becoming well known in London society. They lived at 5 Smith Square, Westminster, and Robert was, at that time, deputy chairman of Sainsbury's, a family food-retailing business transformed under his and his elder brother's stewardship into the most innovative and successful supermarket chain in Britain (Robert was knighted in 1969). It may have seemed unlikely that the Sainsburys would choose Bacon as their painter, but neither Robert nor Lisa had ever shied away from the unconventional or controversial; indeed, the first sculpture purchased by the young Robert Sainsbury was by Jacob Epstein, and his purchase of works by Henry Moore in the early 1930s testified to his engagement with the English avant-garde. Even so, it is a striking, almost audacious, display of confidence to enter into a portraiture process that in the end reveals so much more about Francis Bacon and his concerns as a painter than about his willing subjects.

Lisa Sainsbury is thought to be among the last of Bacon's friends and patrons to sit for him. From this point on, Bacon chose to work from photographs of those closest to him, preferring not to be with his subject as he manipulated their likeness, as if some kind of injury was occasioned under his scrutiny.

A Very Modern Patronage

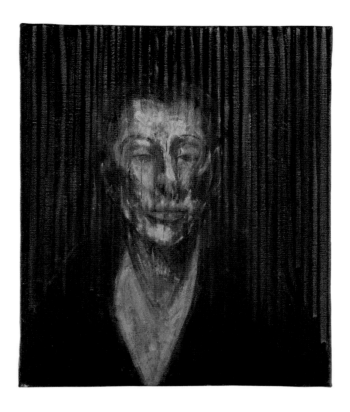

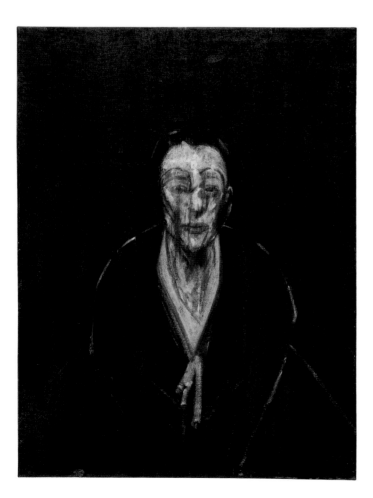

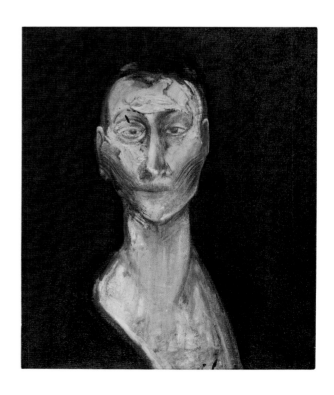

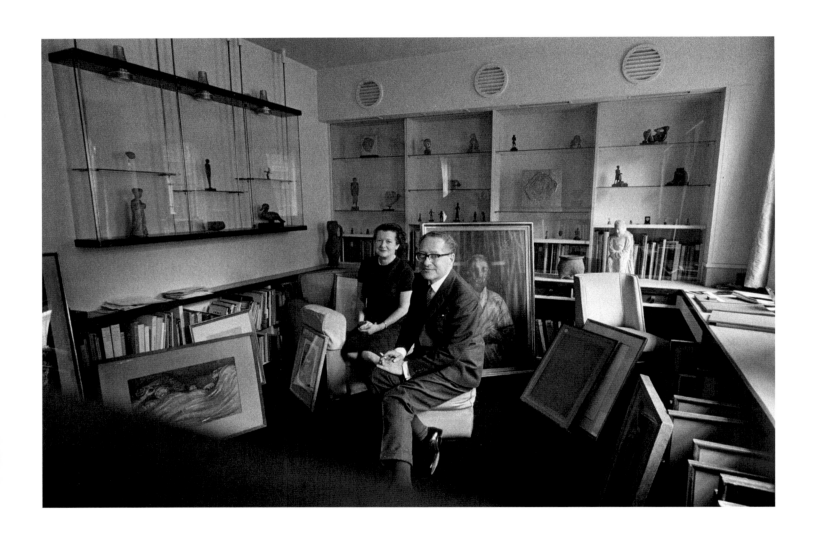

Figure 24. Robert and Lisa Sainsbury
at their home, 5 Smith Square, London
in 1965 (one of a series of photographs
taken in connection with the book *Private
View* (Robertson, Russell and Snowdon,
London, 1965) and reproduced courtesy
of Lord Snowdon)

Two of the paintings of Lisa were gifts to the Sainsburys from the artist, perhaps in recognition of financial support, together with a third work given at that time, *Study (Imaginary Portrait of Pope Pius XII)* (1955; cat. 47). Bacon's series of popes from the 1950s and his ruthless self-censorship of his work are legend. Robert and Lisa would recount the story of meeting Bacon at a social gathering, and how he talked with great excitement about the painting he was then working on. Intrigued, they agreed to go to his studio to see the work, but on the way Bacon's enthusiasm cooled, and by the time they arrived he deemed it unacceptable and resolved to destroy it. The Sainsburys persuaded him not to, and he cut the painting from the stretcher and gave it to them. They took it home, still wet.

More than half a century later, as Francis Bacon is increasingly acclaimed as one of the greatest artists of the twentieth century, it is worth remembering that this was a radical patronage. Until the Sexual Offences Act of 1967 homosexuality was criminalised in England, and Bacon's lifestyle and work were indeed more than simply risqué. It is notable that following the acquisition of paintings such as *Study for a Portrait of P.L., No. 2* (1957; cat. 55), and *Two Figures in a Room* (1959; cat. 57), the Sainsburys didn't flinch from displaying in their home images of such candid, raw physicality. In their support for Bacon, which included their gift of four of his paintings to the Contemporary Art Society in the late 1950s, the Sainsburys were making a courageous statement of their commitment to his work. It is difficult to know how significant this act of faith was for Bacon, but we can imagine their patronage to have been key in a decade of great financial and emotional instability for the artist. In the 1950s the Sainsburys understood the work they acquired as simply being gathered for their home, rather than as a formal collection, but the impact Bacon's work was to have on what we now know as the Robert and Lisa Sainsbury Collection is beyond measure.

There is no extensive written evidence of the friendship between the artist and his patrons. Bacon's letters to the Sainsburys, as with his letters to Erica Brausen of the same period, give a brief outline of travels and are often concerned with money. For many years the Sainsburys had contained their acquisitions within the discipline of an allocated 'art account'. This fund grew with time and in 1953 amounted to £2,000 per annum. It was not their usual habit to give money to artists; instead they were generous with their acquisitions and quick to commission and to provide direct help where it was needed – on more than one occasion organising heating for an excessively cold studio or home. By the late 1950s they were keenly aware of the importance of supporting artists in the early stages of their careers, and established the Sainsbury Art Award, worth £500, given annually to a graduating student.

Robert's response to Bacon's requests for money was to agree to guarantee a £500 overdraft to the artist's account. The story was told that many years later, when Bacon's works commanded high prices, Robert suggested that the guarantee had served its purpose and should be brought to an end. The artist argued otherwise: one never knew what the future might bring, Bacon suggested, and his fortune could go as easily as it came.

A Very Modern Patronage

Lisa Sainsbury (1912–2014) talked about Francis Bacon until the last years of her life. When other friends and acquaintances had diminished in significance or faded from memory, her recollections of Bacon, their friendship, and the time she spent sitting for him remained vivid. These were the stories she never tired of telling.

At the Sainsbury Centre for Visual Arts, designed by Norman Foster and opened in 1978, Robert (1906–2000) and Lisa would linger in front of Bacon's paintings. Never content with a fleeting glance, they would sit and give their full attention to paintings they had known for some fifty years. Eventually Lisa would want to be reminded of what a painting had cost (*Study of a Nude*, 1953, was acquired for just £125) and what its most recent insurance value estimation was. These figures were enormously amusing to her: the paintings had never been an investment, so the current monetary value meant nothing in itself. Rather, Lisa took great pleasure in having been right from the start; the world had finally come around to their way of thinking, and the paintings' monetary values were an acknowledgment of a more profound artistic value of which she and Robert had always been convinced.

The main display area of the Sainsbury Centre, known as the Living Area to reflect the Sainsburys' home, is dedicated to the Robert and Lisa Collection (fig. 27). It contains a selection of works spanning some 5,000 years from Africa, Oceania, the Americas, Egypt, South-East Asia, China and Japan, interspersed with works by twentieth-century European painters and sculptors. With rare exceptions, the works of Francis Bacon in the collection are displayed prominently, but due to the nature of the display not all thirteen works can be shown at one time – Robert and Lisa liked to remark that theirs was the only gallery

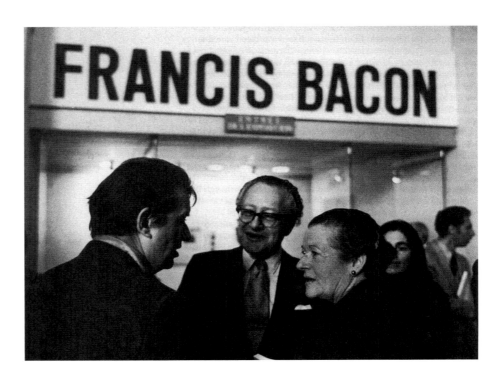

A Very Modern Patronage

with 'Bacons in the basement'. The works by Bacon are among the 'keystones' in a collection distinguished by artists with whom the Sainsburys enjoyed enduring friendships, including Henry Moore and Alberto Giacometti, both of whom were enormously important to Bacon's work in the 1950s and 1960s.

Henry Moore and Robert Sainsbury began a friendship in 1933, when Robert purchased Moore's *Mother and Child* (1932). Robert and Lisa continued to collect sculptures, including larger outdoor works and many drawings, maintaining a close friendship with Moore and his wife Irina – indeed Henry Moore was godfather to their son, David. The Sainsburys are one of a number of patrons and friends that linked Bacon and Moore from the mid-1950s through to the 1970s, a period during which Bacon and Moore were often included in group exhibitions; their work was also shown together at the Marlborough Gallery, London, in 1963 and 1965.

It was in Paris that the Sainsburys met Alberto Giacometti. They were regular visitors to Paris and were first introduced to Giacometti in 1949, by the dealer Pierre Loeb, who would also feature in the life of Bacon. In the years that followed they acquired several sculptures by Giacometti and more than forty drawings, including those of their children, David and Elizabeth, in 1955, the same year Robert and Lisa were sitting for Bacon. Lisa had spent the formative years of her childhood in Paris and, despite an adult life lived in London, was forever a Parisian. Robert did not speak French but sat at dinner with Giacometti, who did not speak English, and enjoyed the friendship facilitated

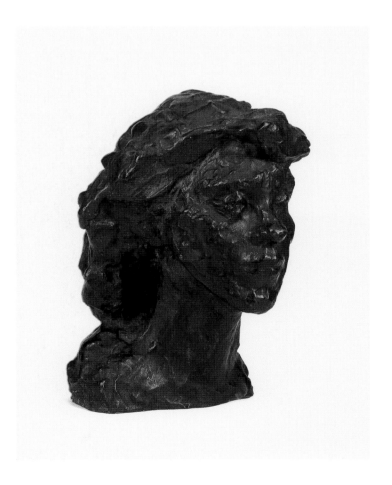

A Very Modern Patronage

Key references
Richard Calvocoressi and Martin Harrison, *Bacon/Moore: Flesh and Bone,* Suffolk: Antique Collectors' Club, 2013
Matthew Gale and Chris Stephens, eds, *Francis Bacon,* New York: Skira Rizzoli, 2008
Steven Hooper, ed., *Robert and Lisa Sainsbury Collection*: catalogue in three volumes, New Haven, Conn., Norwich: Yale University Press in association with the Sainsbury Centre for Visual Arts, University of East Anglia, 1997
Michael Peppiatt, *Francis Bacon in the 1950s,* New Haven, Conn., London, Norwich: Yale University Press in association with the Sainsbury Centre for Visual Arts, University of East Anglia, 2006
Barbara Steffan and Norman Bryson, *Francis Bacon and the Tradition of Art*, Milan and New York: Skira, 2003
David Sylvester, *Looking Back at Francis Bacon,* New York: Thames & Hudson, 2000

by Lisa. From Bacon the Sainsburys acquired *Three Studies for Portrait of Isabel Rawsthorne* in 1965 (cat. 64), and in 1974 acquired Giacometti's *Head of Isabel II* (1938–9; fig. 26), formerly in Isabel Rawsthorne's own collection. An intense relationship with Rawsthorne as friend, artist and muse is an important connection between the two artists. In 1962, it was she who introduced the two men, during Giacometti's visit to London to prepare for an exhibition at the Tate; the artists were friends until Giacometti's death in 1966. Bacon admired Giacometti's drawings, but his reticence about his sculpture belied the visual relationship between Giacometti's sculptural cage structures and graphic framing devices and Bacon's use of 'space frames' to locate and contain his figures in the 1950s and early 1960s. Whatever the reality of inspiration, influence or admiration, the two artists certainly arrived, by different paths, at a similarly penetrating and incisive rendering of their subjects.

Of significance to this exhibition is Bacon's interest in early Egyptian and Greek sculptural forms, a passion shared by Moore and Giacometti. (Lisa Sainsbury gave Giacometti a small Egyptian figure in 1955 in thanks for the drawings of her children, for which he would accept no payment.) The early works by Moore in the Robert and Lisa Sainsbury Collection reveal the impact of pre-Columbian forms he had encountered at the British Museum. What connects these artists to the ancient art and artefacts in the Sainsbury Collection is their passionate engagement with a great range of sculptural traditions of the past. In turn, it was this passion that informed the Sainsburys' acquisitions of world art.

As one moves through the Living Area at the Sainsbury Centre, the works by Francis Bacon play a pivotal role in an extraordinarily rich and complex experience. This experience arises not simply from the works themselves, but from the Sainsburys' very modern conviction concerning the visceral response to form and the potency of adjacent placements of works of art. Bacon was well aware of this context for his early works, and in a letter to Robert just after the opening of the Sainsbury Centre in 1978, he wrote, 'Dear Bob, I went to Norwich last week and saw your magnificent collection of sculptures'. Bacon's image of Lisa's face may have been filtered through his interest in ancient Egyptian sculpture, and now in the Sainsbury Centre galleries we can see how powerfully Bacon's conjuring of Lisa's likeness informs our understanding of the African mask that is shown across from it. As we move between the works in the Sainsbury Collection we are caught in a visual game, a call and response rather than a linear exchange, each work leading to another and then back again. The paintings by Francis Bacon are stations around which this cycle revolves; without them, the conversation between viewer and object would be so much less powerful.

The exchange that occurred over many years between Francis Bacon and Robert and Lisa Sainsbury was indeed a determining force in all of their lives and has left a legacy whose magnificence no one could have foreseen.

A Very Modern Patronage

Margarita Cappock **Francis Bacon's Studio**

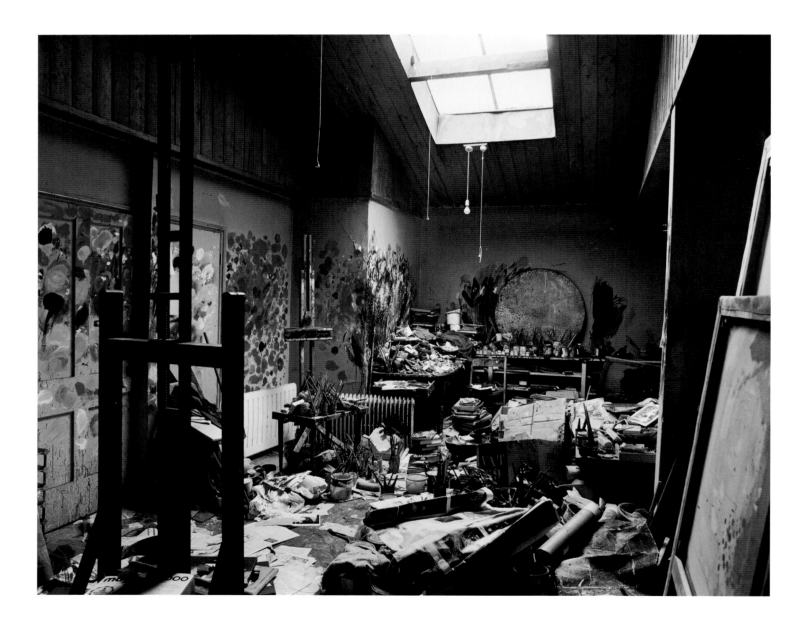

Figure 28. Francis Bacon's Studio,
7 Reece Mews, London; photograph
by Perry Ogden, 1998, C-type print on
aluminium, 122 × 152.5 × 5 cm; Dublin
City Gallery The Hugh Lane

This mess here around us is rather like my mind; it may be a good image of what goes on inside me, that's what it's like, my life is like that.[1]

In the autumn of 1961, Francis Bacon moved into 7 Reece Mews, a modest three-room dwelling in South Kensington, London, which served as the artist's principal studio and residence until his death in 1992. An inveterate hoarder of pictorial material, Bacon eventually accumulated over 7,500 items in this space, including books, magazines, newspapers, photographs, drawings, hand-written notes, destroyed and abandoned canvases and artists' materials. Of this cluttered mess Bacon said, 'I feel at home here in this chaos because chaos suggests images to me'.[2] This small room was to become the locus for the production of some of the most powerful and uncompromising paintings of the twentieth century. During Bacon's lifetime, only his closest friends were allowed to enter his Reece Mews studio. Aside from acknowledging the obvious debts in his work to the photography of Eadweard Muybridge and artists such as Michelangelo, Velázquez, Rembrandt, Ingres, Van Gogh and Picasso, the artist was guarded in terms of revealing any other material from his visual archive or his absorption of the images. The studio contents give a wide-angle view of Bacon's artistic agenda, and the material discovered there has changed the shape and focus of studies of his work, providing an astonishingly detailed portrait of the artist and his work practices. The selection of material from the studio, and the photographs taken by Perry Ogden of the studio prior to deconstruction (fig. 28), offer an intriguing insight into the mind of one of the twentieth century's most significant artists.

Bacon never intended or envisaged that his studio and its contents would be displayed in a museum. Perhaps for this very reason it has taken on a posthumous significance – because it fulfils the notion of what an artist's studio should be: a private fortress, a creative environment, a place to amass material that may prove useful, a space to think and act uninterrupted by the distractions of modern life, a place to survey one's own artistic production and either accept it or reject it; and a magical, mythical space that may provide the clues simultaneously both to artistic genius and quotidian practice. Bacon himself made the analogy between the artist's studio and a chemist's laboratory. For him, the studio was a place of experimentation, creation and destruction. It was where he assimilated material and transformed it for his own unique ends.

Bacon's decision to work in chaos was a conscious one and one that he frequently acknowledged. It was in marked contrast to the Spartan order of his domestic space. The ephemeral nature of much of Bacon's source material, as it mouldered away in the studio, meant that decay and destruction were part of his everyday experience, and something that he was acutely aware of in life. In an interview that took place at the Grand Palais in Paris on 25 October 1971, he said, 'La vie, d'après tout, de la naissance à la mort, est une longue destruction' ['Life, after all, from birth to death is just one long destruction'].[3] Furthermore, the decay of the photographs, papers, canvases, clothing and artists' material strewn around the floor disrupted the normal associations with these objects, creating a sense of disorder whilst also introducing new and alien associations which the artist must have found stimulating. Through both wear and tear and deliberate manipulations by Bacon, a photograph, regardless of the

Francis Bacon's Studio

status of its creator, gradually took on new aesthetic properties as its texture, format and surface changed. Again this was something that the artist himself acknowledged. 'My photographs are very damaged by people walking over them and crumpling them and everything else,' he once told the critic David Sylvester, 'and this does add other implications to an image of Rembrandt's, for instance, which are not Rembrandt's.'[4] In the studio, the fragmentary and damaged nature of much of the material, as a result of Bacon's active engagement with it, gave the artist the freedom to mould it and make it adaptable to his own designs. Images and items were conjugated and transformed into something else. Furthermore, the strange accidental juxtapositions of material in the studio broke the meanings of items, in the same way that Bacon's method of appropriating imagery from unlikely and diverse sources and then conflating them in his art proved fruitful for him.

Photography

In the past decade, much has been written on the central role that photography played in Bacon's work, and without question the studio's large stockpiles of photographs amply confirm his reliance on a medium he believed had done more than any other to change the course of painting itself. He stated, 'Ninety-nine per cent of the time I find that photographs are very much more interesting than either abstract or figurative painting. I've always been haunted by them.'[5] Rather than aping photography, it was a tool that could be adopted and exploited to the artist's own ends. While Bacon selected this material from an existing set of images in illustrated publications, original photographs were advantageous in that he could be, and sometimes was, their dictator or author. In other words, the subject and composition of photographs he commissioned or took were to some extent a reflection of his visual preferences, and in many of them his guiding intelligence is discernible. That Bacon himself at times took up a camera is not in question, and his photographs often show him placing the subject in a more hieratic way. His recorded views on photography are marked by a curiously aggressive terminology – he talks of being 'assaulted' by it, of its 'return[ing] me on to the fact more violently'. In the studio, Bacon cut, tore, folded and painted over photographs, regardless of the prestige of their creator. The artist's interest in photographs was not confined simply to what an image contained; he was also keenly receptive to its physical state. He employed recurring pictorial effects in his work, and the origins of these can be found in the tears, creases and paint accretions on the photographs littered across the studio floor. While sensitive to the way that damage could irrevocably alter an image, Bacon made conscious, deliberate manipulations and modifications to material, with many of his distortions held in place by adhesive tape, safety pins or sewing needles.

The photography of John Deakin (1912–72) played a crucial role in Bacon's portraiture from the early 1960s onwards. The painter possessed more than three hundred of Deakin's photographs, and although many are now in poor condition their visual impact is arguably enhanced by their distressed, often fragmentary state. Bacon commissioned Deakin to photograph his lovers, Peter Lacy and George Dyer, and his friends, Isabel Rawsthorne, Lucian Freud, Henrietta Moraes and Muriel Belcher. The resulting images provided Bacon with a highly serviceable record of a subject's appearance and mannerisms,

Figure 29. Isabel Rawsthorne; black-and-white photograph by John Deakin, 31 × 30.3 cm; Dublin City Gallery The Hugh Lane

Figure 30. George Dyer in the Reece Mews studio; black-and-white photograph by John Deakin, 30.3 × 30.3 cm; Dublin City Gallery The Hugh Lane

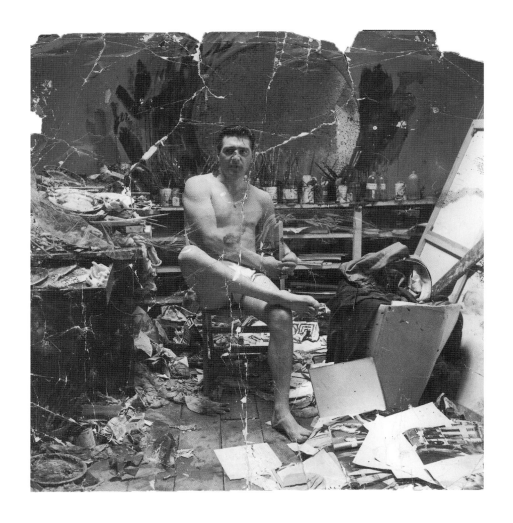

and his portraits from the 1960s onwards are heavily indebted to Deakin's photographs. Bacon tacitly conceded as much when he admitted that 'they helped me to convey certain features, certain details'.[6] Isabel Rawsthorne (1912–92) had a particularly alert and questioning look, and in the 1960s became Bacon's favourite female model (fig. 29). She was photographed on Dean Street in Soho, London, and more than half of the twenty-two Deakin photographs of her found in the studio have been torn or creased in the manner common to the most treasured of Bacon's visual sources.

One hundred and twenty-nine of Deakin's photographs of Bacon's lover, George Dyer (1934–71) were found in Bacon's studio. This number includes about fifty-four fragments of varying sizes. Deakin took at least four dedicated sets of photographs of Dyer, but the series of photographs from which Bacon improvised most often and freely is that of Dyer in his underwear in the Reece Mews Studio, taken around 1964 (fig. 30). With these photographs, Bacon's highly distinctive editing of his material comes to the fore. Several of the prints were sliced in two and he then set about isolating and honing in on the choicest portions. By means of the cut and the tear the artist continued the photographic process of framing, editing and selection. In essence, destruction became another form of inquiry. In the years that followed, Bacon co-opted these images for a whole range of paintings. In *Triptych August 1972* (1972; London, Tate) Dyer's pose in both left and right panels is derived from the Deakin photographs. The same cross-legged template can be observed in other works, including *Three Portraits: Posthumous Portrait of George Dyer, Self-Portrait, Portrait of Lucian Freud* (1973; private collection). Of all the artist's contemporary subjects, Dyer had the most profound and prolonged effect. As Bacon's muse his status was raised for a time, but the lure of these photographs endured for a further twenty years after Dyer's tragic death. As late as 1988 Bacon turned to the Deakin images of Dyer for his *Portrait of John Edwards* (1988; Estate of Francis Bacon). The completed canvas is an effortless amalgam of Dyer's lower body and Edwards' head and shoulders, as recorded in numerous photographs by, among others, Bacon himself. Photography enabled just this type of superimposition and substitution – a strategy whose piquancy was hardly greater than when the anatomies of a current companion and a former lover were combined.

Illustrated Publications

Figure 31. Nazi rally in Nuremberg, 1938; fragment of a page (18) from the *Sunday Times* Colour Section magazine, 18 February 1962, on brown cardboard, 38 × 29 cm; Dublin City Gallery The Hugh Lane

Photographs, of course, made up only one part of a much wider visual store that also included illustrated publications such as magazines, newspapers and catalogues. Bacon sought visual matter on a constant basis, accumulating far more material than he could ever hope to use. Over 570 books and some 1300 loose leaves torn from books were found in the Reece Mews studio. In addition, 200 magazines and leaves from magazines and 246 newspapers and newspaper fragments were uncovered. Their subjects range from art, sport, crime, history and cinema to photography, wildlife, medicine and the supernatural. Bacon ruthlessly assimilated what he needed from the images. His art was partly motivated by the breaking, or at least the modifying, of given associations. In this way a motif could be made more truly his own or, as he preferred to see it, divested of narrative baggage.

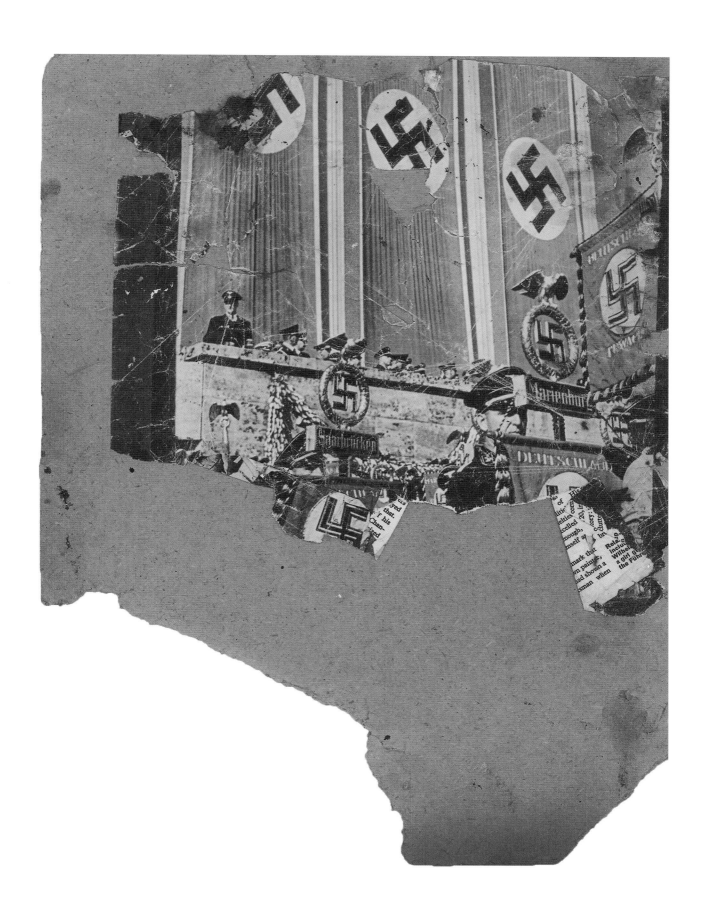

Figure 32. Albert E. Elsen, *In Rodin's
Studio, A Photographic Record of Sculpture
in the Making* (1980, Oxford: Phaidon
in association with the Musée Rodin,
Paris), 28.4 × 22.1 × 2.2 cm; Dublin City
Gallery The Hugh Lane

The importance of the fragment in both Bacon's modus operandi and œuvre, purely in visual terms, is reflected in the studio contents. Bacon was irresistibly drawn to the idea of the fragment. Fragments of the body, the partial figure, isolated or broken limbs, the torso and truncated forms all feature extensively in his paintings but also in the studio material. Bacon referred to the Elgin Marbles as being 'more beautiful because they're fragments'.[7] The work of Rodin, which Bacon held in high esteem, revealed the autonomous artistic possibilities in the fragmentary and incomplete, particularly in the fractured forms of works such as *Iris, Messagère des dieux* (*c.* 1895; Paris, Musée Rodin) and *Figure Volante* (private collection), both of which Bacon knew and admired. Bacon kept several books on Rodin in his studio, and there are also a number of references to the sculptor in Bacon's hand-written notes, in particular to *Figure Volante*.

Similarly, with Michelangelo it was the many fragmentary, unfinished works by the Italian master that had a forceful impact on Bacon's thinking; Michelangelo's preparatory drawings of torsos and limbs became Bacon's principal area of attention. Five leaves with illustrations of the Renaissance artist's drawings have over-drawings by Bacon. Four of these show his interventions on Michelangelo's studies of separate parts of the male nude. This very direct form of engagement suggests that Bacon looked on Michelangelo's drawings as frameworks for new ideas. They also represent his attempts to explore the strengths of a supreme draughtsman. Bacon hoarded more books on Michelangelo in his studio than on any other artist (at least seventeen copies of different monographs and more than eighty leaves from books with illustrations of the artist's work). He particularly admired the drawings, saying, 'for me he is one of the very greatest draughtsmen, if not the greatest'.[8]

Figure 33. Francis Bacon, *Painting 1950*; Leeds Art Gallery

He was intrigued by what he called 'the ampleness, the grandeur of form from Michelangelo'.[9] Bacon's co-opting of Michelangelo was broad and far-reaching. The Florentine's primary interest was the heroic male nude, a form that from the early 1950s came increasingly to dominate Bacon's work. The 'grandeur' of Michelangelo's nudes is clearly discernible in the massive athletic figures in Bacon's paintings, such as *Painting 1950* (fig. 33).

The studio contained an impressive number of books and book leaves on Egyptian art and civilisation. Bacon believed that the achievement of Egyptian sculpture had scarcely been surpassed, even going so far as to say, 'I think perhaps that the greatest images that man has made so far have been in sculpture. I'm thinking of some of the great Egyptian sculpture, of course, and Greek sculpture too.'[10] One of his oldest source books on Egyptian art was *The Art of Ancient Egypt: Architecture, Sculpture, Paintings and Applied Art* (1936; p. 170) with an introduction by the Egyptologist Hermann Ranke. Bacon traced around the features of masks from this book, and the generalised lineaments of the El-Amarna portrait-masks are reinterpreted in the series of portraits Bacon made of Lisa Sainsbury in the 1950s (cat. 49, 50 and 54).

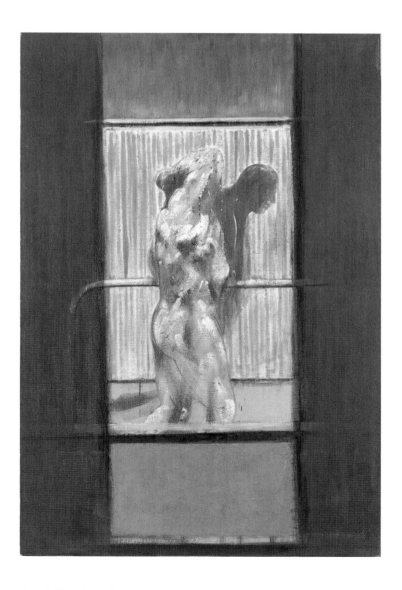

Francis Bacon's Studio

The Role of Drawing

The discovery of forty-one works on paper by Bacon amongst his studio contents was one of the more significant aspects of the documentation of the Reece Mews Studio. These works are important both artistically and also because they refute Bacon's persistent denials that he ever made preliminary sketches for his paintings. Throughout his life the existence of such drawings appeared to be shrouded in secrecy, and whilst some of Bacon's friends and contemporaries owned drawings by the artist, they seemed to have accepted his desire to keep them out of the public domain during his lifetime. Bacon's official denials that he made drawings of any kind became a recurring theme in the numerous interviews he gave. Since the artist's death, a considerable number of drawings, both by Bacon and attributed to him, have surfaced and the notion that he did not produce preparatory drawings has been conclusively dismissed.

Bacon's drawings do not reveal him to be a conventionally skilled draughtsman. Yet this did not prevent him from professing great admiration for drawings by artists including Michelangelo, Ingres, Degas, Picasso and Giacometti, or from rating their graphic work among the best things they did. Bacon's own preliminary drawings compare less favourably with the work of the artists he so admired, and this may have led to a sense of insecurity about his own graphic prowess. More importantly, by admitting that he did draw, Bacon would have dispelled the myth that his work on canvas was entirely spontaneous. On closer examination, however, the deliberate, studied quality of many of his paintings belies any notion that they were done without preparation or study. It is a tribute to his skill that he could nonetheless convey a general aura of painterly freedom.

Of the drawings found in the studio, twenty were made on paper, including tracing paper, bond paper, lined paper and chain-laid manufactured paper. Some are cursory sketches executed in either pencil or ink, including several earlier drawings, the earliest probably dating from the 1930s. Other drawings are in ballpoint or felt-tip pen, and there are also some oil sketches. Most are monochromatic, and all are unsigned and undated. Some bear close similarities to finished paintings; in other instances the links are less obvious.

A sense of hesitancy is discernible in Bacon's early drawings, confirming the general view that he was not a natural draughtsman. The theme of enclosure or confinement is a persistent one in the many studio works on paper, particularly those that appear to date from the 1950s and 1960s. The principal formal devices Bacon used in his paintings were a rectilinear frame, circles, ellipses and arcs, and these are extensively represented in this body of drawings. Such devices serve a number of different purposes, the most important one being the delineation and isolation of the space in which a body is placed. Bacon explained his use of rectilinear frames in the following terms: 'I cut down the scale of the canvas by drawing in these rectangles which concentrate the image down. Just to see it better.'[11] Several drawings from the studio display circular structures. Their use, while widespread in Bacon's paintings of the 1950s and 1960s, has disparate origins. From early in his career a curved line described the boundary between floor and walls in his paintings. This device may first have been prompted by the artist's memory of his maternal grandmother's house at Farmleigh, near Abbeyleix in Ireland. Bacon had a particular attachment to

Francis Bacon's Studio

this house, where some of the rooms had curved walls. Later he was to say, 'one never really knows, but the use I've made of curved backgrounds in some of my pictures may possibly be a recollection of those rooms'.[12] Another more tangible source for his circular and segmental devices is the Modernist furniture that Bacon designed before he became established as an artist. While Bacon later dismissed this aspect of his career, he did accept that his work as a designer had some impact on his paintings, stating 'the tubes do come from my own metal furniture, but fundamentally they are an attempt to lift the image outside its natural environment'.[13]

While Bacon drew on sheets of paper, he sometimes used the blank endpapers of books and catalogues to execute drawings. The blank pages of a hardback book no doubt served as a convenient and durable sketchbook. It is also quite plausible that he used books as a means of concealing his sketches from the curiosity of an occasional studio guest.

The works on paper by Bacon in the Hugh Lane collection make a significant contribution to studies of the artist's work. They suggest that he was much more premeditated in his approach to painting than he cared to admit. While they may have little of the finesse or flair of preparatory studies by other great artists, they do have intrinsic value in helping to unravel Bacon's method of

Francis Bacon's Studio

defining and exploring motifs. They also offer intriguing possibilities when considered next to extant and destroyed paintings from the artist's œuvre. In the end it is richly ironic that Bacon delivered the best summation of these drawings when, during the course of one of his ritual denials of their existence, he suggested that 'any sketches that I did before could only give a kind of skeleton'.[14] In one seemingly throwaway phrase he gave a tellingly accurate description of these secret works.

Artist's Materials

The artist's studio isn't the alchemist's study where he searches for the philosopher's stone – something which doesn't exist in our world – it would perhaps be more like the chemist's laboratory.[15]

The Reece Mews studio, aside from its role as a repository of sources, was primarily a place of manufacture. The basic stuff and accoutrements of painting dominated the room, whether smeared or brushed on the walls and door, kept as powdered pigment in glass jars or oozing from the tops of paint tubes and clotted around the necks of tins. Some two thousand samples of Bacon's painting materials were eventually uncovered. These include hundreds of used paint tubes, packets and jars of loose pigment, paintbrushes, utensils that served as palettes, tin cans, sticks of pastel, pieces of fabric, cans of spray paint and fixative, tins of household paint and countless roller sponges. Alongside the destroyed and unfinished works by Bacon that were found there, the studio provides an opportunity to assess the raw ingredients of painting.

Bacon received no formal training as an artist, something he prided himself on throughout his life. As well as looking at works of art, Bacon required interaction with fellow artists, from whom he could learn the basics of making pictures. His early self-education was strongly informed by the Australian post-Cubist painter Roy de Maistre (1894–1968) whom he met in 1930. De Maistre secured the majority of Bacon's commissions as a furniture designer and interior decorator, and he also guided the fledgling artist in his first steps at oil painting. Later on, his contact with other artists, such as Graham Sutherland, increased his instinctive technical wiliness. There were advantages and disadvantages to Bacon's process of self-education in paint, and on some occasions his work reflects a poorly judged combination of media.

Bacon appeared to use nearly anything he could find in the studio for the purposes of mixing paint. Small cardboard packaging for tubes of paint, plates, saucers, bowls and even baking trays were all employed for mixing; table knives and spoons were his chosen implements for handling pigments. The studio space itself became an extended palette for the artist, and one that served as a developing reference chart in paint. Bacon rather mockingly referred to the walls of his studio as 'my only abstract paintings'.[16] The door of the studio has extensive daubs of paint on both sides, a reminder that the artist painted with it both open and closed. Impressions of corduroy and loose-weave rag cloths are visible over many of the accretions on both the doors and walls of the studio. Bacon applied these to the surfaces, pressed his chosen fabric against it and then 'printed' the canvas with the impregnated cloth. It would seem that he first employed this technique in the late 1950s and continued to

Figure 35. Francis Bacon's Studio, 7 Reece Mews, London; photograph by Perry Ogden, 1998, C-type print on aluminium, 122 × 152.5 × 5 cm; Dublin City Gallery The Hugh Lane

Francis Bacon's Studio

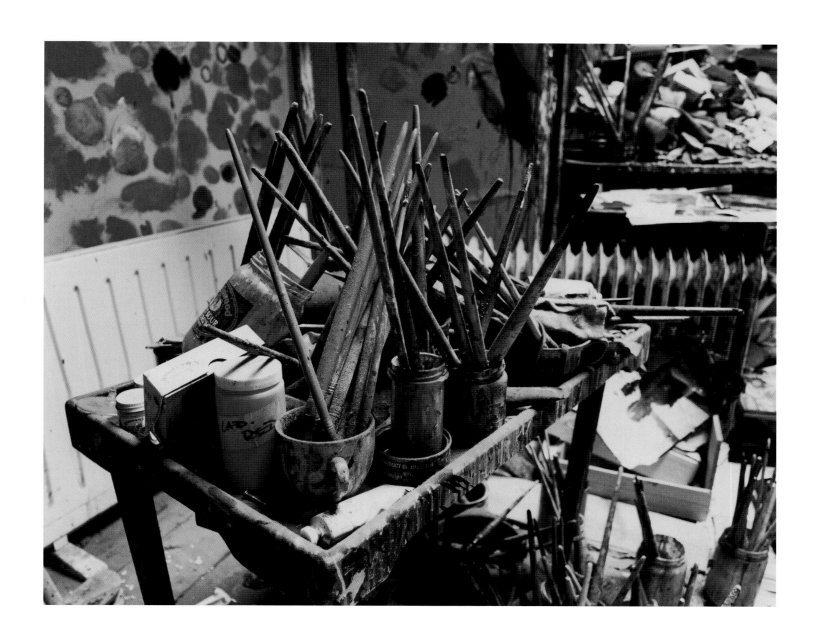

do so throughout the next thirty years in his works (for example, cat. 59). When he required a variety of tactile effects, he found that cashmere sweaters, ribbed socks, cotton flannels – even towelling dressing gowns – all served his purpose. Through each of these Bacon achieved a shuttered effect, giving the sense of a shifting and partially obscured view of the subject. He described the result as a kind of 'network of colour across the image'.[17]

When it came to painting materials, Bacon was remarkably loyal to particular brands. Numerous jars of pure pigment, manufactured by Lefranc & Bourgeois and Winsor & Newton, lined the shelves of the studio. Orange was the artist's favourite colour, and twenty-nine jars of Cadmium Orange pigment were discovered in the studio. Of the Lefranc & Bourgeois pigments, Cadmium Red Orange, Cadmium Red Light, Cadmium Yellow Orange and Alizarin Crimson are the most prominent. Jars of Raw Umber (Natural Earth) and Raw Sienna were also found. The dominant Winsor & Newton pigments were Chrome Yellow, Winsor Orange, Winsor Yellow and, in smaller quantities, Rose Madder, Zinc White, Titanium White and Cobalt Violet Dark. Bacon's experimental tendencies form an interesting counterpoint to his innate conservatism regarding brands and types of pigments – the range of pigments, after all, was not great. His palette was defined by relatively few colours: orange, red, yellow, black, blue and green. It is their daring use and striking contrasts, or dramatic combinations, that deliver the impact. Aside from conventional pigments, Bacon also used household emulsion paint, such as Dulux Vinyl Matt Emulsion, which no doubt contributed to the flat, consistent colour of the backgrounds of his later paintings. Large quantities of emulsion could be applied very rapidly with the use of a paint roller. Well over one hundred roller sponges were found in the studio, most of them soaked and caked in paint.

Whilst Bacon used traditional artist's paintbrushes, he was quite adept at devising unusual ways to apply paint to canvas. He used combs, scrubbing brushes and even brooms to create diverse textured effects. The studio contained numerous one-and-a-half-inch household paintbrushes, presumably employed for the looser brushstrokes in the foreground of some works. Bacon commented: 'I sketch out very roughly on the canvas with a brush, just a vague outline of something, and then I go to work, generally using very large brushes, and I start painting immediately and then gradually it builds up.'[18] In a number of his works paint was squeezed directly from the tube on to the canvas. It was also applied with the plastic lids from these tubes and open ends of bottles found in the studio. Bacon was not averse to using other media in his paintings. He sometimes added sand to the wet paint and also valued the dust that accumulated in his Reece Mews studio as he could rub his fingers in it and then into the wet paint. He used pastel for the backgrounds of a number of works. Relatively late in his career he took to using household spray paints, mainly Humbrol. This created a fine, atomised surface for his works. Cut-out arrows and heads are among the surprise discoveries in Bacon's studio, and the thick deposits of paint on both sides of the arrows imply that Bacon used them to paint around and/or to imprint the shape of an arrow directly onto the canvas.

From the 1970s onwards, jumbled letters from Letraset transfers start to appear in Bacon's paintings, and many partly rubbed sheets of Letraset were found in the studio; the transferred letters seem to have been applied in the spirit of tempting and then frustrating any easy reading of his paintings. His ongoing admiration for the work of Picasso may, at last, have prompted Bacon to incorporate lettering in his works. However, the two diverge in the purpose and handling of the device: the textual content of the Spanish master's work is for the most part legible; in Bacon's case, the Letraset is invariably laid in a random fashion without sense or meaning.

The Art of Destruction

I think I tend to destroy the better paintings, or those that have been better to a certain extent. I try and take them further, and they lose all their qualities, and they lose everything.[19]

Francis Bacon was known for destroying a large part of his output and this has added to the legendary status the artist has been accorded. He was acutely self-critical when it came to his work and seemed to destroy works on impulse. Whilst Bacon's paintings were displayed in the sanctuary of the museum, in the studio he was free to slash, cut, tear and rip at will, and engage with his materials in an entirely different and more visceral way. The violent slashing of the canvases found in the studio attests to this fact. One hundred destroyed canvases were found in Bacon's studio and span some five decades of the artist's career. This is a considerable number of works, given the relatively modest size of his studio. The larger canvases were stacked up against the walls and windows and the smaller ones piled on shelves or discarded on the floor. These works, although destroyed, give tantalising glimpses of what Bacon canvases looked like at various states of completion and reveal his unorthodox techniques in their raw state.

Figure 36. Unframed canvas with extensive paint accretions (used as a palette), 36 × 30.2 × 1.7 cm; Dublin City Gallery The Hugh Lane

Bacon destroyed some works himself, but he also asked others to do so, among them his long-time friend, John Edwards. His earliest and most supportive patrons, Robert and Lisa Sainsbury, witnessed at first hand his reaction to a painting that displeased him. One evening they met the artist at a party where he spoke enthusiastically of a 'Pope' he was working on. They gave him a lift home, hoping to see the painting with a view to buying it. During the journey Bacon, seemingly on a whim, suddenly decided he would destroy the work. They pleaded with him not to, but after he showed it to them, he slashed it with a razor blade. He gave the Sainsburys what was left of the canvas with the paint still wet, and they took it off to Alfred Hecht, Bacon's framer, and had it framed.[20] This is a revealing insight into the artist's ambiguous attitude to the destruction of works and may explain why certain fragments were kept in the studio after being destroyed. Was Bacon afraid to discard them completely, or was the very evidence of their destruction a statement in itself by the artist?

The destroyed canvases found in the studio span some five decades of the artist's career, with the earliest known work dating from around 1946. Bacon's use of unprimed canvas meant that the indelibility of each mark raised the stakes; the medium's intractability posed a rewarding challenge, and Bacon found a technique precisely attuned to his temperament. This left him with little scope to make alterations or rework canvases that had gone wrong in his eyes. In most cases a painting was taken to a relatively advanced stage before it was destroyed. In others only a few sketchily painted contours or preparatory paint applications are visible. The human figures in Bacon's paintings tend to

Figure 37. Unframed painting on canvas by Francis Bacon (portrait; destroyed), 35.5 × 30.6 × 1.8 cm; Dublin City Gallery The Hugh Lane

be two-thirds of life-size, so the major of his large paintings are of full-length figures while the smaller paintings tend to be of heads. More than half of the canvases found in the studio are in a small format (approximately 35.3 × 30 cm). Some were subsequently used as palettes or have preparatory layers (fig. 36), whereas others have portrait studies in varying degrees of completion. The artist apparently used other canvases to test paint colours and techniques and occasionally clean his brushes.

Typically, Bacon seems to have been most anxious to remove the figure from the canvas. The head area of every small portrait study found in the studio has been cut out – quite literally defaced. Since all that remains generally includes just a small area of the neck, edges of the face and head, the identification of the sitter became a matter of deduction from fairly slim evidence. The unframed canvas (fig. 37), for example, which was possibly a portrait of Lucian Freud, appears to have been destroyed while the painting was still quite wet, as there is a build up of paint along the edge of the cut in several areas. This implies that Bacon did not deliberate for long before abandoning the work. In the area of the face, the paint has been applied thickly and quite dry, producing broken brushstrokes and blurred contours. It has been heavily textured using ribbed fabric and/or a bristle brush used end-on. In the fabric-textured area raw orange pigment has been deposited in the textile imprint. Sand appears to have been mixed into areas of the facial flesh paint and background. It is visible on the surface in the sitter's brown hair, on parts of the white flesh paint, and in the brown paint on the left of the sitter's collar. Compared with other destroyed canvases from the studio, relatively little of the composition has been removed.

Nonetheless, some of these slashed head studies can be tentatively related to finished paintings of Lucian Freud, John Edwards, Isabel Rawsthorne and indeed self-portraits of Bacon. With the exception of one destroyed painting, for which the removed fragments were found, none of the strips removed from the other canvases has survived. This suggests that Bacon was assiduous in disposing of the inner fragments, usually belonging to the face, or, in larger works, the body. Certain earlier works have very thick and complex paint films built up of multiple layers of different colours, many of which are invisible on the surface. The implication here is that Bacon reworked some compositions extensively as they progressed, something that tallies with the artist's own statements on his methods.

Many of the large canvases show the remains of compositions that were well established in Bacon's mind before he embarked on the painting. Different elements were executed in spaces reserved for them, with little overlapping of layers. The figures, chairs, box-like structures and so on were first roughly sketched in dilute paint, directly onto the bare canvas. This adumbrative handling of paint closely resembles sketches found in the studio. The backgrounds in many large studies/paintings were applied after the figurative elements, which were built with thicker applications of paint. The physical evidence of these works raises questions about how long paintings were left abandoned before they were destroyed. In some cases the paint along the edges of the cuts is cleanly fractured or has a serrated edge. This indicates that time had elapsed before the canvas was slashed, since the paint was already dry.

Francis Bacon's Studio

I'm rarely happy with the result [21]

In Rothenstein and Alley's 1964 catalogue raisonné of Bacon's work a differentiation is made, albeit with a number of inaccuracies, between completed pictures, abandoned pictures and destroyed pictures, indicating that early in his career the artist's habit was to leave certain works unfinished but not to destroy them. The provisional-sounding titles of Bacon's works and choice of a triptych format lend a contingent air to his canvases. The French author and poet Paul Valéry (1871–1945), whom Bacon both admired and sometimes quoted, wrote on the unfinished and incomplete in works of art. Valéry saw the fragment, the incomplete work, in a metaphysical context – as the reflection of the basic human condition. Bacon's statements on his own work echo Valéry's ideas and he quoted him when talking about the creation of the sensation of the work without the boredom of its conveyance. [22]

The Hugh Lane Gallery, Dublin, has six unfinished paintings by Bacon and one that has been declared a finished painting by the Estate of Francis Bacon. All seven paintings were left untitled by Bacon. These works span the artist's career from the period of his first major breakthrough in the 1940s to the last years of his life when he had attained the status of the leading figurative artist of his time. They are unique among his paintings on public display since they are incomplete and thus reveal his unorthodox techniques in their raw state. They follow Bacon's progress from first exploratory outlines to the application of intense colour and expressive modelling. Each work can be related to others

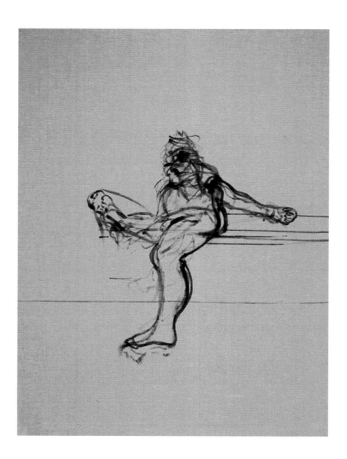

Figure 38. Francis Bacon, *'Seated Figure'*, 1978, oil on canvas, 198 × 147.5 cm; Dublin City Gallery The Hugh Lane (cat. 69)

from the painter's œuvre, and several mark important stages in his development. Unfinished works have captivated viewers for many years, and these paintings by an artist of Bacon's stature are no exception. A disarmingly simple question can be asked when approaching them: why did they remain unfinished and what makes these incomplete works so compelling to the beholder? As with the studio, the incomplete work remains as the creator left it: rather than feel regret at the incompleteness of the work, one welcomes the insight it gives into the artist's methods and thoughts when commencing major paintings. There is also a cryptic quality, because the works are ambiguous, left in a state of becoming something else. Unfinished paintings reveal, as finished works do not, how their creators went about their daily task of painting. This is of particular significance when dealing with Bacon, whose finished paintings reveal complex layers of paint surfaces.

Some of the unfinished works, such as *Untitled (Seated Figure on a Dappled Carpet)* (*c.* 1966; Dublin City Gallery The Hugh Lane), appear almost finished, although each contains an element that Bacon probably considered unresolved. The model for the painting was George Dyer and the thickly impastoed, grittily textured lilac-pink ground resembles that in *George Dyer Riding a Bicycle* (1966; Basel, Fondation Beyeler). Cross sections of Bacon's paintings often reveal major changes in direction, and the appearance of a painting could alter considerably once the outline of a composition had been drawn. A clear distinction between the treatment of the figure and background and the separation of both has been noted in Bacon's work. In paintings such as

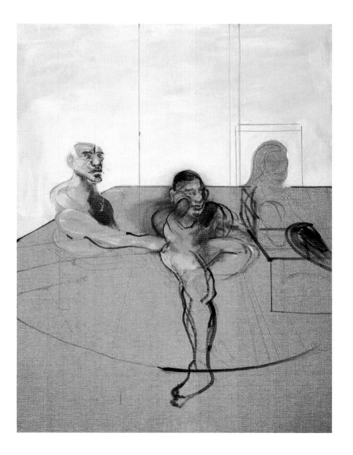

Figure 39. Francis Bacon, *Three Figures,* 1981, oil on canvas, 198 × 147.5 cm; Dublin City Gallery The Hugh Lane (cat. 70)

Francis Bacon's Studio

'Seated Figure' (1978; fig. 38) the fluid outline clearly relates to the drawings found in the studio. However, *Three Figures* (1981; fig. 39) is quite developed yet unusual in that it features three figures, two of whom can be identified as Isabel Rawsthorne and John Edwards. Furthermore, the leg for the figure on the left has been taken from the photograph of Dyer in the studio (fig. 30, p. 151), and shows how Bacon could co-opt aspects of the anatomy of one figure for another. *Figure* (1962; cat. 68) is reminiscent of the figure silhouetted against a black opening on the left-hand side of the painting *Crucifixion* (1965; Munich, Pinakothek der Moderne).

The question that arises, of course, is how would Bacon have felt about his unfinished paintings and private attempts being exhibited in public? Most artists have incomplete or abandoned works in their studios. It takes a certain amount of bravado to destroy something, and we know that Bacon did not hold back when it came to the destruction of works that he felt were unsatisfactory; one wonders, therefore, why these works were not destroyed. Finally, a distinction must be made between the work left incomplete by the death of the artist, and the ones that were simply abandoned.

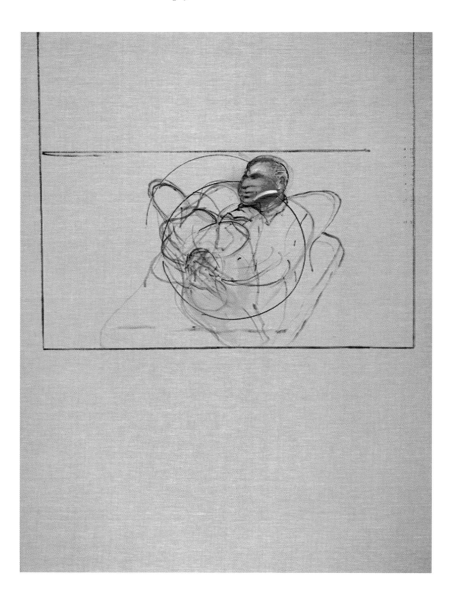

An unfinished portrait was found on Bacon's easel at Reece Mews on his death in April 1992. His sister, Ianthe Knott, recalls seeing the same work on his easel in November 1991. Despite ill health, Bacon remained determined to attempt large-scale paintings. The procedure he employed for this final canvas is familiar from his other unfinished works. The figure(s), sofa and framing device have been sketched in with paint on the unprimed surface, and one head has been brought halfway to completion. It is unclear how many figures the artist intended to include, nor is there any firm indication that he had a set composition in mind. In *'Self-Portrait'* (1992; fig. 40) the brush is still groping to find the right pose and right arrangement of figures: a fitting and apt summation of Bacon's artistic journey.

1. Michel Archimbaud, *Francis Bacon: In Conversation with Michel Archimbaud*, London, 1994. p. 163.
2. David Sylvester, *The Brutality of Fact, Interviews with Francis Bacon*, London, 1975, 1980, 1987 (Third Enlarged Edition, reprint 2012), p. 190.
3. *Francis Bacon Entretiens* (Préface de Hervé Vanel), Paris, 1996. Entretien avec Jean Claire, Maurice Eschapasse, Peter Malchus, p. 35.
4. Sylvester, p. 38.
5. Ibid., p. 30.
6. Archimbaud, p. 12.
7. Martin Harrison, *In Camera*, London, 2005, p. 146.
8. Sylvester, p. 114.
9. Ibid.
10. Margarita Cappock, *Francis Bacon's Studio*, London and New York, p. 142.
11. Sylvester, pp. 22–3.
12. David Sylvester, *Looking Back at Francis Bacon*, London, 2000, p. 108.
13. *Francis Bacon: Recent Paintings 1968–1974*, exhib. cat. (introduction by Henry Geldzahler), New York, Metropolitan Museum of Art, 1975, p. 12.
14. Sylvester, *The Brutality of Fact*, p. 21.
15. Archimbaud, pp. 88–9.
16. Interview with Melvyn Bragg, South Bank Show, London Weekend Television, 1985.
17. Sylvester, *The Brutality of Fact*, p. 90.
18. Ibid., pp. 194–5.
19. Ibid., p. 17.
20. John Rothenstein and Ronald Alley, *Francis Bacon*, London, 1964, p. 100.
21. Archimbaud, p. 163.
22. Bacon owned a copy of Paul Valery's *Monsieur Teste*, which David Sylvester gave to him with the inscription dated 29 September 1989, 'To Francis Hoping you'll understand it much better than I do and that you'll love it as much as I do.'

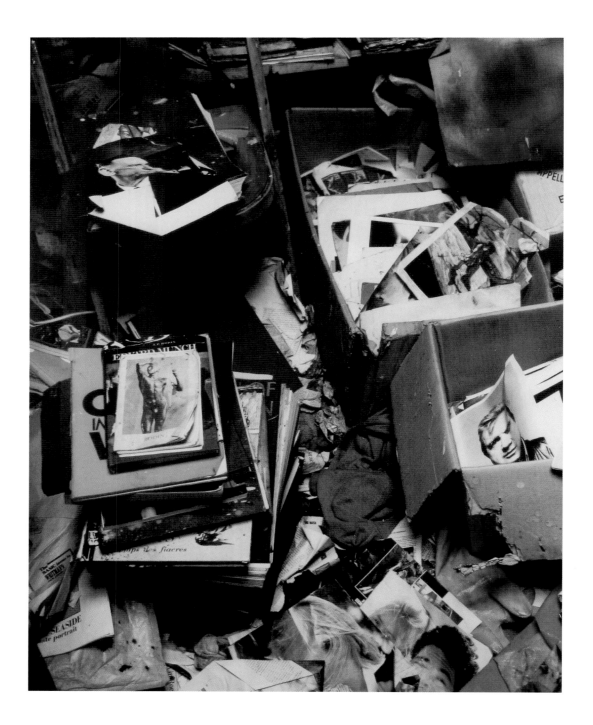

Francis Bacon's Studio, 7 Reece Mews; photograph by Perry Ogden, 1963,
C-type print on aluminium, 122 × 152.5 × 5 cm (left: 1963.05; below: 1963.08)

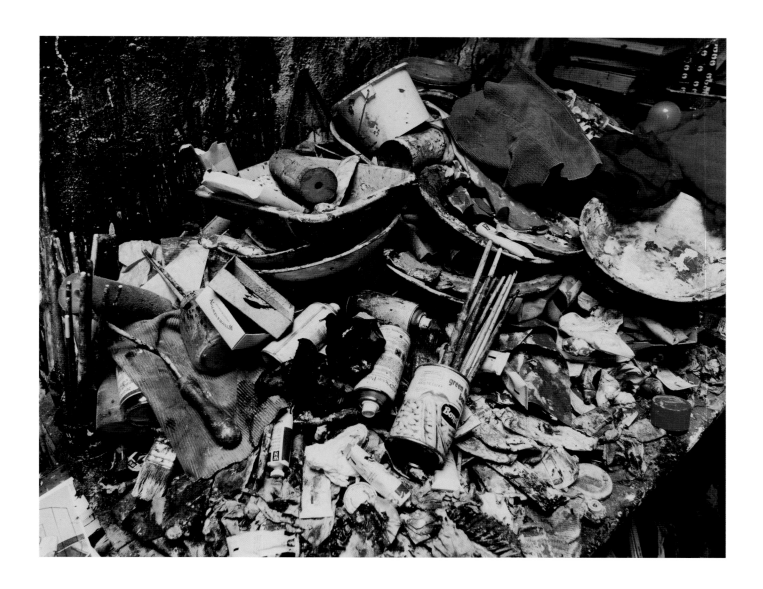

Francis Bacon's Studio Archive

No. 1

I enjoyed the exhibition, but before saying thank you to the organisers I would like to make some remarks which in my opinion are essential:
1) It was interesting to watch the video but the text was in English. luckily I speak English but what about those who don't?
2) Why were there no catalogues again? Maybe they are a luxury not accessible to Soviet visitors? It is pity that you can see the catalogue only through the glass of the show-case . I hope the organisers will pay attention to these remarks.

Marina Lazareva, student, age 30.

No. 2

Francis Bacon's paintings, in spite of their unattractiveness, help us to understand our epoch - the decay of civilisation. Our civilisation is a rotting corpse. Pathologists, arguing amongst themselves, disagree with each other as they study, dissect and prepare the corpse. They suddenly try to revive it and are happy at the stink which is given off, at the bloody scars and black spots on the decaying skin. Bacon's paintings help to understand all this and decompose it even more. Any alternative? I don't know.

Dmitriy Butorin, student, Institute
of Literature, age 21.

No. 3

We are grateful to the artist for his art: the paintings provoke complicated thoughts, though sad and gloomy. Probably life itself is the same mankind is a gigantic creature, which is swallowing itself up. The paintings attract, but at the same time it is difficult to look at them. You feel grief and the brunt of life. We have to take into the future only the best achievements of the past. Thank you, Mr. Francis Bacon, for forcing us to think about many things.

Apolonova Nadezhda Vasilyevna,
retired, age 60.

No. 4

Excellent, amazing and incredible! Indelible impression from Francis Bacon's exhibition! He is a genius!

Chernobruvkina Anna Vladimirovna,
student, school No.249, age 15.

1

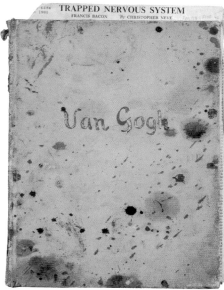

2

3

4

5

1. Translated typescript of visitor comments, Francis Bacon exhibition, Central House of Artists, New Tretyakov Gallery, Moscow, 23 September – 6 November, 1988, 29.8 × 21.1 × 0.8 cm (RM98NF213)
2. Rene Huyghe, *Van Gogh*, Milano, 1958, 28.5 × 21.5 × 1.6 cm (RM98F100:4)
3. Jose Ortega y Gasset, *Velázquez*, Paris, 1954, 29.1 × 23.3 × 2.1 cm (RM98F137:10)
4. *Rembrandt: Selected Paintings*, introduction by Tancred Borenius, London, 1952, 36 × 27 × 2.1 cm (RM98F197:2)
5. *The Art of Ancient Egypt: Architecture, Sculpture, Paintings and Applied Art* 27.2 × 19 × 3.8 cm (RM98F22:10)
6. José Lopéz-Rey, *Velázquez, A Catalogue Raisonné*, 1963, 28 × 22.5 × 5.2 cm (RM98F101:10)
7. Catalogue from an exhibition of watercolours and drawings by Wassily Kandinsky held in 1972 in Paris entitled *Kandinsky: Aquarelles & Dessins*, 22 × 11.5 cm (RM98F22:60)
8. E. R. Meijer, *Rembrandt*, London, 1960, 30.8 × 23.2 × 1.6 cm (RM98F22:6)
9. Lawrence Gowing, *Matisse 1869–1954, A Retrospective Exhibition at the Hayward Gallery*, London, The Arts Council of Great Britain, 1968, 22 × 25.3 × 1.4 cm (BB18.29)
10. Catalogue (paperback), *Watercolour and Pencil Drawings by Cézanne*, introduction by Lawrence Gowing, London, 1973, 14 × 21 cm (RM98NF106)

6

8

7

9

10

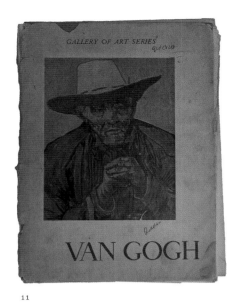

11

12

13

14

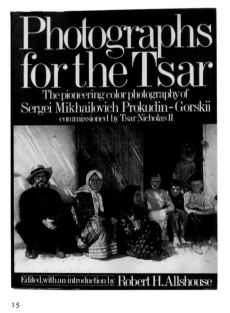

15

16

17

Francis Bacon's Studio Archive

11. Hermann Jedding, *Van Gogh*, Milano, 1950s, 25 × 33.5 × 0.4 cm (BB11.09)

12. Jean Genet, *L'Atelier d'Alberto Giacometti*, Paris, 1967, 14.4 × 19.2 × 0.7 cm (BB11.08)

13. Arnold and Marc Glimcher, *Je suis le Cahier: The Sketchbooks of Picasso*, New York, The Pace Gallery, 1986, 31.3 × 24.3 × 3.8 cm (BB3.12)

14. Anita Brookner, *Ingres*, 1965, 27 × 35.2 × 0.2 cm (BB17.03)

15. Robert H. Allshouse, *Photographs for the Tsar*, London, 1980, 22.1 × 31 × 1.5 cm (BB5.05)

16. Frédéric Rossif, Madeleine Chapsal, *Révolution D'Octobre* (front section missing), Paris, 1967, 23 × 18 cm (RM98F101:5)

17. David Levinthal and Garry Trudeau, *Hitler Moves East: A Graphic Chronicle*, 1977, 22.8 × 29 × 1.1 cm (BB3.19)

18. Leaves (bound, covers and spine missing) from Eadweard Muybridge, *The Human Figure in Motion*, Dover Publications, Inc., New York, 1955, 27.3 × 20.1 cm (RM98F105:97)

19. Mohamed Saleh and Hourig Sourouzian, *Official Catalogue of the Egyptian Museum Cairo*, 1987, 23.5 × 21.5 cm (RM98F101:4)

20. Van Deren Coke, *The Painter and the Photograph: from Delacroix to Warhol*, University of New Mexico Press, 1972, 29 × 23.2 × 3.1 cm (RM98F244:2)

21. Harrison E. Salisbury, *Russia in Revolution 1900–1930*, London, 1978, 21.5 × 30.5 × 2.3 cm (BB11.17)

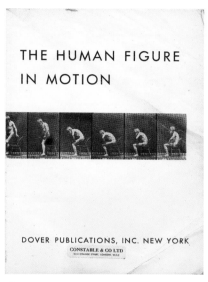

18

19

20

21

22

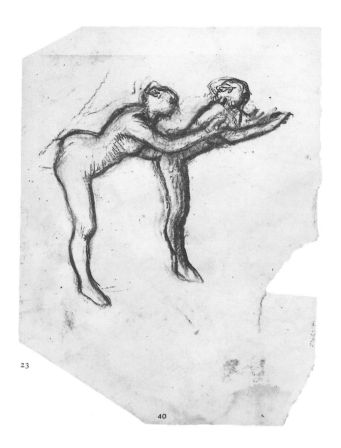

23

40

24

22. Cutting with black and white photographic illustration of the screaming woman in Eisenstein's *The Battleship Potemkin*, mounted on brown card, 16 × 17 cm (RM98F12:13)
23. Leaf (pp. 39, 40) from book by Bernard Champigneulle, *Degas, Dessins*, Paris, Éditions Des Deux Mondes, Dessins Des Grands Peintres, 1952, with black and white photographic illustrations of drawings of ballerinas by Edgar Degas, 18 × 13 cm (RM98F106:17)
24. Colour photographic illustration of an Egyptian carved head of ancient statue (pl. 19, p. 113) removed from book, *Art of the World, Egypt of the Pharaohs*, by Irmgard Woldering, London, 1965, 14.5 × 12 cm (RM98F11:42)
25. Leaf (p. 29) torn from the book *Rubens: Drawings and Sketches*, catalogue of an exhibition at the Department of Prints and Drawings in the British Museum, edited by John Rowlands, London, 1977, 21.2 × 27.6 cm (RM98F22:38)
26. Leaf from book with four-colour photographic illustrations of ancient statuary (RM98F93:22C)

25

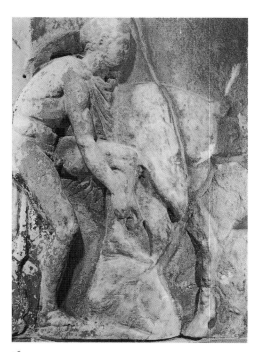

26

Francis Bacon's Studio Archive

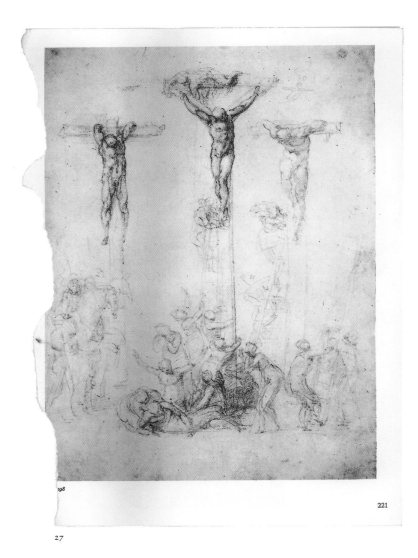

27

28

29

27. Leaf (p. 221) from catalogue with black and white images of drawings by Michelangelo: Frederick Hartt, *The Drawings of Michelangelo*, London, 1971, 31.8 × 23.5 cm (RM98F112:25D)
28. Loose colour plate (pl. 38, p. 172) of an Egyptian carved head from *Art of the World, Egypt of the Pharaohs*, by Irmgard Woldering, London, 1965, 15.6 × 9.1 cm (RM98F16:292A)
29. Title page leaf torn from Russian catalogue for Francis Bacon exhibition in the Central House of Artists, New Tretyakov Gallery, Moscow, 23 September – 6 November 1988, 30.1 × 24.3 cm (RM98F8:15)
30. Leaf (pp. 103, 104) from the French magazine *Realités*, no. 249, 1/11/1966, with article on Francis Bacon: 'Bacon: le Peintre de la Détresse Humaine', 28.3 × 21.4 cm (RM98F16:4)
31. Cut-out fragment from book leaf with photographs by Jacques Lartigue, probably *Diary of a Century*, post-1970, 16.3 × 17.7 cm (RM98F104:66)

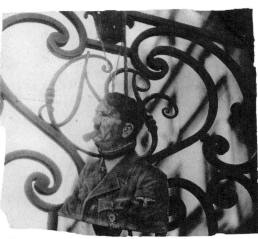

31

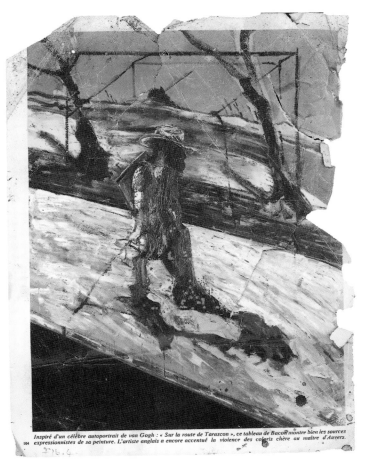

Inspiré d'un célèbre autoportrait de van Gogh : « Sur la route de Tarascon », ce tableau de Bacon montre bien les sources
104 expressionnistes de sa peinture. L'artiste anglais a encore accentué la violence des coloris chère au maître d'Auvers.

30

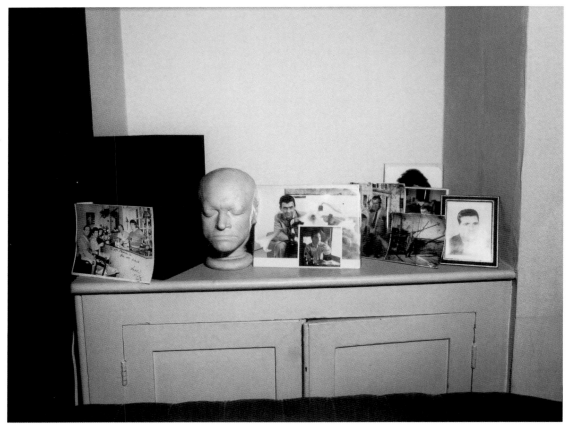

32

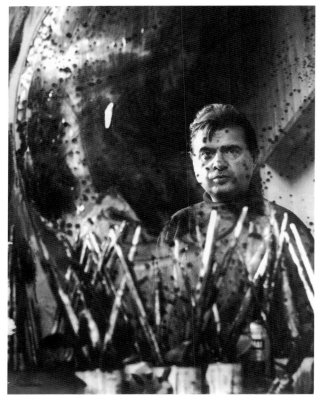

33

34

32. Francis Bacon's Studio, 7 Reece Mews; photograph by Perry Ogden, 1963, 122 × 152.5 × 5 cm (1964.04)
33. Black-and-white photograph of Francis Bacon in his Reece Mews studio, 37.1 × 28.3 cm (RM98F1A:176)
34. Colour photograph of an animal carcass cut in half, photographed by John Deakin, 8.9 × 8.9 cm (RM98F149:45G)
35. Colour photographic postcard addressed to Francis Bacon from Florence, Italy, 10.2 × 14.7 cm (RM98F129:4)
36. Plaster cast life mask of William Blake's head, 28 × 15.5 × 21.5 cm (RM98F203)
37. Canvas with uniform preparatory paint layer application, 152.3 × 119.6 × 2.4 cm (RM98F40)

35

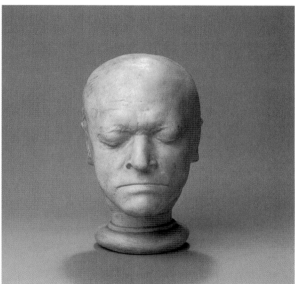

36

37

Francis Bacon's Studio Archive

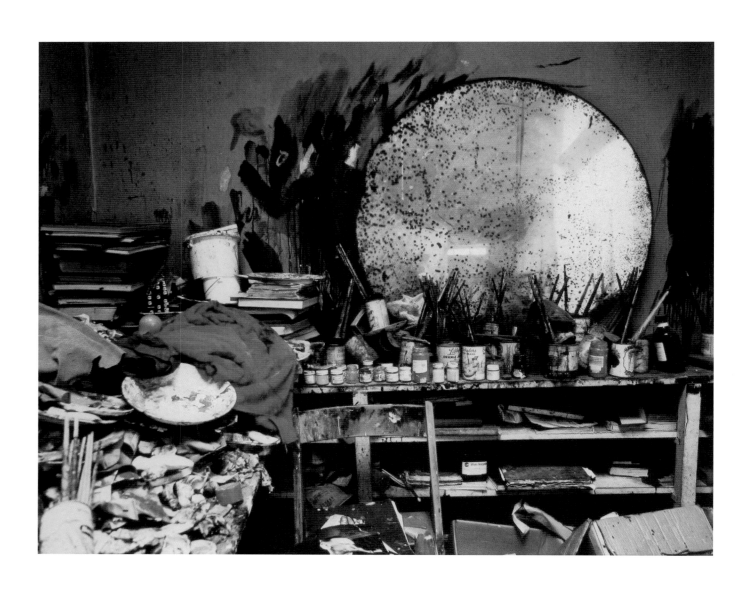

Francis Bacon's Studio Archive

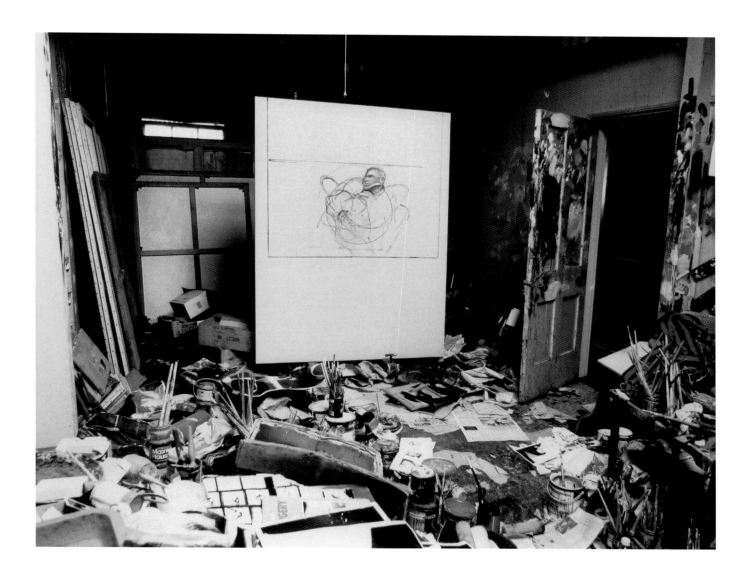

Catalogue Entries

Written and compiled by the curatorial
staff of the State Hermitage Museum,
edited by Elizaveta Renne

Ancient Orient Department
Andrey Bolshakov AB

Classical Antiquities Department
Anna Trofimova AT

Western-European Art Department
Sergei Androsov SA
Irina Artemieva IA
Alexander Babin AAB
Natalia Demina ND
Liudmila Kagané LK
Elena Karcheva EK
Albert Kostenevich AK
Irina Sokolova IS

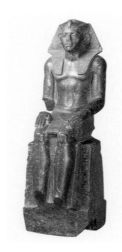

1
Statue of Amenemhat III
Reign of Amenemhat III, second half of the
19th century BC
Black granite; h. 86.5 cm

State Hermitage, inv. no. ΔB 729
Provenance: transferred in 1862 from the
 Kunstkammer (earlier history unknown)
Selected literature: Treu 1871, p. 24; Golénischeff
 1891, p. 1; Golénischeff 1893, vol. 15, pp. 131–6; Lapis,
 Matthieu 1969, p. 43, table 1 (cat. 6); Bolshakov 2008,
 pp. 23–31; Bolshakov 2009, p. 16; Bolshakov 2011,
 pp. 60–3

Royal sculpture of the Middle Kingdom offers some
of the most interesting examples in antiquity (right
up to the period of Roman portraiture) of the way
human individual characteristics were portrayed.
Although Egyptians of all periods conveyed the rul-
er's individual features, as a rule they were strongly
moderated by the conventions of the particular time.
Furthermore, the Egyptian king was considered a
being of double nature, both human and divine, and
the characteristics of divinity had to be shown to
dominate. The Middle Kingdom in this regard is an
exception. The catastrophic fall of the Old Kingdom,
and end of the dynastic succession theoretically going
back to the beginning of the world, were still fresh
in the memory, while the new statehood, although
copying the ancient prototype, was very far removed
from it. As a result portraits began to appear that
showed rulers with the world-weary faces of people
worn down and tormented by cares. The Hermitage
statue of Amenemhat III is an example of this type of
sculpture, although its psychological characteristics
are less sharply delineated than in several other mas-
terpieces of the period. Stylistically the statue is the
work of a craftsman from Lower Egypt, but judging
by the inscriptions it was made for one of the Upper
Egyptian temples where the cult of the sky goddess
Nekhbet was performed. AB

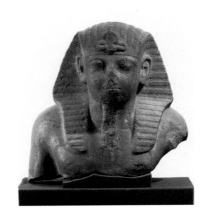

2
Upper Part of a Statue of a King
Late 18th – early 19th Dynasty, 13th century BC
Sandstone; h. 51 cm

State Hermitage, inv. no. ΔB 18240
Provenance: acquired in 1908 by Nikolai Petrovich
 Likhachev at Giza, Egypt from the trader in antiq-
 uities, Ali Abd al-Hadj; transferred in 1918 with
 entire Likhachev collection to the Archaeological
 Institute; from 1925 in the Museum of Paleography
 of the USSR Academy of Sciences; from 1930 in
 the Museum of Books, Documents and Letters of
 the USSR Academy of Sciences; from 1931 in the
 Institute of Books, Documents and Letters of the
 USSR Academy of Sciences; transferred in 1938 to
 the Hermitage
Selected Literature: Lapis, Matthieu 1969, p. 67, cat. 63

This fragment of an unfinished statue of a king raises
a few questions. His name is lost (on the back pillar
are only the first words of the royal titulary: 'King of
Upper and Lower Egypt, Lord of the Two Kingdoms'),
and the facial features are not sufficiently delineated
to make a secure identification. Nonetheless, the face
shows some resemblance with royal sculpture of the
late 18th to early 19th Dynasty. Such a dating is not
inappropriate given both the material – sandstone –
and the type of the uraeus. AB

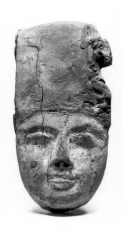

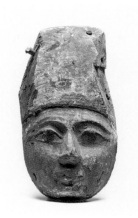

3
Face of an Anthropoid Coffin
11th – 8th century BC
Wood, painting on plaster coating; h. 24.5 cm

State Hermitage, inv. no. ΔB 2694
Provenance: acquired in 1918 as part of the collection of Senator Alexander Alexandrovich Polovtsov
Previously unpublished

While the faces of royal rulers were always individualised by the Egyptians, albeit with varying degrees of stylisation, the way private persons were conveyed – and for Egyptian culture the difference between royal and non-royal was fundamental and essential – was more specific. A certain number of extremely naturalistic portraits are known, but as a rule the depictions were generalised, showing the ideal image of man in general rather than personal characteristics. The generalised image acquired specificity with the inscription of the name of the person depicted.

Around the turn of the 3rd and 2nd millennium BC, anthropomorphic coffins began to appear, and this tradition continued right up to the end of the Pharaonic era. Since this type of coffin was seen as an indestructible imitation of the body, the most important part was the face, which was carved with the greatest possible care. As with sculpture, however, these faces were generalised, their features corresponding to the norms of the time in which they were made.

This face of a coffin, with its full lips, straight nose and subtly rendered eyes, is typical of the 21st – 22nd dynasty. Carved from a separate piece of wood, the face was fixed to the coffin by three pins. Black was the colour of Osiris, so the black face would have identified the deceased with this god of the dead. AB

4
Face of an Anthropoid Coffin
11th – 8th century BC
Wood, remnants of plaster coating, small traces of painting; h. 35 cm

State Hermitage, inv. no. ΔB 2466
Provenance: acquired by Piotr Alexandrovich Sabouroff on the island of Santorini during his term as special envoy to Greece in 1870–9; acquired by the Hermitage as part of the Sabouroff collection
Previously unpublished

This face of a coffin has similar features to another Hermitage example (cat. 3), which allows it to be dated to approximately the same time. The painting and even most of the plaster coating has been lost on the main part of the surface, although very small traces of a reddish-brown pigment have been preserved in the recesses. This shows that the face had a colour used by the Egyptians to convey the tanned skin of men (the skin of women, who were less exposed to the sun, was depicted in yellow). AB

5
Face of an Anthropoid Coffin
1st millennium BC
Wood, painting on plaster coating; h. 30 cm

State Hermitage, inv. no. ΔB 782
Provenance: came to the Hermitage before 1891
Previously unpublished

This face offers an example of another typical paint colour – here a green pigment is used. Like black, green was the colour of Osiris, the colour of vegetation and hence of rebirth to new life. AB

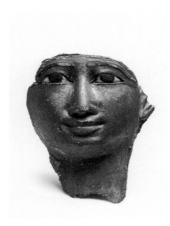

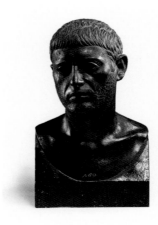

6
Fragment of a Mummy Mask
10th – 9th century BC
Cartonnage, painting on plaster coating; h. 22 cm

State Hermitage, inv. no. ΔB 18798
Provenance: transferred from Lvov Historical Museum
 in 1952
Previously unpublished

Faces were not only depicted on anthropoid coffins
but also on masks placed on the heads of mummies.
This mask is made of cartonnage that comprises
several layers of cloth glued together, covered with
plaster and painted. Stylistically it is similar to masks
created under Libyan rule in Egypt – a time of the
utmost flourishing of coffins and cartonnages. AB

7
Fragment of a Mummy Mask
1st century BC – 1st century AD
Cartonnage, gilded; h. 14.5 cm

State Hermitage, inv. no. ΔB 5056
Provenance: came to the Hermitage before 1939
Previously unpublished

The tradition of mummy masks continued even after
Egypt was conquered by the Macedonians and then
the Romans. Around the turn of the new millennium
there was a huge change in the history of the mask: it
began to be replaced by the so-called Fayum portrait
– a figurative portrait painted on a flat wooden board.
In artistic terms these mummy portraits were already
wholly part of the classical tradition. This change,
however, did not lead to a rejection of the mask in its
particularly Egyptian form, and the lavish use of gild-
ing was a particular feature of this period, gold being
the flesh of the gods. AB

8
Portrait of a Roman
Rome, 50 – 40 BC
Bronze; h. overall 39 cm; h. of head 23.7 cm

State Hermitage, inv. no. ГР 11234 (inventory B 2067)
Provenance: came to the Hermitage via the State
 Museum Fund in 1928
Selected literature: Schweitzer 1948, p. 123,
 Abb. 190–1; Vostchinina 1977, p. 13, no. 4;
 Trofimova 2006, pp. 138–9

The extraordinary intensity of this portrait's emo-
tional power makes it one of the great masterpieces of
classical portraiture. It is also very rare, since very few
portrait busts in bronze have survived. Its superb con-
dition reveals the technical abilities of a sculptor who
was clearly a true master in working with bronze.

The Roman's head is thrown slightly back and to the
left, echoing the composition of early Hellenistic por-
trait statues. The muscles of the neck and collarbone
are worked in relief, emphasising the bust's solid
construction and at the same time conveying a sense
of impetuosity. The wide-open eyes are empty: the
eyeballs would have been affixed into the cavities sep-
arately and have not survived. The deep wrinkles in
the face create strong shadows, while the worry lines
around the lips and somewhat sombre tone of the
bronze give the portrait a suffering, tragic air. In style
the portrait is laconically and simply executed, which
makes these features all the more distinctive. The
head can be seen as representing a type – a movement
in portraiture towards generalisation.

It seems likely that this is a portrait of a man in
mourning. The Roman is depicted unshaven, and
it was ancient Roman custom not to shave their
beards when grieving over the death of relatives or
marking a tragic national event. The work has been
identified as that of a sculptor of the early Augustan
period (Schweitzer 1948, pp. 120–7,), and Alexandra
Vostchinina dated the bust to the last quarter of the
first century BC (Vostchinina 1974, p. 138, no. 4). In
the light of recent discoveries, however, it seems that
the Hermitage bust is closer to a group of objects of a
slightly earlier date – between 50 and 40 BC. Its stylis-
tic analogies – a portrait of Marcus Porcio Cato, found
in North Africa (Simon 1986, p. 59, no. 65), and a por-
trait of Octavianus Augustus from Arles ('the bearded
man') (Simon 1986, p. 57, no. 62) – are considered to be
works of late Republican classicism. AT

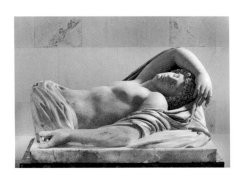

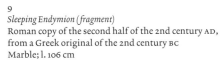

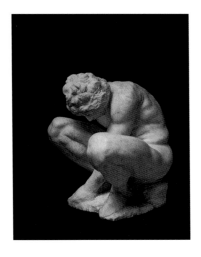

9
Sleeping Endymion (fragment)
Roman copy of the second half of the 2nd century AD, from a Greek original of the 2nd century BC
Marble; l. 106 cm

State Hermitage, inv. no. ГР 1700 (inventory A 2)
Provenance: came to the Hermitage as part of the Lyde Browne collection in 1787; previously in the Palazzo Barberini in Rome
Selected literature: Catalogus Lyde Browne 1768, no. 75; Catalogo Lyde Browne 1779, no. 42; Ficoroni 1744, II. 53; RR III, 122, 8; Kizeritskii 1901, no. 13; Val'dgauer 1923, no. 37; Waldhauer 1931, no. 165, pp. 51–2

This fragment of a statue of a youth is part of a sculptural group comprising the sleeping Endymion and Selene who is looking at him. The scene is taken from the ancient Greek myth of Selene, goddess of the moon, who falls in love with the young Endymion and asks Zeus to grant him immortality. Zeus plunges Endymion into a deep sleep, and in such a way he remains eternally young, enabling Selene to spend the nights with him admiring his beauty. The myth was widely used on sarcophagus reliefs, as a symbol of immortality. In the Hellenistic period the depiction of sleeping mythological figures became part of the repertoire of three-dimensional sculpture. Surviving examples include statues of a sleeping satyr, Eros, Hermaphroditus, Ariadne, as well as Endymion. It appears that Hellenistic sculptors were attracted to the subject not just by the metaphorical, but also the erotic, subtext. The open composition is intended to engage the viewer in a kind of dialogue: Endymion's relaxed pose, his arm stretched out behind his head, invites the viewer to join the goddess of the moon in looking at the sleeping youth. Unlike the more self-contained sculptures of the Classical period, Hellenistic sculptural groups often include an imagined third party, and allow the viewer to conjecture on what is taking place beyond the subject's mythological parameters. The border between the space of the work of art and that of the viewer can seem to dissolve – something that really only happens again in art much later, for example in seventeenth-century Baroque painting and sculpture. AT
Exhibited at State Hermitage Museum only

10
Head of a Youth from the Sculptural Group 'The Death of Laocoön' (fragment)
Roman copy of the late 2nd century AD, from a Greek original by Agesander, Athenodoros and Polydorus of the 2nd century BC
Rhodes School
Marble; h. 23 cm

State Hermitage, inv. no. ГР 1724 (inventory A 46)
Provenance: came to the Hermitage as part of the Lyde Browne collection in 1787; previously in the Palazzo Barberini in Rome
Selected literature: Catalogus Lyde Browne 1768, no. 70; Catalogo Lyde Browne 1779, Teste, no. 6; Helbig 1867, no. 128; Kizeritskii 1901, no. 172; Val'dgauer 1923, no. 86; Waldhauer 1931, no. 170, p. 54; Davydova 2003, pp. 260–9

The head of a man would originally have been part of a figure belonging to a sculptural group. The unusual angle and unnatural twist of the neck show that the figure was depicted in violent motion. The expression of terror and suffering, along with the element of pathos in the way the plastic forms are treated, have led scholars to conclude that the head would have formed part of a Hellenistic composition depicting a subject from Homer. There have, however, been several suggestions as to exactly whom the figure might represent: the dying Achilles; the wounded Ajax; Thersites, Odysseus's companion who was seized by Scylla; or the younger son of Laocoön who was bitten by sea serpents. It is also possible that the Hermitage head is linked to the depiction of Laocoön's elder son from a group based on the original composition by the Rhodian sculptors Athenodoros, Agesander and Polydorus. Sculptural groups depicting Homeric subjects were found in Pergamon, Rhodes in Asia Minor, and other Hellenistic centres. In the Roman period such compositions decorated imperial villas and gardens, like the impressive ensemble of colossal groups in the grotto of Tiberius's Villa at Sperlonga. Sculptures have survived in numerous fragments, now spread throughout the world's museums, and it is not unusual for the figures to get misidentified – the faces of Homeric heroes in these groups are very similar. Amongst the Hellenistic depictions of 'pathetic' figures, the 'suffering Homeric hero' became to a certain extent an artistic cliché. This type of pathos created by Hellenistic sculptors and artists had an unprecedented impact on European art. From the Renaissance onwards it was echoed in painting and sculpture, becoming in the eighteenth century the subject of treatises on aesthetics. AT

11
Crouching Boy
1530–4
Michelangelo Buonarroti
1475, Caprese–1564, Rome
Marble; h. 54 cm

State Hermitage, inv. no. Н.ск. 154
Provenance: came to the Hermitage from the Museum of the Academy of Arts, St Petersburg, in 1851
Selected literature: 'L'Adolescente dell'Ermitage e la Sagrestia Nuova di Michelangelo', Catalogo della mostra a cura di U. Baldini e S. Androsov, Siena, 2000

This sculpture was first mentioned in 1779 in the collection of Lyde Browne in Wimbledon, where it was listed as a work by Michelangelo that had previously been in the collections of the Medicis. In 1785 the Lyde Browne collection was acquired by Catherine II, but it was only in 1851 that *Crouching Boy* took its deserved place in the Hermitage.

For many years the statue was directly linked with Michelangelo's work on the Medici Chapel, and dated to around 1524. This was based on a sketch by the great master that related to the initial phase, in which similar crouching figures can be seen in niches at the top (London, British Museum). But this hypothesis brings into question Michelangelo's authorship since it would seem strange to start work on a secondary statue that was then completely excluded from the project. In our view the superb quality of the Hermitage statue undoubtedly confirms the traditional attribution, and it is entirely possible that an idea Michelangelo had around 1524 was only created in marble some time later – between 1530 and 1534, possibly for some other purpose. SA
Exhibited at State Hermitage Museum only

Sainsbury Centre:
Plaster cast of a crouching Boy
c. 1884
After the marble original in the State Hermitage, St Petersburg
Plaster; h. 54 cm
The Victoria & Albert Museum

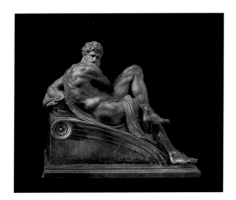 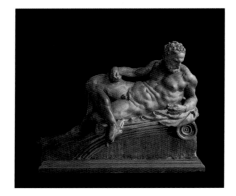

12
Day
Second half of the 16th century
From an original by Michelangelo Buonarroti
1475, Caprese – 1564, Rome
Terracotta; h. 51 cm, l. 56 cm

State Hermitage, inv. no. H.ск. 558
Provenance: in the collection of Filippo Farsetti in
 Venice from the middle of the 18th century; pre-
 sented by Anton Francesco Farsetti to the Russian
 Emperor Paul I in 1800; in the Museum of the
 Academy of Arts in St Petersburg until 1919; came
 to the Hermitage in 1919
Selected literature: Androsov 2006, p. 66, no. 3;
 Androsov 2008, p. 69, no. 51

This statuette, which was listed in the Farsetti
Collection as a work by Michelangelo, is a modified
copy of the marble statue *Day* in the Capella Medici
in Florence, which dates to around 1526–31. The work
is notable for its high-quality execution, although in
the light of contemporary research it cannot in any
way be confirmed as being by Michelangelo. It is inter-
esting that the face of *Day*, which in the large-scale
work is unfinished, has here been completed by an
unknown artist. The treatment of the facial features,
reminiscent of images by Vincenzo de Rossi, suggests
that the Hermitage copy may have been executed
relatively early, probably at the end of the sixteenth
century. SA

13
Evening
Second half of the 16th century
From an original by Michelangelo Buonarroti
1475, Caprese – 1564, Rome
Terracotta; h. 50 cm, l. 68 cm

State Hermitage, inv. no. H.ск. 2500
Provenance: in the collection of Filippo Farsetti in
 Venice from the middle of the 18th century; pre-
 sented by Anton Francesco Farsetti to the Russian
 Emperor Paul I in 1800; in the Museum of the
 Academy of Arts in St Petersburg until the 1970s,
 from where it came to the Hermitage
Selected literature: Androsov 2006, p. 67, no. 4;
 Androsov 2008, p. 69, no. 53

Although this statuette came to the Hermitage
relatively late, from the museum of the Academy of
Arts, there is no doubt that it is a pair to *Day* (cat. 12),
and comes from the Farsetti Collection, where it was
ascribed to Michelangelo. It is a copy of the statue
Evening from the Capella Medici in Florence, which
dates to around 1524–31. Although modern research
means that Michelangelo's authorship must now
be refuted, there is no doubt about the high quality
of the work. Like its pair, *Day*, it may be dated to the
second half of the sixteenth century. SA

14
Sleeping Hercules
16th century
Baccio Bandinelli
1493, Florence – 1560, Florence
Marble; 56 × 27 cm

State Hermitage, inv. no. H.ск. 1669
Provenance: in the collection of Count Alexander
 S. Stroganov in St Petersburg at the end of the 18th
 century; came to the Hermitage from the Stroganov
 Palace Museum in 1930.
Selected literature: Androsov 1973, p. 12; Androsov
 2008, pp. 70, 71, no. 55

This small, irregular bas-relief in marble shows
Hercules asleep. Alongside him are the hero's main
attributes: his club and lion skin. Evidently he is
shown at rest after his labours. The relief was pub-
lished by Sergei Androsov with the suggestion that
it should be attributed to Baccio Bandinelli, a rival
of Michelangelo. Certainly the sense here of slightly
exaggerated sculptural emotion can be found in
Bandinelli's work. It is above all reminiscent of the
marble reliefs portraying the prophets in the choir
of the Cathedral of Santa Maria del Fiore in Florence –
a late work by Bandinelli – as well as some of his
drawings. A further factor that points to this attribu-
tion is that in the collection of Alexander Stroganov
Sleeping Hercules was attributed to Michelangelo.

What remains unclear is the purpose of the relief.
In our view it might have been used as a small-scale
headstone, or it may have decorated the garden
of an Italian art lover, where it could possibly have
stood alongside fragments of antique statues and
sarcophagi. SA

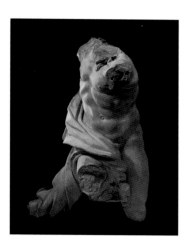

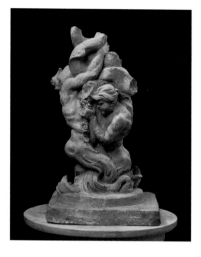

15
Torso of Neptune
1620
Gian Lorenzo Bernini
1598, Naples – 1680, Rome
Terracotta; h. 37 cm

State Hermitage, inv. no. Н.ск. 679
Provenance: in the collection of Filippo Farsetti in
Venice from the middle of the 18th century; pre-
sented by Anton Francesco Farsetti to the Russian
Emperor Paul I in 1800; in the Museum of the
Academy of Arts in St Petersburg until 1919; came
to the Hermitage in 1919
Selected literature: Kosareva 1993, pp. 82–4; Androsov
2006, p. 77, no. 11; Androsov 2014, p. 46, no. 14

This badly damaged torso was identified by Nina
Kosareva as a model for the monumental marble
group *Neptune with Triton*, commissioned from Bernini
by Cardinal Alessandro Peretti Montalto between
March 1622 and February 1623 (now in London,
Victoria & Albert Museum). Although the composi-
tional similarities are undeniable, some scholars are
inclined to see this work as a copy from an original by
Bernini. This is clearly why it has not been included in
the latest catalogue of Bernini's terracotta models and
bozzetti (*Bernini: Sculpting in Clay* 2012).

Nevertheless, the expressive treatment of the naked
body points to the work being an original model,
although it does not have the virtuosity of Bernini's
late models. Furthermore, it is apparent that the
manner of execution here is close to that of the *Torso
of Pluto*, also in the Hermitage (cat. 16). It is quite
possible, therefore, that we are dealing with a fairly
advanced and well-worked model, which may have
appeared at the final stage of the work. One more
argument in favour of attributing the work to Bernini
is that this statuette is listed under his name in early
inventories. SA

16
Torso of Pluto
c. 1621
Gian Lorenzo Bernini
1598, Naples – 1680, Rome
Terracotta; h. 38 cm

State Hermitage, inv. no. Н.ск. 678
Provenance: in the collection of Filippo Farsetti in
Venice from the middle of the 18th century; pre-
sented by Anton Francesco Farsetti to the Russian
Emperor Paul I in 1800; in the Museum of the
Academy of Arts in St Petersburg until 1919; came
to the Hermitage in 1919
Selected literature: Kosareva 1993, pp. 84–91; Androsov
2006, p. 74, no. 10; Androsov 2014, p. 45, no. 17

The attribution of this fragment of a statuette was also
made by Nina Kosareva, who noted its closeness to
the monumental marble group *The Rape of Proserpina*
(c. 1621–2; Rome, Borghese Gallery). Stylistically it is
close to the *Torso of Neptune* (cat. 15), although it may
be assumed that the form for this work was taken
from a previous model and then developed by the
sculptor. This explains the fact that the statuette is
hollow inside, while its front part, to which the figure
of Proserpina would have been attached, has been lost.
This work is also not listed in the latest catalogue of
Bernini's works in terracotta (*Bernini: Sculpting in Clay*
2012). Nevertheless, the high quality of the statu-
ette's execution, particularly noticeable when viewed
from behind, as well as its stylistic similarities with
the *Torso of Neptune*, allow us to consider it a work by
Bernini, possibly dating to around 1621. This attribu-
tion is confirmed by listings in the old inventories of
the Farsetti Collection. SA

17
Tritons Holding Dolphins
c. 1652
Gian Lorenzo Bernini
1598, Naples – 1680, Rome
Terracotta; h. 47.5 cm

State Hermitage, inv. no. Н.ск. 602
Provenance: in the collection of Filippo Farsetti in
Venice from the middle of the 18th century; pre-
sented by Anton Francesco Farsetti to the Russian
Emperor Paul I in 1800; in the Museum of the
Academy of Arts in St Petersburg until 1919; came
to the Hermitage in 1919
Selected literature: Androsov 1989, p. 69; Androsov
2006, p. 82, no. 14; *Bernini: Sculpting in Clay* 2012,
pp. 168–70, no. 12; Androsov 2014, p. 52, no. 21

The attribution of this composition was made by
Sergei Androsov in 1989. It is undoubtedly related
to Bernini's work on the plan for the fountain in
the Piazza Navona in Rome between the end of 1651
and the beginning of 1653. Bernini himself wrote
about ordering marble for this fountain: 'The marble
required to make a group of two tritons and four fish
will cost about 290 *scudi*...'. Other evidence of Bernini's
work on this design can be found in a sketch in the
Royal Library, Windsor, and a damaged terracotta
group (Berlin, State Museums). In May 1653 Pope
Innocent X approved a different plan for the fountain
on Piazza Navona with a figure of a standing Moor (the
fountain which exists today), and work on this model
ceased. Although there can be no doubt about the
overall similarities between the works in St Petersburg
and Berlin, the latter work is more striking. This is
presumably why the authors of a catalogue of Bernini's
works in clay have ascribed the Hermitage group to an
assistant of Bernini. Nevertheless, the quality of exe-
cution in the Hermitage work is extremely high and
worthy of the hand of Bernini. SA

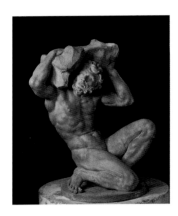

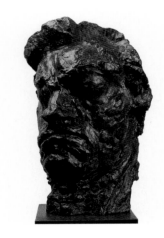

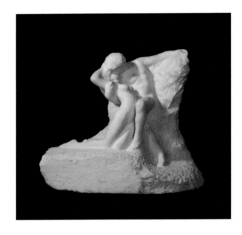

18
Titan
c. 1650
Alessandro Algardi
1598, Bologna – 1654, Rome
Terracotta; h. 36.5 cm

State Hermitage, inv. no. H.ск. 656
Provenance: in the collection of Filippo Farsetti in
 Venice from the middle of the 18th century; pre-
 sented by Anton Francesco Farsetti to the Russian
 Emperor Paul I in 1800; in the Museum of the
 Academy of Arts in St Petersburg until 1919; came
 to the Hermitage in 1919
Selected literature: Androsov 1983, p. 81; Androsov
 2006, p. 124, no. 40; Androsov 2014, p. 83, no. 49

This statuette is traditionally attributed to Algardi,
beginning with the early inventories of the Farsetti
Collection. The attribution was confirmed by Olga
Raggio, who noted in 1974 that a similar figure is
supporting Jupiter in a bronze trivet made by Algardi
and his workshop at the beginning of the 1650s for the
Spanish court (formerly located in the Royal Palace
in Aranjuez). The statuette was published as a work
by Algardi by Sergei Androsov in 1983, an attribu-
tion with which Jennifer Montagu agreed in 1985.
Certainly the similarity between the Hermitage terra-
cotta and the bronze figure of the trivet is undeniable.
The high artistic qualities of the Hermitage *Titan* are
similarly evident, and can be seen in the extraordi-
narily precise and at the same time delicate treatment
of the naked figure of the athlete. SA

19
Ludwig van Beethoven. Grand Masque Tragique
Early 20th century
Émile-Antoine Bourdelle
1861, Montauban – 1929, Le Vésinet (Département
de Seine-et-Oise)
Bronze; h. 76 cm
Signed on the left by the truncation of the neck:
Bourdelle; foundry mark on the right by the truncation
of the neck: *CIRE / A. VALSUANI / PERDUE*; next to the
foundry mark, the monogram of the sculptor: *EAB*
(intertwined)

State Hermitage, inv. no. H.ск. 2429
Provenance: in the collection of the sculptor's
 daughter, Rhodia Dufet-Bourdelle; came to the
 Hermitage in 1973, acquired after an exhibition
 of Bourdelle's work in the USSR in 1972
Selected literature: Hermitage 1988, p. 336, no. 420;
 Kostenevich 2008, vol. II, p. 181, no. 468

The tragic fate of Ludwig van Beethoven (1770–1827),
the great German composer, conductor and pianist,
first caught Bourdelle's attention when he was a
child. The future sculptor happened to see a por-
trait of Beethoven in the window of a bookshop
in Montauban; he was struck by the depth of the
portrait, and by his own uncanny likeness to the com-
poser. Throughout his life Bourdelle felt a spiritual
closeness to Beethoven, and he tried to create a statue
that would reveal and convey as precisely as possible
the extraordinary personality of the great musician.
The sculptor began work on the first version of the
head as early as 1887, and one of his last works, also
dedicated to Beethoven (*La Pathétique. Beethoven à la
Croix*), appeared the year he died. Over forty years,
therefore, Bourdelle made several dozen sculptural
and graphic portraits of Beethoven, in which he strove
to convey not just an iconographic similarity, but also
the essence of his artistic character.

The model for the *Grand Masque Tragique* dates
from 1901. Beethoven's face, with its knitted brows,
apparently quivering nostrils, thick pursed lips and
trembling chin, is imbued with expression and inner
strength; for all the deformation of form, the musi-
cian's features have been retained. The sculpture was
cast in bronze no less than ten times. The first cast
was made in the workshop of Alexis Rudier, and now
belongs to the Wallraf-Richartz-Museum in Cologne
(where it is exhibited in the Cologne Opera House).
Original bronze casts can also be seen in the
Museum of Modern Art in New York, the Philhar-
monia Hall in New York and other museums and
private collections. EK

20
Eternal Spring
c. 1906
Auguste Rodin
1840, Paris – 1917, Meudon
Marble; h. 77 cm
Signed on the right on the base near the right foot of
the youth: *A. Rodin*

State Hermitage, inv. no. H.ск. 1298
Provenance: in the collection of Stepan Petrovich
 and Varvara Sergeyevna Yeliseyev, St Petersburg/
 Petrograd, from 1906 to 1917; came to the Hermitage
 in 1923 from the House of Arts (former Yeliseyev
 House) in Petrograd
Selected literature: Zaretskaia, Kosareva 1960, no. 68;
 Zaretskaia, Kosareva 1963, p. 19, nos. 114, 115; Kosareva
 1967, n.p.; Latt 1987, n.p.; Hermitage 1988, p. 335,
 no. 417; Kostenevich 2008, vol. II, p. 181, no. 468

In 1880 Rodin received an official commission for a
sculptural composition for the main doorway of the
building of the Museum of Decorative Arts, then being
planned for construction in Paris. Inspired by Dante's
Divine Comedy and Charles Baudelaire's *Les Fleurs du Mal*,
the sculptor conceived his most complex composition,
The Gates of Hell, which included a multitude of separate
human figures and groups – both literary heroes and
characters born of the artist's imagination. One of the
work's most important themes was love, and lovers con-
demned to eternal suffering were portrayed by Rodin
in various poses and emotional states. The first sketches
for the group later known as *Eternal Spring* date from the
early 1880s, but it was not included in the final version
of *The Gates of Hell*. Only the bent female figure in the
gates' tympanum is reminiscent of the group.

Eternal Spring as a stand-alone bronze group was first
shown in the Salon of 1898; at the time, though, it was
called *Cupid and Psyche* (Paris, Musée Rodin). Indeed,
behind the youth's back small winglets can be seen, as
if cut off. The composition has changed its name more
than once. It was known variously as *Zephyr and Earth*,
Youth, *Ideal*, and only latterly as *Eternal Spring*. Two
naked human figures intertwined in a burst of passion
became a favourite sculptural motif in Rodin's work; he
produced numerous variations on the theme, starting
with *The Kiss* (1886).

The work was produced in marble on at least six occa-
sions. The Hermitage group, created for the Petersburg
merchant Stepan Yeliseyev and his wife Varvara under
the title 'L'Amour vainqueur' ('Conquering Love'),
was produced in marble before 1906. Apart from the
marbles and several plaster copies of the group, there
are also a large number of bronze casts of *Eternal Spring*
of various sizes, now in different museums and private
collections. EK

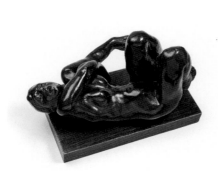

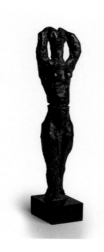

21
Study for The Sinner (The Repentant)
First half of the 20th century
Auguste Rodin
1840, Paris – 1917, Meudon
Bronze; h. 20 cm, l. 37 cm, w. 25 cm
Signed on the left side of the figure: *A. Rodin*; inscribed
further right on the back of the figure: © *by musée
Rodin 1966*; foundry mark on the right side of the back:
Georges Rudier / Fondeur Paris

State Hermitage, inv. no. H.ск. 2397
Provenance: came to the Hermitage in 1968 (as a gift
from the Musée Rodin in Paris)
Selected literature: Berezina 1971, p. 80; Latt 1987, n.d.;
Kostenevich 2008, vol. II, p. 193, no. 499

The model for *The Sinner*, as for *Eternal Spring*, was cre-
ated by Rodin during his work on *The Gates of Hell*, the
main portal for a proposed new Museum of Decorative
Arts in Paris. Rodin received this commission from the
state in 1880, and worked on it for the rest of his life.
The Gates of Hell remained unfinished, but the project
incorporated many of Rodin's ideas and concep-
tions. A whole series of figures and groups initially
conceived for *The Gates of Hell*, such as *The Thinker*, *The
Three Shades* and *Eve*, were later to become known as
stand-alone works, and were repeated more than once
in different materials.

The study for *The Sinner* does not have a precise date,
although the majority of the compositions for *The
Gates of Hell* were created in the 1880s. Rodin placed
The Sinner, lying on her back, in the upper part of the
Gates to the right of the feet of *The Thinker*, past whom
flit shadowy figures. The doubled-up naked figure
with her head thrown back became an embodiment
of the intolerable spiritual torment and misery of the
human condition, deprived of all hope.

The bronze cast of the study for *The Sinner* was given
to the Hermitage by the Musée Rodin as thanks for
preserving the works of the great sculptor. EK

22
Standing Nude (Katia)
1958
Henri Matisse
1869, Le Cateau-Cambrésis – 1954, Nice
Bronze; h. 45 cm
Sculptor's monogram behind the left foot: *HM*; below
on the base the cast number *5/10*; foundry mark on the
back of the base: *CIRE / C.VALSUANI / PERDUE*

State Hermitage, inv. no. H.ск. 2486
Provenance: in the collection of the artist's daughter
Marguerite Duthuit-Matisse, 1958–78; came to the
Hermitage in 1978 as the gift of Mme Marguerite
Duthuit-Matisse and her son Claude Duthuit
Selected literature: Matisse 1984, p. 197 (with preced-
ing bibliography); Duthuit 1997, p. 238; Kostenevich
2008, vol. II, pp. 190–1

Standing Nude (Katia), named after the model who sat
for it, was created in clay in Nice in 1950. However,
it was only given to a foundry for translation into
bronze several years later. Over the years the clay had
dried out, and the figure split around the waist. This
unexpectedly created its own particular sculptural
effect, which made the work even more expressive –
and also gave rise to the sculpture's other title, *La Taille
cassée* ('Broken Waist').

Art historians have often observed that Matisse was
one of the first sculptors to seek greater expression
through the deformation of form. The motif of the
naked figure with her hands raised behind her head
first appeared in Matisse's work as early as the 1900s
(for example, in the painting *Le Bonheur de Vivre*,
1905–6; Merion, Pennsylvania, Barnes Foundation),
and also in the sculpture *Nu debout, bras sur la tête*
(1906), a bronze cast of which is in the Hermitage. He
continued to explore the theme right up to the 1950s.

Standing Nude (Katia) was cast at the famous Fonderie
C. Valsuani in France in an edition of ten, not count-
ing zero, the test cast. The Hermitage sculpture, to
judge from the numbers on the base, is the fifth. It was
made in 1958. The majority of the casts from this edi-
tion have found their way into private collections. A
clay sculpture is kept at the Musée Matisse in Nice. EK

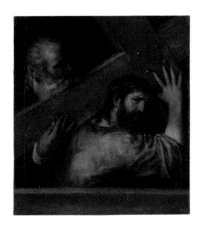

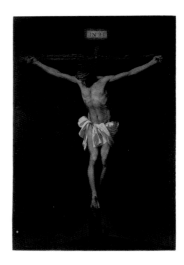

23
Christ Bearing the Cross
1566–70
Titian (Tiziano Vecellio)
1488/90, Pieve di Cadore–1576, Venezia
Oil on canvas; 89 × 77 cm (with extensions)

State Hermitage, inv. no. ГЭ 115
Provenance: came to the museum as part of the
 Barbarigo Gallery collection in 1850
Selected literature: Artemieva 2007, pp. 186–7
 (with bibliography)

In his late period Titian often turned to dramatic reli-
gious subjects. This was not just because in 1563 the
Council of Trent severely limited the range of subject
matter that was deemed worthy of representation, but
also because the artist's own world view had changed.
In his later years Titian began to sense the tragic
aspects of life very keenly, and his brush conveyed his
own personal experiences with great intensity. It was
at this time that such works as the Hermitage's *Christ
Bearing the Cross* were painted. Tears are welling up in
Christ's eyes, drops of blood from the thorn-pricks
run down his forehead and temple. With remarkable
skill, Titian was able to lay bare a whole world of deep
emotions, a world at the centre of which is a man who
remains sublime even in his greatest suffering.

The Hermitage painting is nearly identical to another
version of the composition, signed by Titian, which
is in the Prado in Madrid. An X-ray of the Petersburg
work has shown that Titian used a canvas that
originally depicted 'Christ Blessing'. For the new
composition the artist extended the canvas to the
left. Extensions at the top and bottom appeared later
– no earlier than the eighteenth century. The artist's
alterations are now also clearly visible: Titian changed
the position of Simon of Cyrene's index finger. All this
would suggest that the Hermitage version predated
the Madrid painting, for which it would have served
as a model. Since the picture was clearly not intended
for sale, it remained in the artist's studio and was
acquired, along with all the other works found there,
by the Venetian patrician Cristoforo Barbarigo in
1581. Carlo Ridolfi saw *Christ Bearing the Cross* in the
Barbarigo collection in 1648, and he recorded that
Simon of Cyrene was based upon Francesco Zuccato,
known as 'dal Mosaico' – a member of a famous
Venetian family of artist-mosaicists. Titian studied
under Sebastiano Zuccato, and was a lifelong friend of
the family. The Hermitage version of *Christ Bearing the
Cross* is painted in a very similar manner to the Madrid
painting, and is of a similarly high quality. It can be
dated to between 1566 and 1570. IA

24
The Crucifixion
c. 1636–8
Alonso Cano
1601, Granada–1667, Granada
Oil on canvas; 265 × 173 cm

State Hermitage, inv. no. ГЭ 5572
Provenance: came to the Hermitage from the collec-
 tion of Grand Duke Konstantin Konstantinovich,
 Marble Palace, Petrograd, in 1919
Selected literature: Kagané 2005, pp. 394–7,
 410, 424–5, no. 20; Kagané 2008, no. 25 (with
 bibliography)

Alonso Cano depicts the crucifixion, one of the most
tragic episodes in the Gospels, in the severe, austere
manner characteristic of Seville painting in the first
half of the seventeenth century. The brightly lit, lonely
figure of the dead Christ, head drooping, his side
pierced, stands out against a dark background that
is only relieved by the purplish glow of the horizon.
It is through the contrast of light and shade that the
painting as a whole achieves its dramatic effect. The
skill with which the artist employs the chiaroscuro
technique is also seen in the details, such as the virtuo-
so rendition of the folds of the white loincloth.

It seems likely that this picture was painted by Cano
between 1636 and 1638 for the retable of the Church
of Santa Maria de la Oliva in Lebrija, but was later
replaced by a sculpture based on a wooden model, also
by Cano.

The painting was acquired as being by Velázquez;
later it was considered to be the work of Alonso Cano,
and was also attributed to Francisco de Zurbarán until
finally it was again given the attribution of Cano.
And indeed the elongated, elegant proportions of the
body are characteristic of this artist's work, while in
Zurbarán's paintings on the same theme the figure is
generally more squat and heavy-set. LK

25
Portrait of the Count-Duke of Olivares
c. 1638
Diego Velázquez de Silva
1599, Seville–1660, Madrid
Oil on canvas; 67 × 54.5 cm

State Hermitage, inv. no. ГЭ 300
Provenance: came to the Hermitage from the collec-
 tion of William Coeswelt, Amsterdam, in 1814
Selected literature: Kagané 2005, pp. 94, 157–8,
 162, 410, 506–7, no. 219; Kagané 2008, no. 13 (with
 bibliography)

Don Gaspar de Guzmán (1587–1645), Count-Duke of
Olivares, was for many years, between 1622 and 1643,
Philip IV's principal minister and de facto ruler of
Spain. His overwhelming ambition led him to dream
of restoring Spain to its former power and world
domination, and he embroiled the country in ruinous
wars. By the end of the 1630s a man who had once
seemed to represent such high hopes for the country
was arousing universal discontent, and in 1643 he was
removed from power.

Olivares was a patron of Diego Velázquez, and it was
thanks to him that the artist was invited to court. As
a young man, Velázquez was genuinely enthralled by
the Count-Duke and painted him in highly exalted
and illustrious ceremonial settings. The Hermitage
portrait is quite different. Portrayed shoulder-length,
in a severe, dark costume, this is the image of a man
who has aged and is no longer at the centre of power.
The artist focuses attention on Olivares's character,
finding with remarkable objectivity a delicate point
of correlation between the subject's unprepossessing
appearance and eminent personality. The colour pal-
ette is highly restrained but contains numerous hues,
the depth of the black of the costume and the contrast
with the white collar being evoked with particularly
virtuosic skill.

The picture dates to around 1638. It was engraved
and published in a book by Juan Antonio de Tapis y
Robles, *Illustración del renombre de Grande* (Madrid, 1638).
The engraving bears the inscription: 'Ex Archetypo
Velazquez Hermann Paneels F. Matriti. 1638'. LK

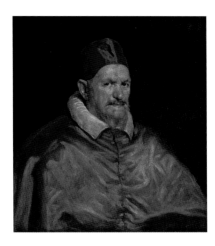

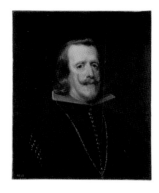

26
Portrait (Pope Innocent X)
*c.*1650
Diego Velázquez de Silva
1599, Seville – 1660, Madrid
Oil on canvas; 82 × 71.5 cm

English Heritage (Wellington Museum, Apsley
House), WM 1590–1948
Selected literature: Camón Aznar 1964; López-Rey
1963, 1979, 1996, 1999 (updated by O. Delenda);
Brown 1986; Méndez Rodríguez 2005; Checa 2008

Early in 1649 Velázquez travelled to Italy, at the
command of Philip IV, to buy pictures and sculptures
for the royal collection. It was his second visit and it
resulted in the appearance of a strong Italian, partic-
ularly Venetian, influence in his work. Velázquez was
afforded the great privilege of painting the portrait of
Innocent X (Giambattista Pamphilj, 1574–1655), whom
he had met as papal nuncio in Madrid in 1626–30
(Harris 1999, p. 210). This portrait is a copy of, or sketch
for, the one now in the Galleria Doria Pamphilj in
Rome, which differs from the Wellington picture in
showing the Pope three-quarter-length, seated and
holding a piece of paper inscribed *Alla Santa di Nro
Sigre / InnocencioX / Per / Diego di Silva y Velázquez de la Ca /
mera di S. Mta. Cattca,* with the addition of a date, now
illegible, which has been read as 1650. This was Jubilee
year, the high-watermark of Innocent's papacy, when
700,000 pilgrims converged on Rome.

Innocent is considered to have been a reforming Pope,
active in sending out missions and reforming reli-
gious orders, but indecisive and too much under the
influence of his sister-in-law, Olimpia Maidalchini.
The masterpiece in the Galleria Doria Pamphilj has
always belonged to the sitter's family and there has
never been any doubt that it is the original painting
commissioned by the Pope, who gave Velázquez
a golden medallion with his portrait as a sign of
his appreciation.

Several contemporary witnesses, and subsequent-
ly Palomino (1724), record that Velázquez brought
a copy of his portrait of Innocent X back with him
when he returned to Madrid in June 1651. The fullest
comment appears in a letter dated 8 July 1651 from
the papal nuncio in Madrid, Giulio Rospigliosi, to
Cardinal Pamphilj in Rome, in which he says that
Velázquez has returned from Italy 'and brought with
him a good many originals by the best painters as well
as a very like portrait of our Lord (Innocent X) which
His Majesty has shown to enjoy very much' (Harris,
'Velázquez en Roma', *Archivo Español de Arte,* XXXI,
1958, p. 186).

It used to be assumed that the Apsley House picture
was the one Palomino recorded as having been
brought back to Spain by Velázquez (Wellington 1901).
It is first listed in the inventories of the royal collec-
tion in 1772, when it was in the passage to the King's
pew in the Royal Palace at Madrid: 'Un retrato del
Papa Innocencio 10 de medio cuerpo de vara de alto, y
poco menos de ancho, original de Velázquez'. The size
fits well (1 vara = 84.7 cm) and it is reasonable to sup-
pose that this is indeed the Wellington picture, which
remained in the royal collection until 1813. (López-Rey
1996 suggests that the record of a painting of identical
description and size in the royal inventory of 1814 is
simply an error.) However, in the 1772 inventory it is
marked as coming from the Marquis de la Ensenada's
collection, bought by Charles III in 1769, which makes
it doubtful whether this was the picture given to
Philip IV by Velázquez in 1651 – if, indeed, the gift was
ever made.

There are many copies of the portrait of Innocent
X; unfortunately none has a provenance extending
further back than the eighteenth century. This makes
it impossible to identify the copy or copies described
by the artist's contemporaries with extant paintings.
The fact that the Wellington picture was accepted as
by Velázquez in the Spanish royal collection in the
inventories of 1772 and 1794 enhances its status, but
it does not prove that it was the copy brought back by
the artist himself in 1651.

Of the many copies, relatively few show the three-
quarter-length composition of the Doria Pamphilj
picture; the majority are, like the Wellington version,
bust size (López-Rey 1963, nos. 446–57). Nearly all
of them are considered to be copies by other hands.
Apart from the one in the National Gallery of Art,
Washington (López-Rey 1963, no. 448; formerly
Horace Walpole and Catherine the Great, Hermitage,
St Petersburg, and Mellon collections), only the
Wellington picture has any claim to be considered
autograph. Subsequently it was copied by Goya
(López-Rey 1963, no. 456, pl. 358) and others, and more
recently the original version inspired a series of com-
positions by Francis Bacon (see cat. 41, 43 and 44).
C. M. Kauffmann, revised by Susan Jenkins
Exhibited at State Hermitage Museum only

27
Portrait of Philip IV
Late 1650s
Studio of Diego Velázquez de Silva
1599, Seville – 1660, Madrid
Oil on canvas; 67 × 53 cm

State Hermitage, inv. no. ГЭ 297
Provenance: acquired by Alexander I from the collec-
tion of William Coeswelt, Amsterdam, in 1814
Selected literature: Kagané 2005, pp. 94, 159–60,
162, 410, 506–7, no. 219; Kagané 2008, no. 13 (with
bibliography)

In the 1650s Velázquez painted two head-and-shoul-
der portraits of the Spanish king Philip IV (1605–65).
One is now in the Prado in Madrid, while the other is
in the National Gallery in London. The two portraits
are very similar, although in the National Gallery
painting the king looks older – his face is more sallow,
his eyes more sunken and puffy, and he has acquired
a conspicuous double chin. There are also differences
in the details: the hair is arranged differently, and
in the London version the king wears the Order of
the Golden Fleece and gold buttons, whilst in the
Prado portrait these are absent. The National Gallery
painting became the model for numerous subsequent
versions – the catalogue lists twenty, but this is by no
means all of them.

The Hermitage portrait is very similar to the London
one. It is believed to be the work of Velázquez's studio,
and is universally considered to be one of the best ver-
sions. The painting was engraved in 1657 by Pedro de
Villafranca in Francisco de los Santos's book *Descripción
breve del Monasterio de S. Lorenzo el real del Escorial.* LK

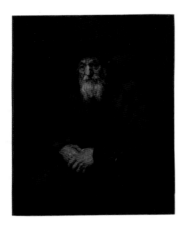

28
Portrait of an Old Man (Old Man in an Armchair)
1654
Rembrandt Harmensz. van Rijn
1606, Leiden – 1669, Amsterdam
Oil on canvas; 109 × 85 cm (extended on three sides; original canvas dimensions 86 × 76.5 cm)
Signed and dated in background: *Rembrandt f 1654*

State Hermitage, inv. no. ГЭ 737
Provenance: came to the Hermitage as part of the collection of Count Silvain-Raphael Baudouin (1715–91), Brigadier of the King's Armies and Captain of the French Guards, Paris, in 1781
Selected literature: Tumpel 1986, p. 303, cat. 141 (Rembrandt Schuler); Schwartz 2006, p. 313, ill. 562; Sokolova 2011, p. 21, ill. 2

The two paintings by Rembrandt in the exhibition belong to his late expressive manner and are generally known by the titles 'Portrait of an Old Man' and 'Portrait of an Old Woman' (cat. 29). They both have the same format, both are dated 1654, and they come from the same collection. So it is hardly surprising that for a long time, from around the middle of the eighteenth century, they were wrongly believed to be pendants. However, the paintings are not only not a pair, they are not even strictly portraits, although they were painted from life.

Commissioned portraits were popular in Holland and were intended to 'memorialise' the subject. For such paintings the identity of the person was clearly an important matter; a family crest or inscription giving the age would help to identify the sitter. In seventeenth-century Dutch documents, portraits were usually called *conterfeytsel* (that which is made against or opposite something else). In Rembrandt's circle other depictions, similar in type, were widely distributed: these were known as *tronies*, or 'half-length historical figures', a term that signified the depiction of models of a distinctive or exotic appearance. Their exuberant costumes and fanciful headwear evoked associations with images from biblical history. It is to this category of 'historical half-length figure' that the two Hermitage paintings belong.

There is a dramatic intensity to this depiction of a frail, hunched old man, leaning slightly forward. The subject retains a sharp sense of individuality despite his advanced age. The look in his heavily lidded eyes is full of sorrow but hasn't lost its acuity. The characteristic features of an untrimmed, two-pointed beard and costume are evidence that the sitter was an Ashkenazi Jew, an immigrant from Central Europe. The nature of his costume confirms this: the heavy, long garment and large soft baretta.

Rembrandt, who from 1639 lived on Joodse Breestraet in the European quarter of Amsterdam, found the models for many of his works around there. According to the artist's younger contemporary, Adriaen van der Werff (1659–1722), Rembrandt would often observe the motley crowd out on the street and select models for his *tronies* and historical compositions from passers-by.

The Hermitage picture is mentioned in the catalogue of Baudouin's collection (1780) as: 'No. 24: The other [picture] represents the Englishman Thomas Park [*sic*] who lived one hundred and fifty two years. This decrepit old man, whose eyes are still full of fire, is seen front-on, and sitting in an armchair. His hands are crossed on his knees; his garment is of a thick brown fabric. This piece, made the same way and with the same vigour as the preceding one, is 3 feet, 3 inches high and 2 feet, 6 inches wide.' From this it would seem that the ancient grey-bearded man is identified with the legendary long-liver Thomas Parr (1483–1635) who, according to established legend, lived for 152 years and nine months. This mythologised interpretation of Rembrandt's subjects, often taken for images of biblical prophets or classical philosophers, was characteristic of art connoisseurship in the eighteenth and nineteenth centuries.

'Portrait of an Old Man' and 'Portrait of an Old Woman' retained these traditionally established titles right up until the second half of the twentieth century, and thanks to their remarkable artistic qualities they became widely known. However, in the last few decades, with Rembrandt's œuvre in collections all over the world being re-examined, many of the artist's late works have become the subject of a discussion that has also touched on the two Hermitage paintings. In the most recent literature they are often attributed to the studio of the great Dutchman, although experts have yet to reach a definitive conclusion. ıs

29
Portrait of an Old Woman (Old Woman in an Armchair)
1654
Rembrandt Harmensz. van Rijn
1606, Leiden – 1669, Amsterdam
Oil on canvas; 109 × 84 cm (extended on three sides; original canvas dimensions 86 × 76.5 cm)
Signed and dated in background: *Rembrandt f 1654*

State Hermitage, inv. no. ГЭ 738
Provenance: came to the Hermitage as part of the collection of Count Silvain-Raphael Baudouin (1715–91), Brigadier of the King's Armies and Captain of the French Guards, Paris, in 1781
Selected literature: Tumpel 1986, p. 303 (ill), cat. A60 (Rembrandt Werkstatt); Rembrandt's Mother 2006, cat. 4; Sokolova 2011, p. 20, ill. 1

This depiction of an old woman deep in thought, melancholy etched on her face, was for a long time mistakenly known as 'Portrait of Rembrandt's Mother'. The composition was described in detail in the catalogue of Baudouin's collection (1780): 'The portrait of Rembrandt's mother. This old woman dressed in brown is seated in an armchair, her hands crossed on her knees. She has a white kerchief round her neck which covers the breast; her headdress is a small black hood which encircles her head and which casts a shadow over her wrinkled face seen front on. This is one of the most beautiful portraits to be found in the artist's œuvre...'

Myths surrounding the subjects of Rembrandt's paintings, which were often seen as depictions of the great Dutchman's relatives, were widely circulated in the eighteenth and nineteenth centuries. Over time the title for the Hermitage work was traditionally established as 'Portrait of an Old Woman'.

The figures of old people, representing the wisdom of advanced age, have a particular place in the work of Rembrandt and his pupils, and they are distinguished by a remarkable spiritual quality. From his early Leiden period right until the end of his life Rembrandt never wearied of studying the faces of old people, marked with various emotions, temperaments and characters. His contemporaries marvelled at the skill with which he managed to convey the signs of advanced years, such as wrinkled skin and grey hair, painted with a verisimilitude that almost rivalled nature itself. The expressivity and psychological depth of Rembrandt's 'studies' made them highly sought after by collectors.

The model for the Hermitage work is seen in several of the artist's paintings of the 1650s and 1660s. Although painted from life, it is not really possible to call this work's specific genre portraiture. The images of devout old women in exotic costumes (often holding a Bible) are generally categorised as 'historical figures'. In recent studies only one composition in this group – *Old Woman Reading* (1655; Br. 385, collection of Duke of Buccleuch and Queensberry, Drumlanrig Castle, Dumfriesshire) – is given a definite attribution to Rembrandt himself.

For several centuries Rembrandt's broad, spare draughtsmanship and virtuosic use of chiaroscuro was the gold standard for many artists who tried to attain the painterly technique of the great Dutchman. *Portrait of an Old Woman* was copied by such celebrated painters as Jean-Baptiste Simeon Chardin (1776) and Ilia Repin (1870). IS

30
Portrait of Count Nicolai Dmitrievich Gouriev
1821
Jean Auguste Dominique Ingres
1780, Montauban – 1867, Paris
Oil on canvas; 107 × 86 cm
Signed and dated bottom left on the parapet: *INGRES, Flor. 1821*

State Hermitage, inv. no. ГЭ 5678
Provenance: commissioned by N. D. Gouriev; by descent to his widow, Marina Dmitrievna Gourieva (née Naryhskina) (1789–1871) from 1849; then to her relatives; came to the Hermitage in 1922 from the collection of A. N. Naryshkina via the State Museum Fund
Selected literature: Berezina 1983, no. 241 (with bibliography); Riopelle 1999, pp. 250–3, no. 86; Hale 2000, pp. 203, 205, fig. 15; Tinterow, Conisbee 1999, no. 86; Pomarède, 2006, pp. 192–3 (reproduced in mirror view)

Nicolai Dmitrievich Gouriev (1792–1849) was the son of the Minister of Finance, Dmitri A. Gouriev. He took part in the Patriotic War of 1812 and the Russian army's foreign campaigns of 1813–14. In 1818 he was appointed aide-de-camp in Alexander I's retinue, transferring that same year to the diplomatic service. From 1821 he was successively Russian ambassador in The Hague, Rome and Naples. He then became Secretary of State at the Ministry of Foreign Affairs, and achieved the position of privy councillor in 1834.

In the autumn of 1820 Gouriev took his new young wife on honeymoon to Rome and Florence where he visited artists' studios and purchased a number of paintings, in particular works by Leopold Robert and Horace Vernet. At the same time he commissioned this portrait by Ingres. From a letter the artist sent from Florence to his friend Jean-François Gilibert in France it can be surmised that the portrait was finished by 20 April 1821.

In its compositional structure the Hermitage painting continues a line that can be traced in Ingres' work, in particular in his portraits of Granet (1807; Aix-en-Provence, Musée Granet) and Bartolini (1820; Paris, Louvre). The artist's interest in the Italian Mannerists, and especially portraits by Pontormo and Bronzino, is clearly evident. The landscape background is an imagined composition, possibly painted with the participation of Granet (see Riopelle 1999; Halle 2000).

Whereas the portraits Ingres painted of his fellow artists are suffused with an inherent warmth, here there is the sense of a certain detachment between artist and sitter. Ingres emphasises the significance of this haughty aristocrat, looking down at the viewer disdainfully from his lofty position. For Ingres, Gouriev remained just that – a distant, rather incomprehensible 'Russian grandee'. The precise draughtsmanship and strongly expressive modelling create an easily readable image. The stormy, sombre sky accentuates still further the cold equanimity of the subject. The contrasting combination of colours – the intense red of the cloak lining and the black of the frock-coat – introduces a marked tension and sense of drama into the viewer's perception of the work. It provokes and forces the viewer to imagine the complicated inner world and temperament hidden beneath the sitter's carapace of outward tranquillity, revealed in particular in his passion for collecting. Here Ingres, an adherent of classicism, has captured the spirit of the incipient Romantic era in a way that was achieved in literature by Stendhal in his novel *Le Rouge et le noir* (1830). AAB

Catalogue Entries

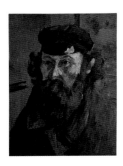

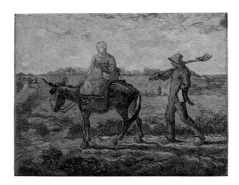

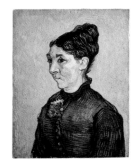

31
Self-Portrait in a Cap
*c.*1873
Paul Cézanne
1839, Aix-en-Provence – 1906, Aix-en-Provence
Oil on canvas; 53 × 39.7 cm

State Hermitage, inv. no. ГЭ 6512
Provenance: Galerie Vollard (purchased before 1904); Havemeyer collection, New York, from 1904; Durand-Ruel Gallery (placed on commission by Louisine Havemeyer, negotiated by Mary Cassatt, and acquired by Durand-Ruel for 7500 francs) from 1909; collection of Ivan Morozov (acquired from the Galerie Durand-Ruel for 12000 francs) from 1909; Second Museum of Modern Western Painting from 1918; State Museum of Modern Western Art from 1923; came to the Hermitage in 1930
Selected literature: Barskaia, Kostenevich 1991, no. 21 (with bibliography); Kostenevich 1999, p. 173, no. 137; Kostenevich 2008, vol. 1, p. 215, vol. 2, no. 392

Lionello Venturi dated this work to 1873–5, the period of Cézanne's close links with Pissarro. John Rewald dated it to *c.*1875, and certainly the compositional simplicity and solidity of Cézanne's work are close to Pissarro's *Self-Portrait* (1873; Paris, Musée d'Orsay). In 1874 Pissarro painted a portrait of Cézanne (London, National Gallery, on loan from the collection of Laurence Graff), and it is also worth noting the close similarity of Cézanne's self-portrait to his 1874 etching, *Self-Portrait in a Cap*. However, it would be unwise to date the Hermitage work to the same year purely on the basis of the outward similarity of the model, for the artist's appearance barely changed over a number of years, and in any event he always looked older than his age. Douglas Cooper gives a more convincing date of 1872–3. In his view, this self-portrait was created before Cézanne started working with Pissarro. He bases his judgement on the fact that the whole painting is executed using a palette-knife. It is probable that *Self-Portrait in a Cap* was painted soon after the artist's move to Auvers at the beginning of 1873. His *Self-Portrait* was a later work (*c.*1875; Paris, Musée d'Orsay).

In all Cézanne painted more than two dozen self-portraits. Here he looks at least ten years older than his actual age, not so much because of his bushy beard, but because the sense of struggle and solitude has prematurely aged him. AK

32
Morning. Going out to Work
1889
Vincent van Gogh
1853, Groot-Zundert – 1890, Auvers-sur-Oise
Oil on canvas; 73 × 92 cm

State Hermitage, inv. no. ЗКР 532
Provenance: collection of Theo van Gogh; collection of Johanna van Gogh-Bonger, Amsterdam; in the Karl Ernst Osthaus-Museum (Folkwang Museum), Hagen, from February 1906; later in the collection of A. Mak, Amsterdam; Galerie Paul Cassirer, Berlin; Galerie Goldschmidt, Frankfurt; Otto Krebs, Holzdorf; came to the Hermitage in 1949
Selected literature: *The Complete Letters of Vincent van Gogh* 1958, No. LT 607, 613, 623, 443; Kostenevich 1995, pp. 232–4, no. 59

Morning. Going out to Work was one of a series of paintings on the 'Four Times of the Day' that Van Gogh based on Adrien Lavieille's wood engravings done in 1860 after Jean-Francois Millet's original drawings of two years earlier. Van Gogh wrote to his brother Theo from the asylum in Saint Rémy in September 1889 about how crucial these engravings were to him as a guide: 'Although copying may be the old system, that absolutely doesn't bother me at all... We painters are always asked to compose ourselves and to be nothing but composers. Very well – but in music it isn't so – and if a person plays some Beethoven he'll add his personal interpretation to it – in music, and then above all for singing – a composer's interpretation is something, and it isn't a hard and fast rule that only the composer plays his own compositions. Good – since I'm above all ill at present, I'm trying to do something to console myself, for my own pleasure. I place the black-and-white reproductions by Delacroix or Millet in front of me as a subject. And then I improvise colour on it but, being me, not completely of course, but seeking memories of their paintings – but the memory, the vague consonance of colours that are in the same sentiment, if not right – that's my own interpretation' (LT 607). On 2 November he elaborated to Theo: 'It seems to me that doing paintings after these Millet drawings is much rather to translate them into another language than to copy them' (LT 613).

Van Gogh undoubtedly assigned great significance to the series of paintings on the 'Times of the Day', which he completed between November 1889 and January 1890. It was later split up and never exhibited as a series. The other three paintings are *Noon. Rest* (Paris, Musée d'Orsay), *End of Work* (Komaki, Japan, Menard Art Museum) and *The Evening Hour* (Amsterdam, Vincent van Gogh Museum). AK
Exhibited at State Hermitage Museum only

33
Portrait of Madame Trabuc
1889
Vincent van Gogh
1853, Groot-Zundert – 1890, Auvers-sur-Oise
Oil on canvas on panel; 63.7 × 48 cm

State Hermitage, inv. no. ЗКР 521
Provenance: collection of Theo van Gogh; collection of Johanna van Gogh-Bonger, Amsterdam; Galerie Thannhauser, Berlin; collection of Otto Krebs, Holzdorf, from 1928 or 1929; came to the Hermitage in 1949
Selected literature: *The Complete Letters of Vincent van Gogh* 1958, No. LT 604, 605, 607; Kostenevich 1995, pp. 232–4, no. 61

During his stay at the asylum of Saint-Paul de Mausole near Saint Remy in 1889, Van Gogh did a portrait of an attendant at the hospital, Monsieur Trabuc, about whom he wrote to his brother Theo: 'I've done the portrait of the orderly ... and I'll also do his wife if she wants to pose. She's an unhappy, faded woman, quite resigned, and so insignificant that I have a great desire to depict that dusty blade of grass' (LT 605). As with the portrait of Monsieur Trabuc, Van Gogh did two versions – one for Madame Trabuc, the other for himself. It is hard to say which of the two portraits, done immediately one after the other, is the surviving one – the life version or its repetition. In contrast to the surviving portrait of Monsieur Trabuc (Solothurn, Museum of Fine Arts), which most experts consider to be the repetition, this portrait of his wife is less stylised. Although the two paintings are the same size and both similarly show the subject from the waist up, in painterly terms they are not a pair, and it seems unlikely that the artist intended them to be so.

It is worth noting that just before he painted the portrait of Jeanne Lafuye Trabuc (1834–1903) Van Gogh was working on a *Pietà*, a 'copy', or more precisely a version, as he wrote to Theo, of Delacroix's *Pietà* from Nanteuil's lithograph after the painting which Van Gogh possessed. The spiral form typical of the baroque, and later of Delacroix, drawing on the example of the seventeenth century, enthralled Van Gogh. Something of the energetic nature of the brushstrokes seen in Van Gogh's *Pietà* (Amsterdam, Vincent van Gogh Museum) is also evident in *Portrait of Madame Trabuc*. At the same time the portrait is similar to the 'heads of peasant women' that he painted when he was still in Holland. It can be linked to the portrayal of national types, a tradition initiated in the 1870s by illustrators for the English weekly journal *The Graphic*. Van Gogh greatly admired these illustrations and collected them. AK
Exhibited at State Hermitage Museum only

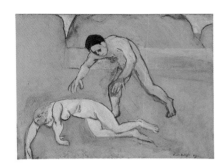

34
Man Picking Fruit from a Tree
1897
Paul Gauguin
1848, Paris – 1903, Atuona, Hiva Oa, Marquesas Islands
Oil on canvas; 92.5 × 73.3
Signed and dated bottom left: *p. Gauguin 97*

State Hermitage, inv. no. ГЭ 9118
Provenance: sent by Gauguin from Tahiti to the
 Galerie Vollard, Paris, on 9 December 1898; Galerie
 Vollard; collection of Sergey Shchukin from 4 May
 1906; First Museum of New Western Painting from
 1918; State Museum of Modern Western Art from
 1923; came to the Hermitage Museum in 1948
Selected literature: Barskaia, Kostenevich 1991, no. 100
 (with bibliography); Kostenevich 1999, p. 173, no.
 137; Kostenevich 2008, vol. 1, p. 265, vol. 2, no. 74

This picture is linked to the monumental work *Who
are we? Where are we from? Where are we going?* (Boston,
Museum of Fine Arts). The central position in the
Boston panel is occupied by a man with his arms
raised towards fruit on a tree. He is depicted in the
same way in the preparatory canvas for the panel that
the artist called *Tahiti: Characters from 'Who are we?...'*
(1897; New York, private collection) – that is, naked
apart from a loin cloth.

In the Boston panel the figure plays an important
symbolic role, as the allusion to the tree of knowledge
is self-evident. In *Man Picking Fruit from a Tree*, however,
the philosophical meaning is less obvious, and the
picture has more of the appearance of an everyday
scene. From this it may be assumed that this work
was completed before the Boston picture. The figure
in the Hermitage painting also appears in the later
Faa ara. Awakening (1898; Copenhagen, Ny Carlsberg
Glyptotek). AK

35
Nymph and Satyr
1908 – 9
Henri Matisse
1869, Cateau-Cambrésis – 1954, Nice
Oil on canvas; 89 × 116.5 cm
Signed and dated bottom right: *Henri-Matisse 09*

State Hermitage, inv. no. ГЭ 9058
Provenance: collection of Sergey Shchukin from 12
 January 1909 (acquired through the mediation of
 the Galerie Bernheim Jeune for 3000 francs); First
 Museum of New Western Painting from 1918; State
 Museum of Modern Western Art from 1923; came to
 the Hermitage in 1948
Selected literature: Barskaia, Kostenevich 1991, no. 185
 (with bibliography); Kostenevich 1999, p. 305, no.
 224; Kostenevich 2008, vol. 1, p. 412, vol. 2, no. 240

In the spring of 1907 Matisse created a ceramic
triptych for the villa of Karl Ernst Osthaus in Hagen,
Germany. He portrayed a dancing nymph on the side
panels and a nymph and satyr on the central panel.
Unlike the later Hermitage version, the satyr in the
ceramic triptych is shown with a shaggy fleece, goat's
legs and so on. The model for the ceramic work was
Correggio's *Jupiter and Antiope* in the Louvre, although
Matisse would, of course, have known other versions
of the motif, in particular Watteau's *Nymph and
Faun* (also in the Louvre). Returning to the motif in
painting, in response to a commission from Sergey
Shchukin, Matisse moved away from the mythological
elements and modified the poses of the characters.

The expressionistic brightness of tone and the overt
sensuality of the picture make it unique in Matisse's
œuvre. Flam sees in it a link with the artist's infatua-
tion for his Russian student Olga Merson (Flam 1986,
p. 248). The red-headed nymph, despite her carica-
tured features, is very similar to the model of *Portrait of
Olga Merson* (1911; Houston, Museum of Fine Arts).

The picture was begun in 1908 but redone in 1909.
Even without X-ray it is possible to make out the
original outlines, now covered in green paint, which
suggest that in its original state the movements of
the characters were even more dynamic. AK

36
Woman in Green
c. 1909
Henri Matisse
1869, Cateau-Cambrésis – 1954, Nice
Oil on canvas; 65 × 54 cm
Signed bottom left: *Henri Matisse*

State Hermitage, inv. no. ГЭ 6519
Provenance: Galerie Bernheim Jeune from 22
 September 1909 (acquired from the artist); collection
 of Sergey Shchukin from 11 October 1909 (acquired
 for 2500 francs); First Museum of New Western
 Painting from 1918; State Museum of Modern
 Western Art from 1923; came to the Hermitage
 Museum in 1930
Selected literature: Barskaia, Kostenevich 1991, no.
 186 (with bibliography); Kostenevich 1999, p. 311, no.
 227; Kostenevich 2008, vol. 1, p. 422, vol. 2, no. 243

Matisse spent the summer of 1909 at Cavalière on
the Mediterranean coast near St Tropez, where he
painted *Lady in Green* (also known as *Woman with a Red
Carnation*), for which the model was Loulou Brouty.
The picture belongs to a genre popular in French
Art from the Romantic period. Such works were
presented as 'figures', and usually portrayed models
who were paid but were not professionals; the affected
poses of the latter held little attraction for Matisse.
Similar portraits, along with other compositions by
the artist at this time, are notable for their pursuit of
a harmonic balance between the decorative details:
Jack Flam described *Lady in Green* as 'an extraordinary
ensemble of rhyming triangular forms' (Flam 1986,
p. 262). Here the range of colour, based on the simplest
possible chord, achieves the utmost tranquillity. By
placing the brightest spot of colour and the woman's
only adornment – the red carnation – directly in the
centre, Matisse underlines the strictly centric nature
of the composition. The traditional portrait pose is
extremely calm; however, the artist breathes new
life into a well-worn composition, imbuing it with
an entirely modern content. It seems probable that
Matisse himself valued the picture highly, for he was
photographed in front of it in Shchukin's house. AK

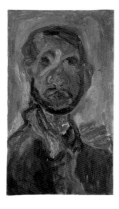

37
A Young Lady
1909
Pablo Picasso
1881, Malaga–1973, Mougins, Alpes-Maritimes
Oil on canvas; 91 × 72.5 cm
Signed on the reverse: *Picasso*

State Hermitage, inv. no. ГЭ 9159
Provenance: Galerie Kahnweiler; collection of Sergey Shchukin; First Museum of New Western Painting from 1918; State Museum of Modern Western Art from 1923; came to the Hermitage Museum in 1948
Selected literature: Barskaia, Kostenevich 1991, no. 245 (with bibliography); Kostenevich 1999, p. 355, no. 307; Kostenevich 2008, vol. 1, p. 482, vol. 2, no. 334

The inspiration for *A Young Lady*, which Picasso painted after his return from Horta de Ebro, was Fernande Olivier. Picasso used the motif of *Nude in a Chair* (1909; private collection) painted in Horta and for which Olivier also posed. Here, though, by adopting the Cubist device of 'faceted' form, the artist moves away from the marked sculptural effect of the earlier work, so that the model has an almost ephemeral quality. The picture, of course, is far from being a portrait of Fernande; nevertheless, certain details – her hairstyle, the line of her nose – are recognisable, albeit less so than in the portraits painted in Spain.

The 'faceting' of the beautiful naked body into large-scale planes was a technique that in itself challenged existing aesthetic notions. Even something as familiar as the traditional interchange between the outlines of the female figure and the rounded armchair is here almost entirely subordinate to the play between crystalline forms. For Picasso it was important to create the sense that a painting was above all a painting, and only then the portrayal of a particular thing or person – even if that person was his girlfriend and regular model. In this work a new understanding of light plays a particular role in establishing the autonomy of a painting. For while early Cubism followed the generally accepted principles of light and shade, here different rules apply. Light bursts out here and there, and is barely used to express shape and volume; the dynamic play of light and shade becomes the *raison d'être* of the picture. From the point of view of objective verisimilitude, light could be said to play a destructive role in *A Young Lady*; viewed differently, however, light becomes the emanation of the artist's consciousness, and thus fills the picture with an 'inner light'. AK

38
Portrait of an Unknown Man Reading a Newspaper (Chevalier X)
1911–14
André Derain
1880, Chatou, near Paris–1954, Garches
Oil on canvas; 162.5 × 97.5 cm
Signed on the reverse: *a derain*

State Hermitage, inv. no. ГЭ 9128
Provenance: acquired by Sergey Shchukin from Galerie Kahnweiler in 1914; First Museum of New Western Painting from 1918; State Museum of Modern Western Art from 1923; came to the Hermitage in 1948
Selected literature: Barskaia, Kostenevich 1991, no. 69 (with bibliography); Kostenevich 1999, p. 332, no. 92; Kostenevich 2008, vol. 1, p. 446, vol. 2, no. 127

This picture has no equivalents in the artist's œuvre. Derain began the work in 1911 and significantly reworked it several times to achieve a more laconic effect. Some of the reworkings are visible beneath the overpainting. A photograph of one of the picture's states, taken in Derain's workshop on Rue Bonaparte shortly before 1914, and reproduced in *Les Soirées de Paris*, 15 February 1914, no. 21, reveals that, as well as some variation in other details, the artist used the Cubist technique of placing a real newspaper in the painted space. It seems likely that Derain painted the final version of the portrait later in 1914.

In *Chevalier X*, as Guillaume Apollinaire called this strange character, Derain has created an overtly grotesque image. The cardboard marionette dressed in austere costume harks back to the centuries-old tradition of the formal portrait, but provocatively subjects it to a primitivist reworking. At the same time the work is acutely modern: the Chevalier is reading 'the most Parisian, the most literary and most *boulevard* [tabloid] newspaper of Paris' (Simon Arbellot). The treatment of form in the portrait uses techniques from African as well as European art. The specific homage to Cézanne's early portraits is obvious: *Portrait of the Artist's Father, Louis-Auguste Cézanne, Reading l'Evénement* (1866; Washington DC, National Gallery), and especially *Portrait of the Painter Achille Emperaire* (1867–8; Paris, Musée d'Orsay). While drawing on such diverse sources as Cézanne, Roman and African sculpture, Henri Rousseau, Velázquez and Dutch miniatures, Derain nevertheless retains a strong authorial individuality. The reproduction in *Les Soirées de Paris* became something of a talisman for the surrealist André Breton, who until the mid-1920s was Derain's most devoted admirer, although he never saw the picture itself. ND

39
Self-Portrait
*c.*1920–1
Chaïm Soutine
1894, Smilovichi, Minsk Guberniia–1943, Paris
Oil on canvas; 54 × 30.5 cm
Signed bottom left: *Soutine*

State Hermitage, inv. no. ГЭ 10599
Provenance: private collection, Paris; Galerie Bing, Paris; came to the Hermitage in 1997
Selected literature: Kostenevich 1999, p. 369, no. 352; Kostenevich 2008, vol. 1, p. 503, vol. 2, no. 426

The Hermitage self-portrait was painted at the very beginning of the 1920s, shortly before the artist achieved renown. While in other self-portraits Soutine presented himself as an artist (either standing in front of his canvas or simply holding a palette), here he is less *peintre maudit* (cursed painter) than simply *maudit*: an outcast who has no need to worry about whether he conforms to accepted norms of decorum. There is not a single hint of setting, not even the merest detail to indicate the subject's profession or sphere of activity. The entire focus of the painting is his inner turmoil. Soutine's picture is painted so broadly, as if in one delirious breath, that at the outset it may appear a daub, or a malevolent caricature. However, one need only compare it with photographs of the painter to get an immediate sense of how mercilessly the artist has captured his most typical external features. The extreme anti-academic style of the portrait, where the brush, without wasting time on half-tones, conveys in a moment the howl of the soul, its silent despair, is entirely appropriate for the most complex tasks which can only be resolved in portraiture; that is, the exposure of the psychology of a character from whom the skin has been torn off. Soutine achieves a likeness rare in its expressivity. AK

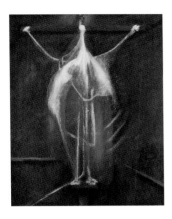

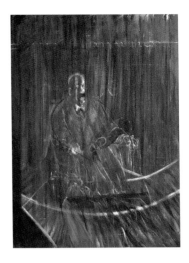

Catalogue entries for works by Francis Bacon (1909–92) are written and compiled by Calvin Winner, Head of Collections and Conservation, Sainsbury Centre for Visual Arts; entries 68–70 by Margarita Cappock, Deputy Director and Head of Collections, Dublin City Gallery The Hugh Lane

40
Crucifixion
1933
Francis Bacon
Oil on canvas; 60.5 × 47 cm

Private collection
Provenance: purchased from the Mayor Gallery by Sir Michael Sadler and later sold; purchased from the Redfern Gallery by Sir Colin Anderson in 1946

This painting was for many years owned by Sir Colin Anderson, who was a patron of the Sainsbury Centre for Visual Arts. Of the small number of works that survive from the 1930s this is by far the most celebrated, owing to its being reproduced in Herbert Read's *Art Now*, where it was juxtaposed with Picasso's *Baigneuse aux bras levés* (1929; Arizona, Phoenix Art Museum). In fact there are three surviving Bacon works from 1933 with the title 'Crucifixion', all of which make reference to Picasso works of the period illustrated in *Minotaure* in 1933 (Bacon–Picasso 2005, pp. 148–9). Whether Bacon saw these images is uncertain, but what is clear is that both artists were inspired by the Isenheim Altarpiece by Matthias Grünewald (1512–16; Colmar, Musée Unterlinden). Certainly for Bacon this masterpiece of the German Gothic provided a proper setting for the true horror of the Crucifixion against a forbidding black background. The use of Christian symbolism and the language of faith is a dominant theme in Bacon's work, but he subverted both to explore the universal human existence in a Godless world. In a believer this would be considered blasphemy, but Bacon stated: 'I know for religious people, for Christians, the Crucifixion has a totally different significance. But as a non-believer, it was just an act of man's behaviour, a way of behaviour to another' (Sylvester 1993, p. 22). In this small painting, the skeletal structure of a human figure with outstretched arms is attached to the horizontal *patibulum* of the cross, laid bear for all to witness.

41
'Study after Velázquez'
1950
Francis Bacon
Oil on canvas; 198.1 × 137.2 cm

Private collection, courtesy The Estate of
 Francis Bacon

This painting was unknown until it reappeared after the artist's death. Two very similar versions painted at around the same time were illustrated in Alley 1964, but recorded as being destroyed. One of those pictures (now in a private collection) was also rediscovered: they had been rolled and stored together at Bacon's art supplier in Chelsea prior to the artist's first trip to Africa, and then presumably forgotten. In 1950 Bacon had intended to make three paintings inspired by the remarkable portrait of Innocent X by Diego Velázquez (Rome, Galleria Doria Pamphilj). Robert Melville reported that he saw one of the paintings in a studio visit towards the end of 1950. Two weeks later he believed that Bacon had destroyed the painting. Melville thought the second painting was also destroyed and that the third was never completed.

In this version, the veiled Pope is emerging from behind the vertical striations, a so-called 'shuttering effect' which Bacon observed in late Degas pastels. The use of sets of close parallel lines that seemed to be passing through a semi-transparent body was applied 'to formalise the folds in background curtains into stripes that passed very emphatically through a figure' (Sylvester 2000, pp. 49–50). Bacon continued that he thought the Velázquez painting 'one of the greatest portraits that have ever been made, and I am obsessed by it. I buy book after book with this illustration in it of the Velázquez pope, because it just haunts me, it opens all sorts of feelings and areas – I was going to say – imagination, even, in me' (Sylvester 1993, p. 24). Sylvester thought the Velázquez portraits of Philip IV were also relevant in the 'elongated Bourbon features' (Sylvester 2000, p. 49), and that one also recalls Titian. The spectator is left to question the open mouth and that eternal self-mocking cry of anguish, laughter, pleasure or pain. Whichever of these, it may be the cry will never be heard as the figure is forever enclosed, isolated and silenced.

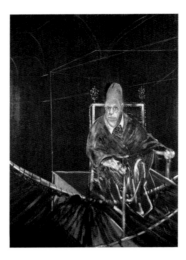

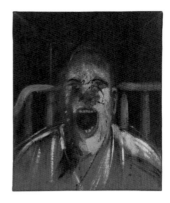

42
'Marching Figures'
1952
Francis Bacon
Oil on canvas; 198.1 × 137.2 cm

Private collection, courtesy The Estate of
Francis Bacon

The painting is unique in Bacon's œuvre in its pre-
sentation of a group of figures – in this instance what
appear to be marching soldiers in close formation.
The Francis Bacon Studio Archive (Dublin City Gallery
The Hugh Lane) contains a number of items relating
to war and militarism and, more specifically, to the
Nazi period (for example *Crucifixion*, 1965; Munich,
Pinakothek der Moderne). Elements of the Nazi pro-
paganda machinery, not least the Nuremberg Rallies,
interested Bacon: the so-called 'cathedral of light' at
Nuremberg was one possible source for the vertical
striations or 'shuttering effect' seen in the top half of
this composition. Designed by Albert Speer (although
chief propaganda minister Goebbels attempted to
take the credit), these displays were designed to show
the military might of Nazi Germany in theatrically
choreographed spectacle. With marching soldiers,
the night-time displays included 150 search lights in
the main arena that shone upwards into the night
sky. The lights could be seen over 100 kilometres
away and were described by the British politician, Sir
Neville Henderson, as a 'cathedral of light'. Aside from
powerful imagery of propaganda, Bacon was drawn to
the inhumanity of it all – the brutality of war and the
horrors that man was prepared to inflict on man.

43
Pope I
1951
Francis Bacon
Oil on canvas; 197.8 × 137.4 cm

Aberdeen Art Gallery and Museums Collections
Provenance: purchased from the Hanover Gallery by
the Contemporary Art Society in 1952 and presented
to Aberdeen in 1958

This work was acquired by Aberdeen through the
good offices of Bacon's patron Robert Sainsbury,
via the Contemporary Art Society. The Pope series
contains Bacon's most celebrated and recognisable
iconography. The earliest surviving painting is *Head
VI* (1949; London, Arts Council of Great Britain) but
the theme had been gestating for some time. In 1950
he completed at least three paintings, two of which
were long thought destroyed (see entry for *'Study after
Velázquez'*, cat. 41). In 1951 the Pope theme became
a dominant and recurring one and in the autumn
of 1951 he painted three Pope studies including this
work. They were exhibited at the Hanover Gallery
in December 1951. However, as with the later *Study
(Imaginary Portrait of Pope Pius XII)* in the Sainsbury
collection (cat. 47), the painting fuses the composition
of the Velázquez image with a face that suggests the
contemporary Pope Pius XII.

Bacon was drawn to Velázquez for the subject matter
and his uncanny ability to make the viewer believe he
is witnessing the person rather than simply a likeness.
In 1962 he stated: 'I've always thought this was the
greatest painting in the world and I've had a crush on
it and the magnificent colour of it' (Sylvester 2000,
p. 42). Bacon uses purple and gold against a blue-black
interior with fan vaulting, while the figure is enclosed
by an incomplete space frame. Colour as well as form
was critically important to Bacon, and he went on to
become recognised as one of the greatest colourists of
the twentieth century. The Velázquez Pope is magnifi-
cent and all-powerful, whereas Bacon reverses the psy-
chology and presents the Pope in isolation, stripped of
his power – a fragile and frightened individual, who
has just witnessed some terrible Nietzschean truth.

44
Study of a Head
1952
Francis Bacon
Oil on canvas; 49.5 × 39.3 cm

Yale Center for British Art, New Haven, USA
Provenance: purchased from the Leicester Galleries,
London, by Mr and Mrs Beekman C. Cannon and
gifted to Yale Center for British Art

Bacon resumed the Pope series in 1952 and here the
figure of a Velázquez-inspired pope is conflated
with that of a screaming old woman from Sergei
Eisenstein's 1925 film *Battleship Potemkin*. With shat-
tered spectacles and blood running down her face, the
woman is seen in a close-up frame in the Odessa Steps
sequence from the film (fig. 6, p. 19). Bacon titled this
work *Study of a Head*, although the skullcap suggest-
ed a later alternative: *Study for the Head of a Screaming
Pope*. However, the related portrait of Innocent X by
Velázquez in Apsley House, London (cat. 26) is much
closer in format to *Head VI* (1949; fig. 16, p. 32) than
the three-quarter-length Doria Pamphilj version.
Unlike the earlier *'Study after Velázquez'* (cat. 41), the
open mouth screams as if witnessing some horror.
Bacon was interested in the movement and shape of
the mouth, and particularly that of the teeth. Visiting
Paris in 1935, Bacon purchased a book illustrated
with colour plates entitled *Diseases of the Mouth*. The
artist had also been moved by Poussin's painting *The
Massacre of the Innocents* (1634), which he had seen at
Chantilly in the late 1920s and said had made 'a terrific
impression on me' (Sylvester 1993, pp. 34–5). Here, the
screaming head is placed in front of a gilded rail and
the space frame device brings the head into focus; as
Bacon stated, 'I use that frame to see the image – for
no other reason' (Sylvester 1993, p. 22). He also con-
sistently painted on the reverse side of commercially
primed canvas, having discovered in 1947–8 that the
rough surface offered the brush greater control when
applying the paint (Sylvester 1993, pp. 195–6).

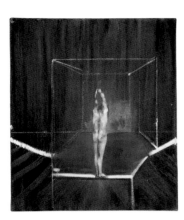

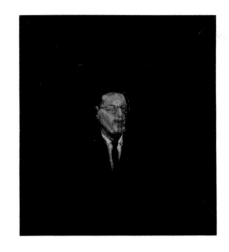

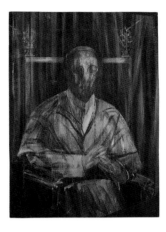

45
Study of a Nude
1953
Francis Bacon
Oil on canvas; 59.7 × 49.5 cm

Sainsbury Centre for Visual Arts
Provenance: purchased by Robert and Lisa Sainsbury
in 1953 from the Hanover Gallery, London;
donated to the University of East Anglia in 1973
(Sainsbury Centre for Visual Arts)

Lisa Sainsbury first encountered the paintings of
Francis Bacon at the Hanover Gallery at the beginning of 1953. Erica Brausen, the owner of the gallery,
agreed that Lisa could take *Study of a Nude* home on
approval to show her husband, Robert Sainsbury.
When he returned later that evening his response was
impulsive: 'We must have it. What is the price?' The
price was £125, not cheap for a work by a relatively
unknown contemporary artist, but their instinct
would prove perceptive. *Study of a Nude* was painted
between December 1952 and January 1953, and purchased in early February.

The power of this striking composition transcends
its modest size. The figure is enclosed within a
space frame, a device of Bacon's own invention. The
source of the figure is the photography of Eadweard
Muybridge, from his book *The Human Figure in Motion*
(1887), and specifically from a series called 'Man
Performing a Standing Broad Jump'. This book was
one of Bacon's principal sources of imagery, and
numerous examples are present in the Francis Bacon
Studio Archive (Dublin City Gallery The Hugh Lane).
The muscularity of the handling of the figure shows
the influence of Michelangelo: as Bacon remarked,
'Michelangelo and Muybridge are mixed up in my
mind together' (Sylvester 1993, p.114). But Bacon has
made the image his own and has produced a quite
terrifying composition. The lonely human figure
teeters on the brink of the abyss, on the very edge of
existence – posed, feet arched, as if confronting both
the enormity and the absurdness of the blue-black
nothingness. This was the first of Bacon's paintings to
enter the Sainsbury Collection. In an exhibition at the
ICA, London, in 1954 it was described as 'Study from
the Human Body'.

46
Portrait of R.J.Sainsbury (Robert Sainsbury)
1955
Francis Bacon
Oil on canvas; 114.9 × 99.1 cm

Sainsbury Centre for Visual Arts
Provenance: purchased by Robert and Lisa Sainsbury
in 1955 directly from the artist via the Hanover
Gallery, London; donated to the University of East
Anglia in 1998 (Sainsbury Centre for Visual Arts)

The painting was commissioned by Lisa Sainsbury
and created in March 1955 at Bacon's studio in Mallord
Street, off the King's Road, London. Rather than working from photographs, which was his usual practice,
here Bacon worked from life, and Robert Sainsbury
went to the studio over a series of nine lunchtime sessions. The portrait should be viewed within the context of the many *Head* studies that Bacon completed in
the mid 1950s, such as *Three Studies of the Human Head*
(1953; private collection). In addition, in 1954 Bacon
began a series of seven paintings under the shared
title *Man in Blue*, in which a single male figure in a formal suit, collar and tie is shown against a blue-black
ground. As with the portrait of Robert Sainsbury, the
suit shares the colour of the ground so that only the
face, shirt and tie emerge from the darkness.

This portrait is remarkable for the economy of its
composition: the head seems to float over a deep black
ground. Here Bacon has produced an image that,
while unmistakably a portrait, succeeds as an intense
physiological exercise in his preoccupation with the
human condition. This intensity of feeling is reflected
in the artist's interest in Rembrandt, especially the
self-portraits. Musing on the mystery of one particular
self-portrait, Bacon noted Rembrandt's ability to
create an image from non-rational marks by 'a coagulation of non-representational marks' (Sylvester
1993, p.58). A similarly profound quality is seen in this
striking portrait of Robert Sainsbury.

47
Study (Imaginary Portrait of Pope Pius XII)
1955
Francis Bacon
Oil on canvas, mounted on hardboard; 108.6 × 75.6 cm

Sainsbury Centre for Visual Arts
Provenance: given by the artist to Robert and
Lisa Sainsbury in 1955; donated to the
University of East Anglia in 1973 (Sainsbury
Centre for Visual Arts)

Painted towards the end of 1955 at Overstrand
Mansions, Battersea, London, the painting owes its
survival to Robert and Lisa Sainsbury. After meeting
the artist at a party hosted by Erica Brausen, Bacon
talked of his work on a pope painting that he believed
had gone well that day. The evening progressed and
Robert and Lisa asked to see the painting, but Bacon
was now sounding less convinced and by the time
they reached his studio he declared that he wanted to
destroy it. They argued for an hour, pleading with him
to spare the painting – Robert stated that it was 'the
most wonderful face ever'. Bacon took a razor blade,
cut out the figure and said 'take it away'.

The theme of the Pope is perhaps the most famous of
Bacon's imagery, inspired by the remarkable portrait
of Innocent X by Diego Velázquez. However, the
painting fuses the composition of the Velázquez
image with a face that suggests the contemporary
Pope Pius XII (as does *Pope I* from Aberdeen, cat. 43).
Seated on a papal throne decorated with gilded finials,
the Pope looks directly out at the viewer; he emerges
from and at the same time is partly fused with a
transparent curtain or screen. Bacon's development of
this device, which he called 'shuttering', is particularly
successful in this painting. The effect was to formalise
the folds in background curtains into stripes so that
they pass very emphatically through the figure.

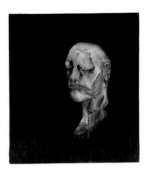

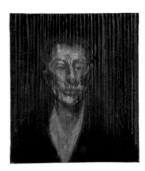

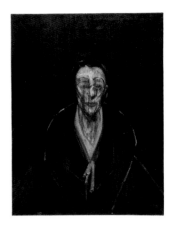

48
Study for Portrait II (After the Life Mask of William Blake)
1955
Francis Bacon
Oil on canvas; 61 × 50.8 cm

Tate Collection
Provenance: purchased from the Hanover Gallery, London by Lady Caroline Citkowitz (later Lady Caroline Lowell) in 1955; purchased by the Tate in 1979 from Lady Caroline Lowell through the Mayor Gallery, London (Grant in Aid)

This is the second of a series of five works based on the life mask of William Blake, the visionary English artist and poet. It is believed that the first three were painted in January 1955 in the Imperial Hotel at Henley-on-Thames, the fourth some weeks later and the fifth the following year. Bacon destroyed two further versions. Initially titled *Study for a Portrait*, the source was immediately identified and subsequently became part of the title. Although Bacon later owned a version of the life mask (p. 179), the source for these paintings was a series of photographs of the mask in the National Portrait Gallery, London. Ronald Alley states that the theme was suggested to Bacon by the composer, Gerard Schurmann, who asked him to design a cover for his song cycle setting some of Blake's poems to music (Alley 1964, p. 92). Schurmann took Bacon to see the plaster cast made after J. S. Deville's famous 1823 life mask of William Blake, but the cover was never completed. Instead Bacon created the paintings based mainly on photographic reproductions, although he did make return visits to the Portrait Gallery.

There has been speculation whether, in fact, Blake's perceived personality was an inspiration to Bacon. Alley wrote of the 'ectoplasmic quality of an apparition', noting that 'the expression, with the closed eyes, suggests a tremendous inward concentration and imaginative power: a true spiritual portrait, one feels, of this great visionary poet and painter' (*Tate Gallery Report 1978–80*, London 1980, p. 39). The head of Blake is off-centre and the space frame is barely perceptible. It appears to be floating against the deep rich black of the ground, and Bacon achieves a sculptural quality to the portrait by applying the modulated paint in high relief. The contrast between the intense dark background and the painted head is striking and ethereal. Bacon manipulates the paint in broad gestural strokes and judicious smearing of paint, and there is a compositional relationship with the portraits of Lisa Sainsbury that he started to paint later the same year (cat. 49, 50 and 54).

49
Sketch for a Portrait of Lisa
1955
Francis Bacon
Oil on canvas; 61 × 54.9 cm

Sainsbury Centre for Visual Arts
Provenance: given by the artist to Robert and Lisa Sainsbury in 1955; donated to the University of East Anglia in 1998 (Sainsbury Centre for Visual Arts)

After commissioning the portrait of Robert in 1955 (cat. 46), Lisa was asked by Bacon if she would sit for him, and thus began a remarkable series of portraits, of which this is the earliest surviving example. Bacon painted as many as eight versions between September 1955 and 1957. Three of the surviving portraits are in the Robert and Lisa Sainsbury Collection (cat. 50, 54). The rest were destroyed, or at least discarded, in the rather ritualistic way in which Bacon would routinely cull his work during this period. *Sketch for a Portrait of Lisa* is often referred to as the best.

The figure is veiled by a series of vertical striations typical of his work of the 1950s and providing depth to the picture whilst at the same time partially obscuring the sitter. Like most of his paintings from the period, the figure emerges from an infinite black background, illustrating Bacon's artistic debt to the Old Masters that he so admired. The deft handling of paint is also characteristic of his work. With an economy of strokes Bacon was able to create the illusion that the viewer is truly seeing the sitter rather than simply a painted likeness. As has often been noted, the tenderness of the portrayal seems to reflect the artist's affection for the sitter, which is reminiscent of the famous bust of the Egyptian Queen Nefertiti in the Neues Museum in Berlin. The work may also be linked to Bacon's painting *Head* (1956; illustrated in Alley 1964, cat. 111), based on the head of Pharaoh Akhenaton, which, although male, appears to relate closely to the portraits of Lisa. Bacon visited Egypt en route to South Africa in November 1950 and considered ancient Egyptian art unsurpassed in its visual power. *Sketch for a Portrait of Lisa* was painted towards the end of 1955 when, after years of a nomadic existence, Bacon settled with friends in a flat in Overstrand Mansions in Battersea. It was here that he painted numerous masterpieces including this portrait of Lisa Sainsbury.

50
Portrait of Lisa
1956
Francis Bacon
Oil on canvas; 100.6 × 72.7 cm

Sainsbury Centre for Visual Arts
Provenance: purchased by Robert and Lisa Sainsbury in 1956 from the artist via the Hanover Gallery, London; donated to the University of East Anglia in 1998 (Sainsbury Centre for Visual Arts)

In September 1955 Bacon moved to Overstrand Mansions in Battersea. He lived and worked in the flat shared by his friends, Paul Danquah and Peter Pollock, for six years, although with frequent trips away, particularly to Tangier. All three surviving portraits of Lisa were painted in Battersea, the first in October–November 1955 and this one in May 1956. The cramped living/studio room in the flat was recorded by the photographer Cecil Beaton in 1959–60 (fig. 20, p. 138). Well before he moved to his more famous Reece Mews studio, Bacon worked amidst similar chaos and clutter – the floor strewn with source material and tubes of paint, the curtains used for wiping paint from his hands – as Lisa confirmed in an interview with the art critic David Sylvester in 1996. Lisa tended to sit in the mornings, which was Bacon's preferred working time, and each session would last an hour to an hour and a half during which the conversation would flow freely. Often Lisa would return only to find the previous day's work had been destroyed. Bacon preferred Lisa not to see the paintings during creation. On one occasion, when she did catch sight of a painting that she considered the very best, Bacon admitted 'it's gone' – meaning that it was destroyed and lost forever.

51
Study for a Portrait of Van Gogh I
1956
Francis Bacon
Oil on canvas; 154.1 × 115.6 cm

Sainsbury Centre for Visual Arts
Provenance: purchased by Robert and Lisa Sainsbury
in 1956 from the Hanover Gallery, London; donated
to the University of East Anglia in 1973 (Sainsbury
Centre for Visual Arts)

The Van Gogh series was a watershed in Bacon's career.
This work, the first in the series, is one of the most high-
ly regarded. The painting was completed in early 1956
and included the following year in an exhibition at the
Hanover Gallery in London, along with four other paint-
ings relating to Van Gogh. The accounts of this celebrat-
ed exhibition's opening night in March 1957 have added
to the Bacon mythology ever since: some of the paint-
ings had arrived very late and were still wet; the rooms
were so densely packed that paint was smeared onto
people's clothes; the artist himself suddenly appeared,
staunching a wound to his scalp after an object had
fallen on him from the balcony. But the critical response
was remarkable: universal praise from the critics for
the first time. John Golding in the *New Statesman and
Nation* suggested that the exhibition confirmed Bacon's
status as the 'most controversial and influential living
English painter' (6 April 1957). John Russell in *The Times*
and Neville Wallis in the *Observer* both singled out this
painting as the most successful.

Van Gogh's self-portrait, *Painter on the Road to Tarascon*
(1888; destroyed in the Second World War but formerly
in Magdeburg, Kaiser-Friedrich Museum; fig. 7, p. 21),
is credited as the inspiration for *Study for a Portrait of Van
Gogh I*, and it was certainly known to Bacon through
colour reproductions. The Dutchman's *Sower* of the
same year (Otterlo, Kröller-Müller Museum) may also
have played on his mind. Bacon was fascinated, too, by
Van Gogh's published letters, which were a constant
source of inspiration. Here, the thickness of the paint
and the repeated reworking suggest that it took time
for an image to coalesce from out of the miasma. The
dark and brooding presence that did materialise now
seems trapped in paint, its haunting eyes peering out
from within, while the black shadow, little more than a
stain, haunting what Bacon called the 'Phantom of the
road', surely signals death. The figure and vegetation
were once thought to have been cut out from another
canvas, although the artist denied it and recent research
confirms Bacon's account: the heavily textured paint-
ing is scraped back with a palette knife. The sombre
palette is disrupted by the vibrant yellow of the straw
hat and shoulder straps, as well as the two intriguing
red V-shaped paint-strokes, as if spelling out his hero's
name. This is unquestionably one of the most important
paintings in the Sainsbury Collection.

52
'Figures in a Landscape'
1956
Francis Bacon
Oil on canvas; 147.3 × 132.1 cm

Private collection, courtesy The Estate of
Francis Bacon

The crouching nude has several sources, as has
already been discussed (see entry for *Two Figures in a
Room*, 1959; cat. 57), but Michelangelo's *Crouching Boy*
(1530–4; cat. 11) is the most relevant. The work is one
of several crouching nude studies that Bacon painted,
and is also closely related to *Figures in a Landscape* (1956;
Birmingham Art Gallery). The landscape in the com-
position may be a reference to a trip to South Africa
that Bacon made in the same year, and the grasslands
of the Veld appear in a number of works from the
period. Although less obviously grassland in this
painting, the landscape is created by rapid, sweeping
brush strokes with hints of colour that make up the
background and engulf the figures.

53
Owls
1956
Francis Bacon
Oil on canvas; 61 × 51 cm

Private collection

Bacon was principally concerned with the human
body but animals appear routinely in his work,
including apes, dogs, elephants and owls. The 1950s
were a time of debate in zoology, ethology and human
socio-biology, concerning human as well as animal
behaviour. After so much savagery and butchery in
two world wars, the post-war era was marked by
renewed examination of what constitutes human-
ity in a world now haunted by the thought that the
human species was no more than a 'human animal'.
This was, of course, an intrinsically Baconian theme.

The source of this image was a plate entitled 'Newly
fledged long-eared owls' from *Birds of the Night* (1945)
by the ornithological photographer Eric Hosking. The
composition is particularly faithful to Hosking but
perhaps the most striking element of the painting is
the deep blue ground. This gloriously rich colour is
more associated with the Virgin in Italian Renaissance
painting or as a backdrop in historical portraits such
as Giovanni Bellini's *Portrait of Doge Leonardo Loredan*
(1501–4; London, National Gallery).

The owl is fertile in symbolism and mythology
throughout art history, and as a motif it appears in
a number of Bacon's works. For instance, two owls
appear as finials on the throne of a pope in *Pope with
Owls* (1958; Brussels, Musée d'Art Moderne). The
presence of these two watchful, wise and nocturnal
creatures, framing a nervous and anguished pope,
adds an unsettling motif to the composition, whereas
here the two owls gaze out at the spectator as if to bear
witness. The subject of owls returns in two sketches –
Two Owls, No.1 and *Two Owls, No.2* (London, Tate), both
dated *c.*1961.

Catalogue Entries

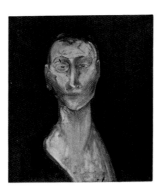

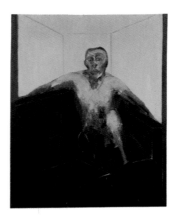

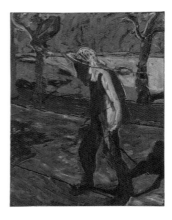

54
Portrait of Lisa
1957
Francis Bacon
Oil on canvas; 59.7 × 49.5 cm

Sainsbury Centre for Visual Arts
Provenance: given by the artist to Robert and
Lisa Sainsbury in 1957; donated to the
University of East Anglia in 1998 (Sainsbury
Centre for Visual Arts)

The third surviving portrait of Lisa Sainsbury was
painted in 1957; according to Lisa, it was painted
quickly. Of the three it is the most expressionist in
style and the least recognisable as a likeness. The
elongated head and neck are richly painted in strik-
ingly bold colours, which are fleshy and raw and
reminiscent of Soutine. The greater control of paint,
even when applied thickly and in relief, demon-
strates Bacon's growing confidence in its handling.
The resulting form is finely sculptured but Lisa later
claimed of the portraits, 'I could never see myself in
them'. Bacon once said of Picasso that he absorbed
everything, and Bacon likewise fused multiple and
varied sources and references into each image. Art
critic David Sylvester states that when he sat for Bacon
the artist was also looking at other found imagery,
even when painting from life. Bacon would later claim
in an interview in 1966 that he found it inhibiting to
have the subject sitting in front of him. 'They inhibit
me because, if I like them, I don't want to practise the
injury I do to them in my work. I would rather prac-
tise the injury in private by which I think I can record
the fact of them more clearly' (Sylvester 1993, p. 41).

55
Study for Portrait of P.L., No. 2
1957
Francis Bacon
Oil on canvas; 151.8 × 118.5 cm

Sainsbury Centre for Visual Arts
Provenance: purchased by Robert and Lisa Sainsbury
in 1957 from the Hanover Gallery, London;
donated to the University of East Anglia in 1973
(Sainsbury Centre for Visual Arts)

Bacon's relationship with Peter Lacy ('P.L.') was com-
plicated and emotionally charged. He is portrayed in a
confident, watchful pose that verges on the menacing.
This is one of two portraits he made of Lacy in 1957
before returning to the subject for a posthumous
study in 1963. The composition marks an early break
from the dark brooding interiors of the 1950s with the
top third of the interior bathed in light. The familiar
space frame device focuses attention on the head,
underlying Bacon's statement, 'I use the frame to see
the image – for no other reason' (Sylvester 1993, p. 22).
The head or, more specifically, the face is the focus, and
the power and technical virtuosity of the modelling in
paint is striking, revealing a debt to Picasso. The great
paintings of the past by artists such as Ingres, Degas,
Gauguin and Picasso would permeate Bacon's work.
'It's not so much the painting that excites me', he stat-
ed, 'as that the painting unlocks all kinds of sensation
within me which returns me to life more violently'
(Sylvester 1993, p. 142). The pale green painted back-
ground is rich in debris and studio detritus. Bacon has
conjured up a life mask of Peter Lacy, and rather than
diminishing the overall effect, the truncated torso
intensifies the magnetic sensation of Lacy's gaze.

56
Study for a Portrait of Van Gogh IV
1957
Francis Bacon
Oil on canvas; 152.4 × 116.8 cm

Tate Collection
Provenance: purchased from the Hanover Gallery by
the Contemporary Art Society and the R.J. Sainsbury
Discretionary Fund and presented to the Tate in 1958

This painting was acquired by the Tate through the
good offices of Bacon's patron Robert Sainsbury, via
the Contemporary Art Society. In addition to *Study for
a Portrait of Van Gogh I* in the Sainsbury Collection (cat.
51), Bacon completed *Van Gogh II*, *Van Gogh III* and this
painting, *Van Gogh IV*, prior to the 1957 exhibition at
the Hanover Gallery. Two further canvases arrived
after the opening, identified by Ronald Alley as *Study
for a Portrait of Van Gogh V* and *Study for a Portrait of Van
Gogh VI*. The work signalled a dramatic shift in Bacon's
technique: the boldly painted expressionist colouring
contrasted with the more sombre palette employed in
the preceding years. The primary colours of blue, red
and yellow, as well as orange, feature prominently in
the background. The figure is mostly in shadow and so
rendered in black, apart from the bold striking yellow
of the hat. As with the Sainsbury painting, Bacon
applied the paint thickly and used a palette knife in
some areas to scrape back the surface to the underly-
ing colour. Similar, too, is the way the background was
added around the figure.

This composition relates closely to Van Gogh's
self-portrait, *Painter on the Road to Tarascon* (1888; fig.
7, p. 21). The colouration and the application of paint
are informed by Soutine, who Bacon is known to have
admired. Bacon never saw the original painting by
Van Gogh, but as with his works based on Velázquez's
Portrait of Innocent X his established method was to
work from reproductions and photography, which
he found suggested more than the original. There
can be little doubt that Bacon identified with Van
Gogh and his struggles to be accepted as a painter, so
evident in his famous letters to his brother Theo. The
works could therefore be considered, in part at least,
as a series of self-portraits that metamorphosed out
of the haunted figure of Van Gogh. The release of the
film *Lust for Life*, starring Kirk Douglas, in September
1956 may have played a part in the series, although the
Sainsbury *Van Gogh* predates it by some months.

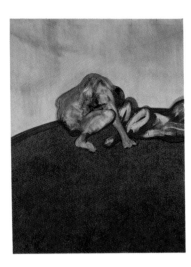

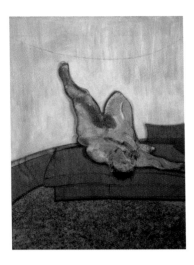

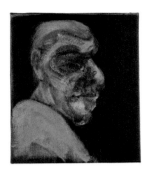

57
Two Figures in a Room
1959
Francis Bacon
Oil on canvas; 198 × 142 cm

Sainsbury Centre for Visual Arts
Provenance: purchased by Robert and Lisa Sainsbury
in 1960 from the Marlborough Gallery, London;
donated to the University of East Anglia in 1973
(Sainsbury Centre for Visual Arts)

This was the first of the Sainsbury Bacon paintings to
be created in what would become his standard large-
scale format. It was also the first painting acquired
after the artist's switch to Marlborough Fine Art Ltd
from the Hanover Gallery in October 1958. Although
the title indicates a room, gone are the claustrophobic
interiors of the 1950s, replaced with a more expansive
space and lighter palette. The crouching nude has sev-
eral possible sources, including Matisse's *Bather with a
Turtle* (1908; New York, MOMA) and Degas's *After the
Bath, Woman Drying Herself* (c. 1890–5; London, National
Gallery), but Michelangelo's carving of *Crouching Boy*
(c. 1530–4; cat. 11) is the most relevant source for a work
in which it seems as if the spine 'almost comes out of
the skin altogether' (Sylvester 1993, pp. 46–7). The
painting shares many characteristics with another by
Bacon, *Lying Figure* (1959; cat. 58), such as the barely
visible arc at the top. In addition the canvas was first
painted in emerald green, identical to an unfinished
canvas in the Francis Bacon Studio Archive (Dublin
City Gallery The Hugh Lane; p. 179). The bottom two
thirds of the painting are a mixture of red/pink, blue
and white over green. This is worked into a stippled
impasto, modulated using a cloth or rag, and rich in
studio detritus. A flattened band of paint along the
very top edge suggests the painting may have been
framed before it was completely dry, and exhibit-
ed shortly afterwards at Bacon's first Marlborough
Gallery exhibition in March to April 1960. The reclin-
ing figure is painted with a green halo affect and has
a somewhat spectral presence but nevertheless adds a
suggestive charge to the composition.

The painting was completed between Porthmeor
Studios, St Ives, where Bacon resided between
September 1959 and January 1960, and London, at
Overstrand Mansions, prior to the exhibition in
March. This is supported by the fact that the painting
shows signs of having been taken off its stretcher,
presumably for ease of transport.

58
Lying Figure
1959
Francis Bacon
Oil on canvas; 198.5 × 142.6 cm

New Walk Museum & Art Gallery, Leicester
Provenance: purchased from Marlborough Fine
Art Ltd with the assistance of the Museums and
Galleries Commission / Victoria and Albert Museum
Purchase Grant Fund, 1960

This painting was shown in Bacon's first Marlborough
Gallery exhibition in March to April 1960 alongside
Two Figures in a Room (1959; cat. 57). The two paintings
share the same organisation of space, the painted
arc at the top of the canvas and a similar palette. The
canvas also has a painted ground of emerald green,
identical to an unfinished canvas in the Francis Bacon
Studio Archive (Dublin City Gallery The Hugh Lane;
p. 179). Likewise, the bottom third is handled in a sim-
ilar manner but with a different colour combination.
The paint is applied as a stippled impasto, possibly
worked over with a cloth or rag, and is rich in studio
detritus. The figure in the composition is closely
related to *Reclining Woman* (1961; London, Tate) as well
as two associated sketches, *Reclining Figure, No.1* and
Reclining Figure, No.2 (c. 1961; London, Tate). The figure
rests awkwardly on a green sofa with one leg raised.
Annotations made by Bacon between December 1958
and January 1959 on the endpapers of V. J. Stanek's
book *Introducing Monkeys* (c. 1957; Tate Archive) indicate
that these forms were variations on the contorted
figures of Rodin: 'Figure as Rodin figure on Sofa in
centre of room with arms raised'; 'use figure volante of
Rodin on sofa arms raised' (Gale 1999, pp. 77–9). The
painting was completed in Porthmeor Studios, St Ives,
where Bacon resided between September 1959 and
January 1960, or in London at Overstrand Mansions
prior to the exhibition in March.

59
Head of a Man
1960
Francis Bacon
Oil on canvas; 38.5 × 32 cm

Sainsbury Centre for Visual Arts
Provenance: purchased by Robert and Lisa Sainsbury
in 1960 from the Marlborough Gallery, London;
donated to the University of East Anglia in 1973
(Sainsbury Centre for Visual Arts)

The switch to Marlborough Fine Art, and the period
in St Ives prior to his first exhibition, was a pivotal
moment in Bacon's career. Bacon rented a studio in
St Ives from the artist William Redgrave, who ran an
art school in Porthmeor Studios. He paid six months'
rent, suggesting he had planned to stay until his
inaugural exhibition at Marlborough in March 1960.
This portrait may well be based, at least in part, on
Redgrave. The paint has been expressively manipu-
lated and worked with brush and rag, achieving in
a few gestures a portrait with remarkable sculptural
qualities. It is significant that Bacon later empha-
sised the role of accident in his use of source material
– the 'transformations of existing images' – in his
conversations with art critic David Sylvester. In 1962
(at a time when Sylvester was preparing a London
retrospective of Soutine), Bacon told him: 'I foresee
[the transformed work], and yet I hardly ever carry
it out as I foresee it. It transforms itself by the actual
paint' (Sylvester 1993, p. 16). Here the painted canvas
folds around the stretcher frame and has unevenly cut
edges, suggesting that the painting may have been
reduced in size. The head has great variation in the
thickness of paint; in some areas the canvas texture
is clearly visible while in other places, where paint
expresses the facial features, it is worked up into thick
impasto in a variety of colours including pink-red,
green-blue, yellow and white-cream.

Catalogue Entries

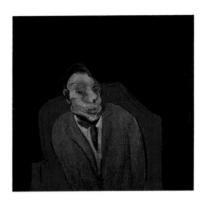

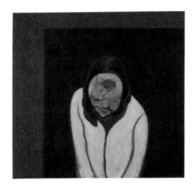

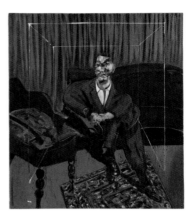

60
Head of a Man
1960
Francis Bacon
Oil on canvas; 85.2 × 85.2 cm

Sainsbury Centre for Visual Arts
Provenance: purchased by Robert and Lisa Sainsbury
in 1960 from the Marlborough Gallery, London;
donated to the University of East Anglia in 1973
(Sainsbury Centre for Visual Arts)

The painting *Head of a Man* is a self-portrait and when
Robert Sainsbury purchased it he understood it to
be so. The matter is noted in a letter from Sainsbury
to Ronald Alley in March 1962 in which he states,
'[Bacon] himself told me it is a self-portrait. In any case
the likeness confirms the matter' (Robert Sainsbury
Archive, University of East Anglia). As such this is a
relatively early self-portrait; from the late 1960s they
become more common. In these it is the influence of
late Rembrandt that is perhaps felt most keenly, in
particular the Dutch master's ability to bring forth the
physiological intensity of his subject, typified by the
extraordinary self-portraits associated with his late
style in which paint and image are impossible to sepa-
rate. In an introduction to the painter Matthew Smith,
Bacon wrote of a 'complete interlocking of image
and paint, so that the image is the paint and vice
versa.' He continued: 'Here the brush-stroke creates
the form and does not simply fill it in. Consequently,
every movement of the brush on the canvas alters the
shapes and implications of the image. This is why real
painting is a mysterious and continuous struggle with
chance – mysterious because the very substance of the
paint, when used in this way, can make such a direct
assault upon the nervous system; continuous because
the medium is so fluid and subtle that every change
that is made loses what is already there in the hope of
making a fresh gain' (Peppiatt 2006, p. 65).

The painting was purchased by Robert and Lisa
Sainsbury, along with *Two Figures in a Room* (cat. 57),
Head of a Man (cat. 59) and *Head of Woman* (cat. 61),
directly from the Marlborough Gallery's exhibition
Francis Bacon: Paintings 1959–1960, in the spring of 1960.

61
Head of Woman
1960
Francis Bacon
Oil on canvas; 85.2 × 85.2 cm

Sainsbury Centre for Visual Arts
Provenance: purchased by Robert and Lisa Sainsbury
in 1960 from the Marlborough Gallery, London;
donated to the University of East Anglia in 1973
(Sainsbury Centre for Visual Arts)

The painting was completed in the lead-up to
Bacon's first exhibition with Marlborough Fine Art
in March 1960. It may have been started and perhaps
even completed in St Ives, as the subject is believed
to be a portrait of Mary Redgrave, wife of the artist
William Redgrave who rented Bacon a studio in
St Ives. Only six paintings have been documented
as being completed in St Ives (Alley 1964, p. 124).
However, according to Redgrave, a large number of
unfinished canvases were shipped up to London when
Bacon returned in early January, and completed at
Overstrand Mansions in time for the exhibition in
March. Bacon was photographed in his studio prior to
the exhibition by Cecil Beaton, surrounded by some of
the thirty-two paintings he showed at Marlborough
that spring (fig. 20, p. 138). Bacon completed seven
paintings with the title *Head of Woman* and this one
was catalogued in the exhibition as 'no. 30'. The use of
emerald green for the ground links many paintings
from this period, and the sitter appears in several por-
trait heads from the St Ives period. The broad expres-
sive brushstrokes sweep around the left eye socket and
provide a sense of a figure in motion, causing the nose
and mouth to undertake disfiguration, or what Bacon
described as 'disruption' or 'distortion' (Sylvester 1993,
p. 116). His desire was for realism to be reinvented.
Recalling one of Van Gogh's letters to his brother
Theo, Bacon states that Van Gogh 'speaks of the need
to make changes in reality, which become lies that are
truer than literal truth. This is the only possible way
the painter can bring back the intensity of the reality
which he is trying to capture' (Sylvester 1993, p. 172).

62
Seated Figure
1961
Francis Bacon
Oil on canvas; 165.1 × 142.2 cm

Tate Collection
Provenance: purchased from Marlborough Fine Art
Ltd, London, by J. Sainsbury Ltd for presentation to
the Tate Gallery in 1961

Acquired by the Tate under the patronage of Robert
Sainsbury, this was the sixth painting by Bacon
to enter the National Collection, and is a masterly
example of his accomplishment as painter. Although
not identified, the subject resembles Peter Lacy, who
died in Tangier in 1962. The painting recalls earlier
works of the 1950s portraying the same man in formal
dress (the *Man in Blue* series) and placed in a space
frame. Although Bacon claimed 'I use that frame
to see the image' (Sylvester 1993, p. 22), the intense
claustrophobia created by the enclosure heightens
the sense of isolation from the world around. An
existential reading of the space frame imagery might
identify the condition of man as one of loneliness
and isolation, although Bacon distanced himself
from any such interpretation. This work was painted
in 1961, the same year that Adolf Eichmann went on
trial in Jerusalem, and the image of the accused in
headphones, enclosed within a bullet-proof glass box,
provides a chilling parallel. Although Bacon's use of
the space frame predates this by over a decade, a pho-
tograph of Eichmann's trial was found in his studio.

The seated figure is placed over a large expanse of
deep red. These colour fields had become increasingly
common from the late 1950s onwards, echoing devel-
opments in abstract painting of the period, although
Bacon had used expanses of colour in his work of the
1940s. Splashes of paint and incidental marks denote
a more contemporary concern with the physical act of
painting. The figure or, more specifically, the head is
the most thoroughly worked area, producing a highly
textured surface in relief. The smearing of the paint
creates distortions without loss of the actual image:
the likeness, it seems, has emerged from the paint
itself. Unlike the intensity of the portraits of the 1950s,
Bacon now placed his figures in recognisable domestic
spaces, in this case with a chair, sofa and rug. The
vertical grey striations, meanwhile, recall the Pope
paintings of 1950.

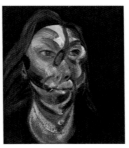

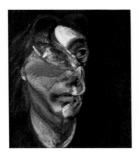

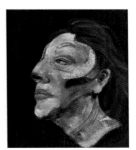

63
Landscape near Malabata, Tangier
1963
Francis Bacon
Oil on canvas; 198 × 145 cm

Private collection, London

Landscape near Malabata, Tangier is inscribed 'Tangier'
on the back but, intriguingly, Ronald Alley states that
it was painted in London (Alley 1964, p. 152). The title
assumes the absence of a figure, although this is con-
founded by an inexplicable presence in the shadowy
forms. It is as if the figure has simply vaporised before
our eyes. The place – 'near Malabata' – is where Peter
Lacy ('P. L.') was buried the year before. Bacon's rela-
tionship with Peter Lacy was complicated and emo-
tionally charged. The trips to Tangier had by this time
become more irregular than in the previous decade,
and this event marked the closing of an important
chapter in Bacon's life. Within a few short years the
support afforded by Marlborough Fine Art, along
with Bacon's move to 7 Reece Mews, gave the artist
some stability at last from the nomadic existence of
previous years. Reece Mews was a former coach house
in South Kensington. With the old stables below, the
flat was approached by a steep wooden staircase. The
living quarters offered a modest-sized studio with a
single skylight. Amongst the chaos of accumulated
source material and painting materials there was
barely enough room to complete paintings such as
this one, at what became Bacon's standard canvas size
of 198 × 145 cm.

64
Three Studies for Portrait of Isabel Rawsthorne
1965
Francis Bacon
Oil on canvas; 35.5 × 30.5 cm (each panel)
Inscribed in Bacon's hand on the back of the left
canvas: *3 studies of portrait Isabel Rawsthorne 1965*

Sainsbury Centre for Visual Arts
Provenance: purchased by Robert and Lisa Sainsbury
 in 1965 from the Marlborough Gallery, London;
 donated to the University of East Anglia in 1973
 (Sainsbury Centre for Visual Arts)

Isabel Rawsthorne was a painter and friend of Bacon.
She had been painted by Picasso and André Derain
and was a confidante of Alberto Giacometti. After the
Second World War she settled in London where she
subsequently met Bacon, and they became close. This
painting is the second of the fourteen portraits of
Rawsthorne that Bacon painted and the first triptych,
of which he went on to produce five. The small-scale
triptych of heads became an established format in the
1960s; in all Bacon produced more than forty, claim-
ing that the inspiration was police file photographs
(Sylvester 1993, p. 86). A number of other close friends
were also painted in this format, including George
Dyer, Lucian Freud, John Hewitt, Henrietta Moraes
and Muriel Belcher. 'I see every image all the time in a
shifting way and almost in shifting sequence', Bacon
commented (Sylvester 1993, p. 21).

The painting presents three views of Rawsthorne,
the centre panel being a frontal view, while the left
shows the head turned towards the centre and the
right a profile. At this time Bacon could no longer bear
to have his subjects in the studio so he used photo-
graphs commissioned from his friend, the celebrated
photographer John Deakin, who produced several
series of images for Bacon as source material. Deakin's
photographs of Rawsthorne in the Francis Bacon
Studio Archive (Dublin City Gallery The Hugh Lane;
fig. 29, p. 151) demonstrate how Bacon could physically
manipulate photos of the sitter. Selectively torn,
creased, folded and crumpled, the features were dis-
torted in ways that Bacon could then transfer to paint.
But despite the distortions it is remarkable how Bacon
was able to retain a likeness of his subject, in a similar
way to Picasso. This work shows Bacon at the height
of his powers, combining masterly technique whilst
'locking in' the essence of the sitter. The application of
paint and brushwork is assured and confident, often
showing the imprint of a cloth. The pinholes found in
the corner of each canvas suggest that they may have
been painted prior to stretching.

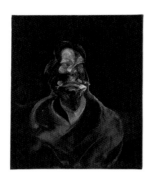

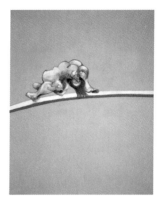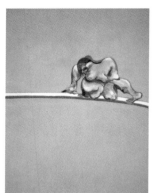

65
Portrait of Isabel Rawsthorne
1966
Francis Bacon
Oil on canvas; 81.3 × 68.6 cm

Tate Collection
Provenance: purchased by the Tate from the
 Marlborough Gallery, London, in 1966

This portrait was painted just one year after the
Sainsbury triptych *Three Studies for Portrait of Isabel
Rawsthorne* (cat. 64); it was exhibited alongside five
other portraits of Rawsthorne in March 1967 at the
Marlborough Gallery. The masterly technique of the
triptych is evident here, but the composition, a head
against a black ground, is a return to the mid-1950s.
Bacon went to great lengths to explain his style of
portrait painting: he aimed above all to avoid illustra-
tion, seeking instead to unlock the very essence of the
human character through a kind of transfiguration
which he saw in the work of artists such as Ingres,
Cézanne or Degas. Bacon often claimed this could
happen by chance, intuition or accident: 'I used a very
big brush and a great deal of paint and I put it on very,
very freely, and I simply didn't know in the end what
I was doing, and then suddenly this thing clicked,
and became exactly like this image I was trying to
record' (Sylvester 1993, p.17). The remarkable paint-
work applied in the construction of the head is an
exercise in paint manipulation. The work is a grand
portrait in the historical tradition, reinvented by
Bacon in the mid-twentieth century as part of the
modernist project. He would acknowledge his debt
to the great masters of the past such as Velázquez
or Rembrandt, without compromising his radical
approach to image making.

66
Studies of the Human Body
1970
Francis Bacon
Oil on canvas; 198 × 147.5 cm (each panel)

Private collection, courtesy Ordovas

Following the celebrated *Three Studies for Figures at the
Base of a Crucifixion* (1944; London, Tate), Bacon did
not return to a large format triptych until 1962, when
he painted *Three Studies for a Crucifixion* (New York,
Solomon R. Guggenheim Museum; fig. 3, p.17). That
the format has now become synonymous with Bacon
is a testament to his achievement in the late period
of his career. This work dates from 1970, and the
period is recognised as a highpoint in his creation of
large-scale triptychs.

A single female figure in each panel is placed along a
rail or bar on a lilac ground. The central figure rests
on a low plinth and is framed by a striking black
umbrella. The bold expanse of a single colour recalls
the so-called 'great decorations' of Matisse, such as
Nymph and Satyr (1908–9; cat. 35) and also particularly
his treatment of interior space. The three truncated
and distorted naked figures recall more sculptural
concerns, as well as the treatment of bodies in the
work of Rodin. The female figures may well have
been sourced from John Deakin's photographs of
Henrietta Moraes, which Bacon had commissioned
in 1963 or early 1964. This seems most evident in the
central reclining figure. Many of Bacon's nude female
figures were based on these photographs of Moraes,
celebrating the curvaceous fleshiness of her form.
During this period Bacon expressed his desire to work
in sculpture, although he stated that 'I haven't done it
yet because each time I want to do it I get the feeling
that perhaps I could do it better in painting' (Sylvester
1993, p.108).

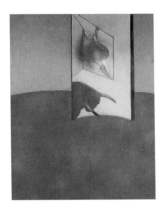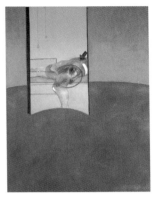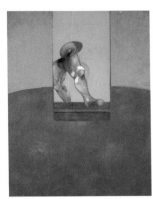

67
Triptych
1987
Francis Bacon
Oil on canvas; 198 × 147.5 cm (each panel)

Private collection, courtesy The Estate of
 Francis Bacon

The Spanish bullfight was a theme that Bacon turned
to on a number of occasions. It is not hard to see why
a spectacle so full of colour, performance and ritual
might appeal to his particular sensibilities. Alongside
the elements of chance, risk and potential martyr-
dom, the smell of death is never far away. As well
as seeing bullfights first-hand in Spain, Bacon kept
many images of bullfighting in his studio. In this late
work, the inspiration came from a poem written in
1935 by Federico García Lorca, *Lament for Ignacio Sánchez
Mejías*, which immortalised the famous Spanish
bullfighter, who died in 1934 in the Plaza de Toros de
Manzanares following a bloody gouging. The wounds
are present in the left and central panel, circled with
pointing arrows, devices common to Bacon's large
triptychs. The bull appears in the right-hand panel
complete with bloodied horn along with the vengeful
Eumenides in attendance.

In 1972 Bacon described his deep admiration for Titian
when recalling *The Death of Actaeon*: 'When I look at
Actaeon being torn to bits by the hounds, I think
also of the Eumenides, and it makes me think of how
perhaps they could be used. Because we don't only live
our lives, as it were, in the material and physical sense:
we live it through our whole nervous system, which
is, of course, also only a physical thing, but it's a whole
kind of long process of human images which have
been passed down – and yet nobody knows how to go
on using them. The painting suggests how forms and
images could be remade to carry meaning as definite
as the death of Actaeon' (Peppiatt 1996, pp. 246–7).

Bacon has captured the essence of Lorca's powerful
lament on the theme of an agonising public death:
'The room was iridescent with agony at five in the
afternoon.'

68
Figure
1962
Francis Bacon
Oil on canvas; 198 × 147.5 cm

Dublin City Gallery The Hugh Lane, Reg. No. 1980

In this work, the figure of a nude female is isolated
against the unprimed canvas. She is painted in fluid,
rapid brushstrokes of black, grey and pink. The face
of the figure is incomplete. The work calls to mind the
left panel of *Crucifixion* (1965; Munich, Pinakothek der
Moderne) and also the later work, *Female Nude Standing
in a Doorway* (1972; private collection). The figure has
been placed slightly to the left of the canvas; the barely
visible outline of a three-legged black stool or a chair
suggests that the figure is seated. In terms of the iden-
tity of this female figure, it is possible, given the long
dark hair, that it was Henrietta Moraes. It has been
noted that the fluidity of the flesh tones recall Bacon's
admiration of Géricault: 'The impressive thing about
Géricault is the sense of movement in everything. But
when I talk about movement, I don't mean represen-
tation of speed, that's not what it's all about. Géricault
somehow had movement pinned to the body...'
(Archimbaud 1993, p. 41).

The painting relates to an item found in Bacon's stu-
dio where Bacon has removed a sheaf of pages from
Eadweard Muybridge's *The Human Figure in Motion*
showing a series of photographs under the heading
'Woman Walking Downstairs, Picking up Pitcher,
and Turning'. The artist painted around a figure from
the centre row of the images in black paint. The left
panel of *Crucifixion* (1965) and *Female Nude Standing in a
Doorway* (1972) both offer paraphrases of this frame.

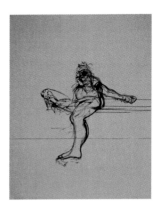 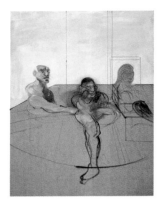

69
'Seated Figure'
1978
Francis Bacon
Oil on canvas; 198 × 147.5 cm

Dublin City Gallery The Hugh Lane, Reg. No. 1983

This painting is the clearest example of how Bacon liked to paint the broad outline of his compositions in thinned oil paint. The outline is blurred and sketchy and provides, as Bacon put it, 'a skeleton … of the way the thing might happen'. The figure appears to be reclining on a sofa or bed, and one notes that Bacon is tentatively exploring the position of the legs which gives a sense of motion to the image. The face of the figure has a large stain of black paint although one also can discern the distinctive profile of George Dyer. Essentially, it is an unresolved work although clearly the artist had an idea of what he wanted to depict before he put it to one side.

70
Three Figures
1981
Francis Bacon
Oil on canvas; 198 × 147.5 cm

Dublin City Gallery The Hugh Lane, Reg. No. 1982

This unfinished composition with three figures shows John Edwards in the centre, a male seated figure on the left and a female sphinx-like figure on a dais to the right. There is a strong resemblance between the head of the male on the left and some of the illustrations of Egyptian art that Bacon had in his studio. In particular, the strong facial features of the male figure call to mind a photograph of the beautiful Salt Head (named after its donor, the nineteenth-century Egyptologist Henry Salt) from the Louvre collection, which Bacon possessed and which indicates extensive handling by the artist.

Bacon believed that the achievement of Egyptian sculpture had scarcely been surpassed and he also spoke in the 1970s of making his own paintings more sculptural (Sylvester 1993, p. 114). In this unfinished work the female figure to the right is reminiscent of Bacon's paintings such as *Sphinx I* (1953), *Sphinx II* (1953) and *Sphinx* (1954). However, the profile of the hairline of the same figure is similar to that of Isabel Rawsthorne in the photograph by John Deakin (fig. 29, p. 151), which gives this sphinx-like figure a more human dimension. The central figure of Edwards is the most fully realised and Bacon has used spray paint in the area of his head. It was relatively late in his career that Bacon took to using household spray paints. In the early 1980s he used aerosol cans of car paint to create a fine atomised surface for his works. It is interesting to note that the leg of the male figure on the left is similar to that of George Dyer in the studio, as photographed by John Deakin (fig. 30, p. 151). This merging of disparate sources was typical of Bacon. Ultimately, Bacon must have been dissatisfied with this three figure composition and decided to discard it.

Bibliography

Androsov 1983 – Sergej Androsov, 'Some Works of Algardi from the Farsetti Collection in the Hermitage', *The Burlington Magazine*, 1983, vol. 123

Androsov 2008 – Sergej Androsov, *Museo Statale Ermitage. La scultura italiana dal XIV al XVI secolo*, Milano, 2008

Artemieva 2007 – [Irina Artemieva] in: *Tiziano. L'ultimo atto. Catalogo della mostra a cura di Lionello Puppi. Belluno, Palazzo Crepadona, Pieve di Cadore, Palazzo della Magnifica Comunita`, 15 settembre 2007–6 gennaio 2008*, Milano, 2007

Berezina 1983 – Valentina Berezina, *The State Hermitage Museum. Catalogue of Painting. Vol. XI: French Painting. Early and Mid-Nineteenth Century*, Moscow–Florence, 1983

Bernini: Sculpting in Clay 2012 – *Bernini: Sculpting in Clay*, exhib. cat., curated by C. D. Dickerson, A. Sigel and I. Wardropper, Metropolitan Museum of Art, New York, 2012

Bolshakov 2008 – Andrey Bolshakov, 'Mut or not? On the Meaning of a Vulture Sign on the Hermitage Statue of Amenemhat III', *Servant of Mut. Studies in Honor of Richard A. Fazzini*, Leiden – Boston, 2008 (pp. 23–31)

Brown 1986 – Jonathan Brown, *Velazquez: Painter and Courtier*, New Haven–London, 1986

Catalogus Lyde Browne 1768 – *Catalogus veteris aevi varii generis monumentorum quae Cimelarchio Lyde Browne apud Wimbledon asservantur*, London, 1768

Camón Aznar 1964 – José Camon Aznar, *Velázquez*, Madrid, 1964

Catalogo Lyde Browne 1779 – *Catalogo dei pui scetti e preciosi-marmin che se conservano nella Galleria del Sir Lyde Browne a Wimbledon*, Londra, 1779

Checa 2008 – Fernando Checa, *Velázquez: The Complete Paintings*, New York, 2008

Duthuit 1997 – Claude Duthuit, *Henri Matisse. Catalogue raisonné de l'oeuvre sculpté*, Paris, 1997

Ficoroni 1744 – Ficoroni, *La vestigial e rarita e Roma antica*, 1744

Flam 1986 – Jack Flam, *Matisse: The Man and his Art. 1869–1918*, Ithaca-London, 1986

Golénischeff 1891 – [Wladimir Golénischeff] *Ermitage Imperial. Inventaire de la collection égyptienne*, St Petersburg, 1891

Golénischeff 1893 – Wladimir Golénischeff, 'Amenemhā III et les sphinx de 'Sân'', *Recueil de travaux relatifs a la philologie et à l'archéologie égyptiennes et assyriennes*, Paris, 1893

Hale 2000 – Charlotte Hale, 'Portraits by Ingres: Images of an Epoch: Reflections, Technical Observations, Addenda and Corrigenda', *Metropolitan Museum Journal*, Vol. 35, New York, 2000 (pp. 203, 205, fig. 15)

Helbig 1867 – Wolfgang Helbig, 'Ermitage Imperial. Musee de Sculpture Antique', *Bulletino dell' Instituto di corrispondenza archeologica per anno 1867*, I, Roma, 1867

Kagané 2005 – Ludmila Kagané, *La pintura española del Museo del Ermitage. Siglos XV á comienzos del XIX. Historia de una colección*; traducción Aquilino Duque, Sevilla, 2005 (en español y ruso)

Kostenevich 1995 – Albert Kostenevich, *Hidden Treasures Revealed*, London–New York, 1995

Kostenevich 1999 – Albert Kostenevich, *Bouguereau to Matisse: French Art at the Hermitage. 1860–1950*, London, 1999

López-Rey 1999 – José López-Rey, *Velázquez: Catalogue Raisonné of His Oeuvre*, with an Introductory Study, London, 1963, 1979, 1996, 1999 (updated by O. Delenda)

Matisse 1984 – *Henri Matisse. Peintures et sculptures dans les musées Soviétiques*, Leningrad, 1984

Montagu 1985 – Jennifer Montagu, *Alessandro Algardi*, New Haven–London, 1985

Pomarède 2006 – *Ingres: 1780–1867*, Ouvrage dirigé par Vincent Pomarède [...]. Musée du Louvre, Paris (24 février–15 mai 2006), Paris, 2006

Riopelle 1999 – Chris Riopelle, *Count Nicolai Dmitrievich Gouriev, in Portraits by Ingres: Images of an Epoch*, exhib. cat., London–Washington–New York, 1999–2000 (pp. 250–3, no. 86)

Schwartz 2006 – Gary Schwartz, Paul van Calster, *De grote Rembrandt*, Zwolle, 2006

Schweitzer 1948 – Bernard Schweitzer, *Die Bildniskunst des Römische Republik*, Leipzig–Weimar, 1948

Simon 1986 – Erika Simon, *Augustus. Kunst und Leben in Rom um die Zeitwende*, Munchen, 1986

Sokolova 2011 – Irina Sokolova, *Due opere di Rembrandt dalla collezione dell'Ermitage, in L'Ermitage a Padova*, exhib. cat., Milano, 2011

The Complete Letters of Vincent Van Gogh – *The Complete Letters of Vincent van Gogh*, 3 vols, Greenwich, Conn., 1958

Tinterow, Conisbee 1999 – *Portraits by Ingres: Images of an Epoch*, ed. Gary Tinterow and Philip Conisbee, London–Washington–New York, 1999–2000

Treu 1871 – G. Treu, *Ueber die ägyptische Sammlung der Eremitage, mit Bezugnahme auf die Todtengebräuche der alten Aegypten*, St Petersburg, 1871

Trofimova 2006 – Anna Trofimova, 'Classicism in the Roman Portrait', *The Road to Byzantium: Luxury Arts of Antiquity*, exhib. cat., London, 2006

Tumpel 1986 – Christian Tumpel (mit Beitragen von Astrid Tumpel), *Rembrandt. Mythos und Methode*, Antwerpen, 1986

Vostchinina 1977 – Alexandra Vostchinina, *Le Portrait Romain. Musée de l'Ermitage*, Leningrad, 1977

Waldhauer 1931 – Oscar Waldhauer, *Die Antiken Sculpturen der Ermitage*, Berlin-Leipzig, 1931, vol. II

Androsov 1973 – Сергей Андросов. «Спящий Геркулес» Бандинелли // Сообщения Государственного Эрмитажа. XXXVII. – Ленинград, 1973.

Androsov 1989 – Сергей Андросов. Неизвестные произведения Джан Лоренцо Бернини // Искусство, декабрь 1989

Androsov 2006 – Сергей Андросов. «Славная коллекция скульптурных произведений»: Собрание Фарсетти в Италии и России. – Санкт-Петербург, 2006

Androsov 2014 – Сергей Андросов. Государственный Эрмитаж: Итальянская скульптура XVII-XVIII веков / Каталог коллекции. – Санкт-Петербург, 2014

Barskaia, Kostenevich 1991 – Анна Барская, Альберт Костеневич. Французская живопись: Вторая половина XIX-XX век // Государственный Эрмитаж. Собрание западноевропейской живописи. XII. – Ленинград, 1991.

Berezina 1971 – Валентина Березина. Живопись и скульптура // Сообщения Государственного Эрмитажа. XXXII. – Ленинград, 1971

Bolshakov 2009 – Андрей Большаков. Эрмитаж: Древний Египет. – Санкт-Петербург, 2009

Bolshakov 2011 – Андрей Большаков. Древний Египет в Эрмитаже: Новые открытия. – Санкт-Петербург, 2011

Davydova 2003 – Людмила Давыдова. Фрагмент скульптурной группы «Гибель Лаокоона и его сыновей» из коллекции Античного отдела Эрмитажа // Памятники культуры: Новые открытия / Ежегодник. – Москва, 2003

Hermitage 1988 – Эрмитаж: Западноевропейское искусство: Живопись. Рисунок. Скульптура / Автор вступительной статьи Борис Асварищ. – Ленинград, 1988

Kagané 2008 – Людмила Каганэ, Альберт Костеневич. Государственный Эрмитаж: Испанская живопись XV–начала XX века / Каталог коллекции. – Санкт-Петербург, 2008

Kizeritskii 1901 – Гангольф Кизерицкий. Музей древней скульптуры – Санкт-Петербург, 1901

Kosareva 1967 – Нина Косарева. Огюст Роден (к 50-летию со дня смерти). – Ленинград, 1967

Kosareva 1993 – Нина Косарева. Два терракотовых фрагмента из собрания Эрмитажа // Страницы истории западноевропейской скульптуры / Сборник научных статей памяти Жанетты Мацулевич (1890–1973). – Санкт-Петербург, 1993

Kostenevich 2008 – Альберт Костеневич. Искусство Франции: 1860-1950: Живопись. Рисунок. Скульптура. В двух томах. – Санкт-Петербург, 2008

Lapis, Mat'e 1969 – Ирма Лапис, Милица Матье. Древнеегипетская скульптура в собрании Государственного Эрмитажа. – Москва, 1969

Latt 1987 – Любовь Латт. Скульптура Родена в Эрмитаже. – Ленинград, 1987

Val'dgauer 1960 – Оскар Вальдгауер. Античная скульптура. – Санкт-Петербург, 1960 (переиздание книги 1923 г.)

Zaretskaia, Kosareva 1960 – Зинаида Зарецкая, Нина Косарева. Государственный Эрмитаж: Западноевропейская скульптура XV–XX веков. – Москва-Ленинград, 1960

Zaretskaia, Kosareva 1963 – Зинаида Зарецкая, Нина Косарева. Французская скульптура XVII–XX веков. – Ленинград, 1963

Ades, Dawn, and Forge, Andrew, *Francis Bacon*, exhib. cat., Tate Gallery, London 1985

Alley, Ronald, and Rothenstein, John, *Francis Bacon: Catalogue Raisonné and Documentation*, London 1964

Archimbaud, Michel, *Francis Bacon: In Conversation with Michel Archimbaud*, London, 1993

Arya, Rina, *Francis Bacon: Painting in a Godless World*, London, 2012

Bacon – Picasso: The Life of Images (Anne Baldassari), Paris, 2005

Bacon and Rembrandt, exhib. cat., Ordovas, London, 2011

Boxer, David W., 'The Early Work of Francis Bacon', unpublished Ph.D thesis, John Hopkins University, Baltimore, Maryland 1975

Cappock, Margarita, *Francis Bacon's Studio*, Hugh Lane Gallery, Dublin, 2005

Davies, Hugh M., *Francis Bacon: The Early and Middle Years, 1928–1958* (Ph.D thesis, Princeton University, 1975), New York and London 1978

Deleuze, Gilles, *Francis Bacon: logique de la sensation*, Paris 1981 (translated as *Francis Bacon, The Logic of Sensation*, Paris, 2005)

Dussler, Luitpold, *Die Zeichnungen des Michelangelo*, Berlin, 1959

Farson, Daniel, *The Gilded Gutter Life of Francis Bacon*, London, 1993

Ficacci, Luigi, *Bacon*, London, 2003

———, *Francis Bacon e l'ossessione di Michelangelo*, Milan, 2008

Francis Bacon, exhib. cat., Tate Gallery, London, 1962

Francis Bacon: Recent Paintings 1968–1974, exhib. cat. (intro. Henry Geldzahler), Metropolitan Museum of Art, New York, 1975

Francis Bacon, exhib. cat., Hirshhorn Museum and Sculpture Garden, Smithsonian Institute, Washington D.C., 1989–90

Francis Bacon, exhib. cat. (ed. Rudy Chiappini), Museo d'Arte Moderna, Lugano, 1993

Francis Bacon, exhib. cat., Centre Georges Pompidou, Paris, 1996

Francis Bacon and the Tradition of Art (eds. Barbara Steffen and Norman Bryson), Basel, 2004

Francis Bacon (eds. Matthew Gale and Chris Stephens), New York, 2008

Francis Bacon / Henry Moore: Flesh and Bone (Richard Calvocoressi and Martin Harrison), Oxford, 2013

Gale, Matthew, *Francis Bacon, Working on Paper*, Tate Gallery, London, 1999

Harrison, Martin, *In Camera: Francis Bacon*, London, 2005

———, *Movement and Gravity: Bacon and Rodin in Dialogue*, Ordovas, London, 2013

———, and Daniels, Rebecca, *Francis Bacon, Incunabula*, London, 2008

Leiris, Michel, *Francis Bacon: Full Face and in Profile*, New York, 1983

Peppiatt, Michael, *Francis Bacon: Anatomy of an Enigma*, London, 1996

———, *Francis Bacon in the 1950s*, New Haven, Conn., London, Norwich: Yale University Press in association with the Sainsbury Centre for Visual Arts, University of East Anglia, 2006

———, *Francis Bacon: Studies for a Portrait*, London and New Haven, 2008

Robert and Lisa Sainsbury Collection: catalogue in three volumes (ed. Steven Hooper), New Haven, Conn., Norwich: Yale University Press in association with the Sainsbury Centre for Visual Arts, University of East Anglia, 1997

Russell, John, *Francis Bacon*, London, Paris and Berlin, 1971; 2nd ed. London and New York, 1979; 3rd ed. London, 1993

Sinclair, Andrew, *Francis Bacon: His Life and Violent Times*, London, 1993

Sylvester, David, *Interviews with Francis Bacon*, London, 1975; revised as *The Brutality of Fact: Interviews with Francis Bacon*, 1980; 3rd ed. 1990, 4th ed. as *Interviews with Francis Bacon*, 1993

———, *Looking Back at Francis Bacon*, New York, 2000

Trapping Appearance: Portraits by Francis Bacon and Alberto Giacometti from the Robert and Lisa Sainsbury Collection, Sainsbury Centre for Visual Arts, Norwich, 1996

Van Gogh by Bacon, Fondation Vincent Van Gogh, Arles, 2002

Index

Index

Picture Credits

All reasonable efforts have been made to reach photographers and/or copyright owners of images used in this book. The publishers will be happy to amend any information in any subsequent edition and are prepared to pay fair and reasonable fees for usage made without prior agreement.

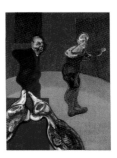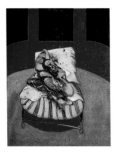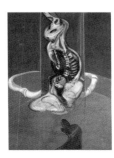

Page 14, fig. 1. Photograph by Irving Penn. Francis Bacon, British artist, with poster of Rembrandt self-portrait in background, London, 1963. © Condé Nast.

Page 16, fig. 2. Giovanni Cimabue, *Crucifix.* c. 1287–8; tempera on wood, 448 × 390 cm. Basilica di Sante Croce, Florence. De Agostini Picture Library / Bridgeman Images

Page 17, fig. 3. Francis Bacon, *Three Studies for a Crucifixion* (right panel). 1962; oil and sand on canvas, 198 × 145 cm (each panel). Solomon R. Guggenheim Museum, New York. Photo: Prudence Cuming Associates Ltd. © The Estate of Francis Bacon. All Rights Reserved. DACS 2015.

Page 18, fig. 4. Diego Velázquez, *Portrait of Pope Innocent X.* 1650; oil on canvas, 141 × 119 cm. Galleria Doria Pamphilij, Rome / Bridgeman Images

Page 19, fig. 5 (cat. 41). Francis Bacon, *'Study after Velázquez'.* 1950; oil on canvas, 198.1 × 137.2 cm. Private Collection. Courtesy The Estate of Francis Bacon. Photo: Prudence Cuming Associates Ltd. © The Estate of Francis Bacon. All Rights Reserved. DACS 2015

Page 19, fig. 6. Still from Sergei Eisenstein's film Battleship Potemkin, 1925. Ronald Grant Archive

Page 22, fig. 8. Francis Bacon in his studio at 7 Reece Mews. Photo: Francis Goodman. © National Portrait Gallery

Page 23, fig. 9. Diego Velázquez, *Las Meninas*, or *The Family of Philip IV.* c. 1656; oil on canvas, 316 × 276 cm. Prado, Madrid / Bridgeman Images

Page 26, fig. 10. Francis Bacon, *Two Figures.* 1953; oil on canvas, 152.5 × 116.5 cm. Private collection. Photo: Prudence Cuming Associates Ltd. © The Estate of Francis Bacon. All Rights Reserved. DACS 2015

Page 27, fig. 11. *Wrestlers*, Roman sculpture after a Greek original; marble. Galleria degli Uffizi, Florence / Bridgeman Images

Page 28, fig.12. *Spinario (Boy with a Thorn).* 1st century BC; bronze. Musei Capitolini, Rome / Bridgeman Images

Page 28, fig. 13. Francis Bacon, *Three studies of the Male Back.* 1970; oil on canvas, 198 × 147.5 cm. Kunsthaus Zürich, Vereinigung Zürcher Kunstfreunde. Photo: Prudence Cuming Associates Ltd. © The Estate of Francis Bacon. All Rights Reserved. DACS 2015

Page 30, fig. 14. Henri Matisse (French, 1869 1954). *Blue Nude*, 1907. Oil on canvas. 36 1/4 × 55 1/4 in. (92.1 × 140.3 cm.). The Baltimore Museum of Art: The Cone Collection, formed by Dr. Claribel Cone and Miss Etta Cone of Baltimore, Maryland, BMA 1950.228. Photo: Mitro Hood. Artwork: © Succession H. Matisse/DACS, 2015

Page 31, fig. 15. Francis Bacon, *Three Figures in a Room.* 1964; oil on canvas, 198 × 147.5 cm. Centre Georges Pompidou, Musée d Art Moderne, Paris. Photo: Prudence Cuming Associates Ltd. © The Estate of Francis Bacon. All Rights Reserved. DACS 2015

Page 32, fig. 16. Francis Bacon, *Head VI.* 1949; oil on canvas, 93 × 76.5 cm. The Arts Council of Great Britain, London. Photo: Prudence Cuming Associates Ltd. © The Estate of Francis Bacon. All Rights Reserved. DACS 2015

Page 33, fig. 17. Michelangelo, *L'Anima Damnata.* c. 1523; charcoal on paper. Galleria Stampe e Disegni degli Uffizi, Florence / Bridgeman Images

Page 34, fig. 18. Leaf from book Martin Weinberger, *Michelangelo: the Sculptor*, London: Routledge & Kegan Paul and New York: Columbia University Press, 1967. © The Estate of Francis Bacon. Collection: Dublin City Gallery The Hugh Lane

Page 35, fig. 19. Francis Bacon, *Triptych – Studies of the Human Body.* 1979; oil on canvas, 198 × 147.5 cm. Private collection. Photo: Prudence Cuming Associates Ltd. © The Estate of Francis Bacon. All Rights Reserved. DACS 2015

Page 138, fig. 20. Francis Bacon in his Battersea studio; photograph by Cecil Beaton, 1959. Courtesy of the Cecil Beaton Studio Archive at Sotheby's

Page 141, fig. 21 (cat. 49). Francis Bacon, *Sketch for a Portrait of Lisa.* 1955; oil on canvas, 61 × 50.8 cm. Robert and Lisa Sainsbury Collection, Sainsbury Centre for Visual Arts, University of East Anglia. Photo: James Austin. © The Estate of Francis Bacon. All Rights Reserved. DACS 2015

Page 141, fig. 22 (cat. 50). Francis Bacon, *Portrait of Lisa.* 1956; oil on canvas, 100.6 × 72.7 cm. Robert and Lisa Sainsbury Collection, Sainsbury Centre for Visual Arts, University of East Anglia. Photo: James Austin. © The Estate of Francis Bacon. All Rights Reserved. DACS 2015

Page 141, fig. 23 (cat. 54). Francis Bacon, *Portrait of Lisa.* 1957; oil on canvas, 59.7 × 49.5 cm. Robert and Lisa Sainsbury Collection, Sainsbury Centre for Visual Arts, University of East Anglia. Photo: James Austin. © The Estate of Francis Bacon. All Rights Reserved. DACS 2015

Page 142, fig. 24. Robert and Lisa Sainsbury at their home, Smith Square, London in 1965. Photograph by Snowdon / Trunk Archive.

Page 144, fig. 25. Francis Bacon with Robert and Lisa Sainsbury at the opening of his second retrospective exhibition at the Tate Gallery, London, 1977 (photographer unknown)

Page 145, fig. 26. Alberto Giacometti. *Head of Isabel II (Isabel Rawsthorne).* 1938–9; bronze, 0/6, h. 21.7 cm. Robert and Lisa Sainsbury Collection, Sainsbury Centre for Visual Arts, University of East Anglia. Photo: James Austin. All Rights Reserved. DACS 2015

Page 146, fig. 27. The Living Area gallery, Sainsbury Centre for Visual Arts, University of East Anglia, 2014. Photo: Pete Huggins

Page 148, fig. 28. Francis Bacon's Studio, 7 Reece Mews, London. Photo by Perry Ogden, 1998, C-type print on aluminium, 122 × 152.5 × 5 cm (1963.14). Dublin City Gallery The Hugh Lane. © The Estate of Francis Bacon

Page 151, fig. 29. Black and white photograph of Isabel Rawsthorne by John Deakin, 31 × 30.3 cm (RM98F112:15). Dublin City Gallery The Hugh Lane. © The Estate of Francis Bacon

Page 151, fig. 30. Black and white photograph of George Dyer in Reece Mews studio by John Deakin, 30.3 × 30.3 cm (RM98F1A:161). Dublin City Gallery The Hugh Lane. © The Estate of Francis Bacon

Page 153, fig. 31. Piece of brown cardboard with fragment of leaf from magazine 'Sunday Times Colour Section', 18 February 1962 (p.18) with colour photographic illustration of a Nazi rally in Nuremberg 1938 attached to the card, 38 × 29 cm (RM98F114:140). Dublin City Gallery The Hugh Lane. © The Estate of Francis Bacon.

Page 154, fig. 32. Book (hardback), Albert E. Elsen, *In Rodin's Studio, A Photographic Record of Sculpture in the Making*, Phaidon, Oxford in association with the Musée Rodin, Paris, 1980, 28.4 × 22.1 × 2.2 cm (RM98F110:11). Dublin City Gallery The Hugh Lane. © The Estate of Francis Bacon

Page 155, fig. 33. Francis Bacon, *Painting 1950*. 1950; oil on canvas, 198 × 132 cm. Leeds Museum and Galleries: City Art Gallery. Photo: Hugo Maertens. © The Estate of Francis Bacon. All rights reserved, DACS 2015

Page 157, fig. 34. Francis Bacon, Biomorphic Drawing. *c.*1930s; black, blue and dark-brown ink on lined paper, 16.7 × 12.1 cm. Dublin City Gallery The Hugh Lane. © The Estate of Francis Bacon

Page 159, fig. 35. Francis Bacon's Studio, 7 Reece Mews, London. Photograph: Perry Ogden. C-type print on aluminium, 122 × 152.5 × 5 cm (1963.03). Dublin City Gallery The Hugh Lane. © The Estate of Francis Bacon

Page 161, fig. 36. Unframed canvas with extensive paint accretions (used as a palette), 36 × 30.2 × 1.7 cm (RM98F200:1). Dublin City Gallery The Hugh Lane. © The Estate of Francis Bacon

Page 162, fig. 37. Unframed painting on canvas by Francis Bacon (portrait; destroyed), 35.5 × 30.6 × 1.8 cm (RM98F226:4). Dublin City Gallery The Hugh Lane. © The Estate of Francis Bacon.

Page 164, fig. 38 (cat. 69). *'Seated Figure'*, 1978, by Francis Bacon, oil on canvas, 198 × 147.5 cm (Reg. 1983). Dublin City Gallery The Hugh Lane. © The Estate of Francis Bacon

Page 165, fig. 39. (cat. 70). *Three Figures*, 1981, by Francis Bacon, oil on canvas, 198 × 147.5 cm (Reg. 1982). Dublin City Gallery The Hugh Lane. © The Estate of Francis Bacon

Page 166, fig. 40. *'Self-Portrait'*, 1992, by Francis Bacon, oil on canvas, 198 × 147.5 cm; Dublin City Gallery The Hugh Lane. © The Estate of Francis Bacon

Pages 168–181 (all illustrations). Dublin City Gallery The Hugh Lane. © The Estate of Francis Bacon

Catalogue

26 (pl. 31). *Portrait (Pope Innocent X)*, Diego Velázquez de Silva, 1599, Seville – 1660, Madrid. Oil on canvas; 82 × 71.5 cm. English Heritage (Wellington Museum, Apsley House), WM 1590–1948

35 (pl. 66). *Nymph and Satyr*, Henri Matisse, 1908–9. Oil on canvas; 89 × 116.5 cm. State Hermitage Museum, St Petersburg. © Succession H. Matisse/DACS, 2015

36 (pl. 51). *Woman in Green*, Henri Matisse, *c.*1909. Oil on canvas; 65 × 54 cm. State Hermitage Museum, St Petersburg. © Succession H. Matisse/DACS, 2015

40 (pl. 30). *Crucifixion*, 1933, Francis Bacon 1909–92. Oil on canvas; 60.5 × 47 cm. Private collection. Photo: Prudence Cuming Associates Ltd. © The Estate of Francis Bacon. All Rights Reserved. DACS 2015

41 (pl. 33). *'Study after Velázquez'*, 1950, Francis Bacon. Oil on canvas; 198.1 × 137.2 cm. Private Collection. Courtesy The Estate of Francis Bacon. Photo: Prudence Cuming Associates Ltd. © The Estate of Francis Bacon. All Rights Reserved. DACS 2015

42 (pl. 27). *'Marching Figures'*, 1952, Francis Bacon. Oil on canvas; 198.1 × 137.2 cm. Private collection, courtesy The Estate of Francis Bacon. Photo: Prudence Cuming Associates Ltd. © The Estate of Francis Bacon. All Rights Reserved. DACS 2015

43 (pl. 43). *Pope I*, 1951, Francis Bacon. Oil on canvas; 197.8 × 137.4 cm. © Aberdeen Art Gallery and Museums Collections. All Rights Reserved. DACS 2015

44 (pl. 12). *Study of a Head*, 1952, Francis Bacon. Oil on canvas; 49.5 × 39.3 cm. Yale Center for British Art, Gift of Beekman C. and Margaret H. Cannon. © The Estate of Francis Bacon. All Rights Reserved. DACS 2015

45 (pl. 46). *Study of a Nude*, 1953, Francis Bacon. Oil on canvas; 59.7 × 49.5 cm. Robert and Lisa Sainsbury Collection, Sainsbury Centre for Visual Arts, University of East Anglia. Photo: James Austin. © The Estate of Francis Bacon. All Rights Reserved. DACS 2015

46 (pl. 38). *Portrait of R. J. Sainsbury (Robert Sainsbury)*, 1955, Francis Bacon. Oil on canvas; 114.9 × 99.1 cm. Robert and Lisa Sainsbury Collection, Sainsbury Centre for Visual Arts, University of East Anglia. Photo: James Austin. © The Estate of Francis Bacon. All Rights Reserved. DACS 2015

47 (pl. 1). *Study (Imaginary Portrait of Pope Pius XII)*, 1955, Francis Bacon. Oil on canvas, mounted on hardboard; 108.6 × 75.6 cm. Robert and Lisa Sainsbury Collection, Sainsbury Centre for Visual Arts, University of East Anglia. Photo: James Austin. © The Estate of Francis Bacon. All Rights Reserved. DACS 2015

48 (pl. 58). *Study for Portrait II (After the Life Mask of William Blake)*, 1955, Francis Bacon, 1909–1992. Oil on canvas; 61 × 50.8 cm. Tate London, 2015. All Rights Reserved. DACS 2015

49 (pl. 4). *Sketch for a Portrait of Lisa*, 1955, Francis Bacon. Oil on canvas; 61 × 54.9 cm. Robert and Lisa Sainsbury Collection, Sainsbury Centre for Visual Arts, University of East Anglia. Photo: James Austin. © The Estate of Francis Bacon. All Rights Reserved. DACS 2015

50 (pl. 39). *Portrait of Lisa*, 1956, Francis Bacon. Oil on canvas; 100.6 × 72.7 cm. Robert and Lisa Sainsbury Collection, Sainsbury Centre for Visual Arts, University of East Anglia. Photo: James Austin. © The Estate of Francis Bacon. All Rights Reserved. DACS 2015

51 (pl. 49). *Study for a Portrait of Van Gogh I*, 1956, Francis Bacon. Oil on canvas; 154.1 × 115.6 cm. Robert and Lisa Sainsbury Collection, Sainsbury Centre for Visual Arts, University of East Anglia. Photo: James Austin. © The Estate of Francis Bacon. All Rights Reserved. DACS 2015

52 (pl. 21). *'Figures in a Landscape'*, 1956, Francis Bacon. Oil on canvas; 147.3 × 132.1 cm. Private collection, courtesy The Estate of Francis Bacon. Photo: Prudence Cuming Associates Ltd. © The Estate of Francis Bacon. All Rights Reserved. DACS 2015

53 (pl. 63). *Owls*, 1956, Francis Bacon. Oil on canvas; 61 × 51 cm. Private collection. © The Estate of Francis Bacon. All Rights Reserved. DACS 2015

54 (pl. 7). *Portrait of Lisa*, 1957, Francis Bacon. Oil on canvas; 59.7 × 49.5 cm. Robert and Lisa Sainsbury Collection, Sainsbury Centre for Visual Arts, University of East Anglia. Photo: James Austin. © The Estate of Francis Bacon. All Rights Reserved. DACS 2015

55 (pl. 14). *Study for Portrait of P. L., No. 2*, 1957, Francis Bacon. Oil on canvas; 151.8 × 118.5 cm. Robert and Lisa Sainsbury Collection, Sainsbury Centre for Visual Arts, University of East Anglia. Photo: James Austin. © The Estate of Francis Bacon. All Rights Reserved. DACS 2015

56 (pl. 48). *Study for a Portrait of Van Gogh IV*, 1957 Francis Bacon, 1909–1992. Oil on canvas; 152.4 × 116.8 cm. © Tate London, 2015. All Rights Reserved. DACS 2015

57 (pl. 17). *Two Figures in a Room*, 1959, Francis Bacon. Oil on canvas; 198 × 142 cm. Robert and Lisa Sainsbury Collection, Sainsbury Centre for Visual Arts, University of East Anglia. Photo: James Austin. © The Estate of Francis Bacon. All Rights Reserved. DACS 2015

58 (pl. 54). *Lying Figure*, 1959, Francis Bacon. Oil on canvas; 198.5 × 142.6 cm. New Walk Museum & Art Gallery, Leicester, UK. Photo © Leicester Arts & Museums / Bridgeman Images. © The Estate of Francis Bacon. All Rights Reserved. DACS 2015

59 (pl. 41). *Head of a Man*, 1960, Francis Bacon. Oil on canvas; 38.5 × 32 cm. Robert and Lisa Sainsbury Collection, Sainsbury Centre for Visual Arts, University of East Anglia. Photo: James Austin. © The Estate of Francis Bacon. All Rights Reserved. DACS 2015

60 (pl. 42). *Head of a Man*, 1960, Francis Bacon. Oil on canvas; 85.2 × 85.2 cm. Robert and Lisa Sainsbury Collection, Sainsbury Centre for Visual Arts, University of East Anglia. Photo: James Austin. © The Estate of Francis Bacon. All Rights Reserved. DACS 2015

61 (pl. 52). *Head of Woman*, 1960, Francis Bacon. Oil on canvas; 85.2 × 85.2 cm. Robert and Lisa Sainsbury Collection, Sainsbury Centre for Visual Arts, University of East Anglia. Photo: James Austin. © The Estate of Francis Bacon. All Rights Reserved. DACS 2015

62 (pl. 56). *Seated Figure*, 1961, Francis Bacon, 1909–1992. Oil on canvas; 165.1 × 142.2 cm. © Tate London, 2015. All Rights Reserved. DACS 2015

63 (pl. 64). *Landscape near Malabata, Tangier*, 1963, Francis Bacon, 1909–1992. Oil on canvas; 198 × 145 cm. Private collection, London. © The Estate of Francis Bacon. All Rights Reserved. DACS 2015

64 (pl. 60). *Three Studies for Portrait of Isabel Rawsthorne*, 1965, Francis Bacon. Oil on canvas; 35.5 × 30.5 cm (each panel). Inscribed in Bacon's hand on the back of the left canvas: *3 studies of portrait Isabel Rawsthorne 1965*. Robert and Lisa Sainsbury Collection, Sainsbury Centre for Visual Arts, University of East Anglia. Photo: Prudence Cuming Associates Ltd. © The Estate of Francis Bacon. All Rights Reserved. DACS 2015

65 (pl. 62). *Portrait of Isabel Rawsthorne*, 1966, Francis Bacon, 1909–1992. Oil on canvas; 81.3 × 68.6 cm. © Tate London, 2015. All Rights Reserved. DACS 2015

66 (pl. 67). *Studies of the Human Body*, 1970, Francis Bacon. Oil on canvas; 198 × 147.5 cm (each panel). Private Collection, courtesy Ordovas. Photo: Prudence Cuming Associates Ltd. © The Estate of Francis Bacon. All Rights Reserved. DACS 2015

67 (pl. 24). *Triptych*, 1987, Francis Bacon. Oil on canvas; 198 × 147.5 cm (each panel). Private collection, courtesy The Estate of Francis Bacon. Photo: Prudence Cuming Associates Ltd. © The Estate of Francis Bacon. All Rights Reserved. DACS 2015

68 *Figure*, 1962, Francis Bacon. Oil on canvas; 198 × 147.5 cm. Dublin City Gallery The Hugh Lane, Reg. No. 1980. © The Estate of Francis Bacon. All Rights Reserved. DACS 2015

69 *'Seated Figure'*, 1978, Francis Bacon. Oil on canvas; 198 × 147.5 cm. Dublin City Gallery The Hugh Lane, Reg. No. 1983. © The Estate of Francis Bacon. All Rights Reserved. DACS 2015

70 *Three Figures*, 1981, Francis Bacon. Oil on canvas; 198 × 147.5 cm. Dublin City Gallery The Hugh Lane, Reg. No. 1980. © The Estate of Francis Bacon. All Rights Reserved. DACS 2015

Picture Credits